KB178808

Hanok

The Traditional Korean House

Hanok
The Traditional Korean House

Edited by Yi Ki-ung

Photos by Seo Heun-kang and Joo Byoung-soo

Translated by Isabella Ofner and Tina Stubenrauch

B
Youlhwadang

Introduction

The Representation of Traditional Residences in Korea

1.

Forty five years ago I founded a publishing house. As a publisher, I have continuously been concerned with traditional residential buildings and other aspects of material culture stemming from my immediate surroundings, as well as with other beautiful objects from the past. From the time of my childhood until adulthood, I had lived in Seongyojang house, resulting in a deep connection and a precise memory of every single detail of a traditional Korean residential house deeply ingrained into my memory. These memories are likely the source of my nostalgia for the past in my native home, which might have eventually led me to become a publisher.

There have been continual inquires of and requests for publication and I guess this might be associated with my personal experience and inclination. However, for a number of years it seemed to me that I was mostly occupied with refusing such requests. Having been elected a board member of the National Museum of Korea and visiting the museum regularly, I made the acquaintance of the museums' director Yi Geon-mu. Yi Geon-mu had dedicated his career to this particular area and was finally appointed Director of the Cultural Heritage Administration. In this role, he planned to issue a series of encyclopaedias on various aspects of Korean culture and asked me if I wanted to oversee the part on 'traditional residential housing'.

Admittedly, I was hesitant at the start as I had previously had some negative experiences in collaborations with state departments. However, as the owner of a traditional residence myself I was reminded of the invaluable treasure of our cultural heritage and the importance of their conservation. A number of editorial difficulties had to be overcome by our team before the project was finalised, which made us realise how much more there could be done to preserve our national heritage in this present time.

The great encyclopaedia of Korean culture, *Korean Traditional Houses and Folk Villages*, is divided into three volumes: Volume 1 focuses on the province of Gyeoggi, the areas of Gwandong and Hoseo[1]; Volume 2 deals with the area of Yongnam[2]; and

Volume 3 provides information about Honam[3] and the Jeju Island. The photographs were taken by Seo Heun-kang. Although the project was cost extensive, the determined efforts of my editorial team still allowed us to collect a plethora of material. To preserve the extensive data of our research, I decided to produce a separate commemorative book on traditional Korean residential houses and asked Seo Heun-kang to support this undertaking with his photographic expertise.

This book is the result of these events. While working on its different stages, I consistently wondered about the current state of our culture. I am personally quite concerned about the state of our national heritage and am appealing to society at large to take the task of protecting our country's historical monuments seriously. I believe that thorough legislation could help counteract the deterioration of our cultural heritage; sadly, at this present time the efforts are rudimentary at best.

Unfortunately, my fears came true when the great Sungnyemun Gate burned to the ground in 2008. After five years of reconstruction the public can once more be proud of the Sungnyemun Gate even though the efforts towards rebuilding the significant monument were overshadowed by a number of scandals.

In 2013 after ten years of painstaking labour, the Youlhwadang[4] Publishers released The Complete Works of Ko Yu-seop (10 vols). The Youlhwadang, the *sarangchae* of Seongyojang house, which celebrates its bicentenary this year, was indeed built by my great-grandfather O-eun Yi Hu in 1815, the 15th year of King Sunjo's reign. Given these personal circumstances, the release of U-hyeon Ko Yu-seop's oevre was of immense personal importance to me. Its publication coincided with the completion of the Sungnyemun Gate's reconstruction and its official return to the people of Korea. It was during that time that I was inspired to write a number of seminal articles about the complete works of U-hyeon and the restoration of the Sungnyemun.

Due to its prominent position in the city's landscape, people have always revered the Sungnyemun. This was undoubtedly the reason for the public agitation following the destruction of the historic gate. The peoples' reaction was comparable to one one would get from destroying a beehive. This is what led us, the Youlhwadang Publishers, to stay true to our achievements in supporting the conservation of traditional values, while compensating our modest means of resources with tireless commitment to this goal.

2.

I remember the time my father commissioned the extension of the men's living quarters, which were then called the 'upper house'. This was around 1948 and after Korean independence and is one of my most cherished memories. The farmers, tired

from a day's work on the fields, drank a cup of rice wine before starting to fortify the building grounds for the new house – in bright moonlight. During the entire working process, one of the workers sang a lead rhythm and the others followed, repeating his melody. This is how the building grounds were fortified by pounding. We children enjoyed this motivational melody until we fell asleep then and there on the grounds. The workers called this work song *Deolgujil Sori* but to this day I do not know the exact meaning of it. The text in essence wished the owner's family an abundance of luck, wealth and many sons. All these wishes came true for the Seongyojang family with the building of this new house, and all these experiences remain deeply anchored in my memory.

Mr Choi Yeo-gwan, who advised my father on the building plans, materials, roof tiles, etc. is no one less than the geomantics[5] master of the house, and a joiner himself. The houses' construction corner stone blocks were positioned on the previously fortified soil and standing wooden columns erected on top of them; on top of those, cross-beams were placed and finally the roof construction was attached. My father himself kept the building's chronicles, called *Sangnyangmun*[6].

In Western building traditions, houses are erected from the ground up, while buildings in Korea are constructed from the top. Firstly the roof is built, which is supported by wooden columns so that construction of the house can take place from top down. In the West, rain forces construction to halt, yet the Korean construction method allows the workers to proceed even in rainy conditions without any problems. After the structural work is finished, the floors of the inner rooms are fitted with high-quality *jangpan*[7]. The walls of our rooms were tastefully decorated with landscape paintings of the four seasons of Baekryeon and inscriptions of Songpo[8]. Songpo Yi Byeong-il (1801–1873) was a well-known painter and calligraph at the end of the Joseon Dynasty; he especially used the writing of Bibaek.[9]

From the age of eight until I was 20 years old, I lived in this newly built house, moving between the women's and men's houses. After the completion of the house, or maybe a year after, the Korean war broke out and our house was occupied in turns by both North Korean and South Korean soldiers. As a consequence, almost all art treasures we possessed, such as scripts, paintings and furniture, were lost. We not only suffered from material loss but also very much from the personal loss of these treasures.

These memories do not only capture positive memories. Some things are forever lost; but despite all this, many positive memories of these cultural treasures remained in our hearts. Even if these memories are faint, they are still strongly anchored as if one could easily reconstruct it all. All we need to do is assemble the basic details like a jigsaw puzzle.

This book was planned for this reason. Seo Heun-kang is both a protector and researcher, systematically capturing and researching the traces of these traditional houses. Every time he is documenting them, he regrets not being able to also capture the essence of life in the history of the houses, just their material past.

Not only photographic artist Seo Heun-kang, everyone feels this special atmosphere when stepping into these traditional houses. Seo attempts to revive the essence of life of past inhabitants of these old traditional houses through his images. I noticed these endeavours in his work from time to time, which is why I have suggested in the past to include his photographs of these houses in the past amongst the present photographs to create a living transition between restoration and originality.

3.

The houses bequeathed to us are simply called *hanok* or 'traditional house'. Shin Young-hun, a joiner and researcher of the traditional houses himself, phrased it this way:

"Clothes worn by people living during the Joseon Dynasty are called *hanbok*, Korean food is called *hansik* and the traditional houses *hanok*. The *hanok* building style is different in character from building styles in any other country. *Maru* (a wooden-floored room without underfloor heating) and *gudeul* (a room's floor heated with underfloor heating) are built at the same time. In other countries, houses are either equipped with a *maru* without *gudeul*, or a *gudeul* without *maru*. The correct building form of a *hanok* literally refers to a *daecheong*, a large wooden-floored room between heated rooms (as can be seen in the images of the Gung-jip) and the *toenmaru*, the narrow wooden floor (along outside of a room) as well as a *maru*, located between the *anbang*, a inner room and the adjacent rooms with *gudeul*."

It is especially important to note that the Korean traditional *hanok* style is uniquely different from a Japanese or western building style. These traditional houses were built approximately until the opening of Korean ports at the end of the 19th century and the remaining houses were shaped by considerations of the requirements of everyday life. Nevertheless, they display specific regional differences and are adapted to the respective environmental conditions. Within these old houses, one can feel the flair and breath of life of their inhabitants as well as their traces everywhere.

A historian Cha Jang-seop explains it thus:

"Owner and house are one. When looking at a person, one can imagine the house

he lives in. From ancient times on Koreans have acknowledged that the dignity of a person is also the dignity of his house. A house is thus as much a subject as a person and the history of a house is equally the history of its residents."

For this reason, traditional houses with their beautiful forms were designated national cultural heritage. They are also important subjects of scholarly research and cultural memorials to the country. 3500 cultural assets are looked after by the Korean government, 1447 of those are buildings. In the regional divisions, 7793 cultural assets are registered, 5305 of those are memorial buildings. 164 traditional houses are listed as protected memorials. According to statistical documentation about 60 percent of all memorials are buildings.

Listed by region, these are: 1 house in Seoul, 8 houses in Gyeonggi province, 5 houses in Gangwon province, 16 houses in Chungcheongbuk-do province, 14 houses in Chungcheongnam-do province, 3 houses in Daegu, 69 houses in Gyeongsangbuk-do province, 5 houses in Gyeongsangnam-do province, 4 houses in Jeollabuk-do province, 33 in Jeollanam-do province and 5 houses on Jeju Island.

This book describes 40 of the traditional houses referred to above. They are only a fraction of the 164 buildings designated important national cultural memorials. In terms of order, they are ordered by area, time of construction and form of living. It is important to acknowledge the fascinatingly beautiful photographs accompanying the text and brief explanations to the history and special details of each *hanok*.

For the book, 3 from Gyeonggi province, 2 from Gangwon province, 3 from Chungcheongbuk-do province, 5 from Chungcheongnam-do province, 1 from Daegu, 13 from Gyeongsangbuk-do province, 3 from Gyeongsangnam-do province, 2 from Jeollabuk-do province, 7 from Jeollanam-do province and 1 from Jeju Island were selected and ordered by their time of construction.

The selected houses are predominantly houses with tiled roofs; however, some also feature straw thatched roofs, such as e.g. the houses of Yi Ha-bok in Seocheon and of Kim Sang-man in Buan. Other straw thatched houses can be found in open-air museum villages, such as e.g. Kim Dae-ja's home in the folk culture heritage village of Nakan in Suncheon, and Go Pyeong-o's home in Seong-eup village on Jeju Island. Many of the houses display differences in regional characterstics, such as e.g. the *neowa-jip* covered with thin wooden shingles and stones; or the *gulpi-jip* covered with thick oak bark. Other houses display regional characteristics dominated by differences in life styles, such as the *tumak-jip* in Nari-dong on Ulleung Island, or houses such as the *kkachi-gumeong-jip,* showcasing the life in the different provinces. Their rareness and significance, their history and even regional differences are important cultural assets.

The buildings presented in this volume tell of the social rank and wealth of their

owners, both of which provide for specific characteristics in architecture. Most of them belong to the socially highly regarded *yangban* class[10] of the individual regions. To give some examples: The Confucian scholar Yun Jeung from King Sukjong's times also had a Myeongjae-Gotaek[11] built in Nonsan. Both display very specific and typical characteristics.

Some of these heritage houses, deriving from the social upper class even have ties to the Royal Palace, as e.g. the Gung-jip in Namyangju, the home of King Yeongjo's last daughter Hwagil-Ongju. Another one in this category is former President Yun Bo-seon's birth house. They also display the specific features of their times and reflect the personality of their owners. The houses Seongyojang in Gangneung and Unjoru in Gurye show us the large scale of some of these estates with their generously designed buildings, the inner and outer living areas, the buildings accommodating workers, and their artificial lakes.

4.

The features of the traditional *hanok*s were designed to harmonise with the surrounding natural environment. According to the theory of geomancy, the condition of the soil and the natural waterways needed to be carefully considered as it was believed that they would affect people's fortune or misfortune. Building owners therefore took great care to select the most auspicious plots for their homes.

Apart from geomantic aspects, climate was the most important factor for building constructions. As Korea has four distinct seasons, features to protect from the cold and the heat needed to be included in the architectural design; in winter, inner rooms with floor heating (*ondolbang*) offered warmth, while rooms such as the *daecheong* and the *maru* afforded cooling during the hot summer months. As the kitchen needed to be accessible at all times, it was embedded harmoniously into the floor plan of the house. Furthermore, households during the Joseon period consisted of several generations, including the grandparents, the families of the patriarch's male siblings and sometimes even his sons' families. This extended family necessitated a different and generous construction plan and design.

Another feature of the traditional architecture is the strict separation between the women's and men's spheres because Confucian philosophy prescribes gender-segregation. The inner living area was therefore reserved for women while men as well as guests frequented the outer spaces. The separation between the genders has been somewhat relaxed since the 19th century and the separating walls between women's and men's quarters have often been demolished. The walls separating the masters' and the servants' quarters, however, remained intact. Indeed, there are examples whereby the inner and outer buildings have been joined together, creating one large complex. With Confucianism being the state ideology

during the Joseon period, ancestor worship was considered highly important.

Every house therefore included a special place for worship. After his accession to the throne, the founder of the Joseon Dynasty King Taejo ordered everyone in the country, from the civil servants to the servants, to build an ancestral shrine. Those who could not afford to build a shrine in their home were instructed to worship their ancestors in the *joengchim*. This is the reason why the ancestral shrines are found in elevated places as they needed to be situated above the living areas. Under no circumstances should an ancestral shrine be demolished as it is considered a sacred site.

In the past, Koreans believed in 'protector' or 'house' deities. Amongst these, Seongjusin was particularly worshipped and held in high esteem. The house gods included a god of the grounds, a door god, a *maru* god, a kitchen god named Jowang, a god of the stables and the god of wells, Yongshin. In addition, other gods, such as the god of good luck of the house, Samsin, who was responsible for the children's fortune, or the Dwitgansin, the toilet god, existed as well. Home gods like these were respected and paid respect at every opportunity.

The social system of the Joseon Dynasty was one of a strictly ordered class system and building ground allocations were distributed according to ancestry and rank. King Sejong (1397-1450) legislated the '*Gasagyuje*' according to which the sons of the king were only allowed to build their residential estates up to a maximum size of 60 *kan*[12]. Ordinary people's estates were not to exceed 9 *kan*.

Apart from class, also hierarchy of age played a defining role in building construction, which the names of buildings clearly express as well. *Keun-sarangbang*, the large men's room, is the patriarch's room, whereas the *jageun-sarangbang* (small men's room) describes the room reserved for the son and heir in the men's quarters. The *anbang* (inner room in the women's quarters) is the mother-in-law's room, while the *geonneonbang* (room on the opposite side), or *meoritbang* (literally 'upper room', located next to the *anbang*) was reserved for the daughter-in-law. The first generation's rooms are double in size compared to the second generation's rooms. Other rooms are the *darak, golbang* and *byeokjang* (storage rooms), that were added to the buildings.

The quarters of the domestic service staff or 'lower class' is strictly separated from the main living quarters by a wall. The building for domestic servants was called *haengnangchae*. It is situated to the left and right of the main entrance gate and is confined by walls between the inner and outer living areas. The size of the *haengnangchae* differed according to the owners' needs and featured between 10 and 20 *kan*. Depending on whether more house celebrations (such as *jesa,* ancestral celebrations or other events) were planned, additional servants' quarters were built as needed.

The traditional houses comprise the *anchae* (women's quarters) and *sarangchae* (men's quarters). The *anchae* is mainly inhabited by women, and are thus situated in the inner area of the building grounds. The building parts *anbang* (inner room), *daecheong* (main wooden-floored hall for the reception of guests), *geonneonbang* (opposite room) and *bueok* (kitchen) are the basic elements of a residential house. The *sarangchae* is inhabited by the head of the household and is thus located in the front part of the estate, usually between the *anchae* and *haengnangchae*. *sarangbang* (men's room), *daecheong* and *chimbang* (the patriarch's bedroom) are all located within the men's quarters. If no *chimbang* exists, the head of the household sleeps in the *sarangbang*. Such a strict separation between women and men existed since the 16th century of the Joseon Dynasty and was based on the Seongnihak[13] theory giving the patriarch all-embracing rights over his family.

Around the actual living quarters, an array of additional courtyards and buildings, such as the *byeoldang* (separate house), *madang* (courtyard), *oeyanggan* (cow stables), *jangdokdae* (storage area for clay pots filled with spices), and a *jeongja* (pavilion) was planned. The *byeoldang* deserves special mention in this selection, as it originated around the middle of the Joseon Dynasty, together with the life style of the patriarch. Over time, the function of the *byeoldang* expanded to include other uses for the male members of the household. An increasing number of social events, such as ancestral rites, research seminars or the reception of guests took place at home, so that the number of additional *byeoldang* increased.

The strict hierarchical order and class rules eased by the end of the Joseon Dynasty, and building styles reflected such change. From the Gabogyeongjang[14] 1894 (King Gojong's 24th year of reign) onwards, a new society called *jungin*[15] arose, with a so called newly-rich class that took its place between the previously so strictly separated *yangban* (upper class) and *sangmin* (lower class), and which seemed to have significant economic power. This new social class built their homes according to their needs and thus overhauled the old, strict building laws of the past.

As the images of traditional houses portrayed in this book date from the early 21st century, they give evidence of our national memorial buildings. Homes are typically only taken due care of while they're lived in. With the old traditional building no longer satisfying our standards of living, especially in terms of comfort, they are mostly uninhabited today, which has a negative effect on their maintenance. It is our duty to take care of these traditional houses passed on to us with wisdom, diligence and circumspection. But we cannot rest there, all of this will also need to be recorded and passed on to future generations. This is why I present this book as a special edition that will be exhibited at 2016 Leipzig Book Fair Korea Pavilion, whose theme for 2016 is Korean Traditional Architecture, by International Culture Cities Exchange Association in cooperation with Youlhwadang Book Museum.

We sincerely thank Mr Seo Heun-kang and Joo Byoung-soo, the photographers

of this book, for their magnificent documentary images and hope our readers will enjoy the world of Korean traditional architecture.

Translator's Notes

1. The Gwandong area is part of Gangwon Province and South Hamgyeong Province. The Hoseo area comprises Chungcheongnam-do and Chungcheongbuk-do Provinces.
2. Gyeongsangnam-do and Gyeongsangbuk-do Provinces form the Yeongnam area.
3. The Honam area is formed by Jeollanam-do and Jeollabuk-do Provinces.
4. Youlhwadang is the *sarangchae* of publisher Yi Ki-ung's family home Seongyojang in Gangneung.
5. A geomantics master assesses a building ground to find the ideal construction site for a house in relation to its surrounding landscape, e.g. its position towards mountains and rivers, c.f. Feng Sui.
6. Short chronicle or documentation of construction naming dates of construction, building owner and building legend.
7. Thick, oil-soaked paper.
8. Baekryeon Ji Yun-yeong (1852–1935) was a calligrapher. He had studied calligraphy and literature with master Gang Wi, who himself had been a disciple of Chusa (Kim Jeong-hi, 1786–1856, famous calligrapher, painter and writer) and older brother of Ji Seok-yeong, who introduced the smallpox vaccination to Korea.
9. Script originating in China, that can only be written with a brush.
10. *Yangban* class consisted of military and civil servants.
11. *Gotaek* means old, venerable house.
12. 1 *kan* equals 2,4 x 2,4 = 5.76m^2. A typical house is between 3 and 6 *kan* in size, exceptions are up to 9 *kan* in size.
13. Scientific theory originating from the Sung Dynasty in China, reaching its peak in the Joseon Dynasty in the 17th century.
14. Reform movement from 1894-1896.
15. *Jungin* literally means 'middle man'. Amongst this class, merchants, tradesmen and translators, etc. prevail.

Contents

Honam, Jeju Areas

Gyeonggi, Gwandong, Hoseo Areas

Residence of Kim Yeong-gu in Yeoju

Built mid-19th century
98 Botong1 gil, Daesin-myeon, Yeoju-si, Gyeonggi-do

Kim Yeong-gu's house is situated in a village located on the slope of a low mountainous landscape, overlooking the Namhangang River in the south.

It is this region, his mothers' native region, where Jo Gyeong-in of the Changnyeong Jo clan found refuge during the Imjinwaeran (Japanese invasion between 1592-1598) and settled with his family. His house, in its form still preserved today, dates from his descendant Jo Seok-u. Jo Seok-u was a high ranking public servant at King Gojong's court, which places the time of construction at the period of the 1860s. The current owner of the house moved into the house in 1970.

The living quarters are facing south. The ground plan of the complex presents a perfect square, with the inner *anchae* (womens' quarters) following the Korean letter 'ㄷ', and the *keun-sarangchae* (the father's manor house) as well as the *jageun-sarangchae* (little manor house) and *heotganchae* (the storage house) closing off the square in the form of the Korean letter '一'. The walls featuring fragments of roof tiles surround the western side and the rear of the *anchae*. According to the ground plan of the estate, it seems to be a typical residential home of the Yeoju region.

This *hanok* is situated higher on the slopes of a hill stretching from southerly to northerly direction and overlooking the neighbouring estates. Entering through the courtyard gate, visitors reach the *madang* (courtyard) and the entrance to the living quarters on the left hand side. Today's *anchae* consists of a modern kitchen area with *toenmaru* (narrow wooden floor along outside of a room). The *anbang* (inner room) with traditional kitchen area is located on the left with adjacent second room and storage. *Byeonso*, a toilet room is located to the right, followed by another room with kitchen and storage facilities.

The *keun-sarangchae* consists of the *daecheong* (the main wooden-floored hall for reception of guests) with a wooden porch (*toenmaru*) at the front and another room to the right separated by a wall from the main area and featuring a fireplace. The *numaru* (open, roofed two-storey structure with a raised wooden floor) stretches out in a southern direction in front of the *toenmaru*. The entire complex is arranged in a south-facing quadrangle with *anchae, keun-sarangchae* and *jageun-sarangchae* functionally arranged.

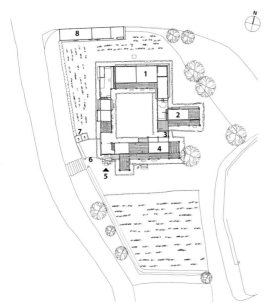

1. anchae
2. jageun-sarangchae
3. jungmun
4. keun-sarangchae
5. daemungan
6. hyeopmun
7. byeonso
8. heotganchae

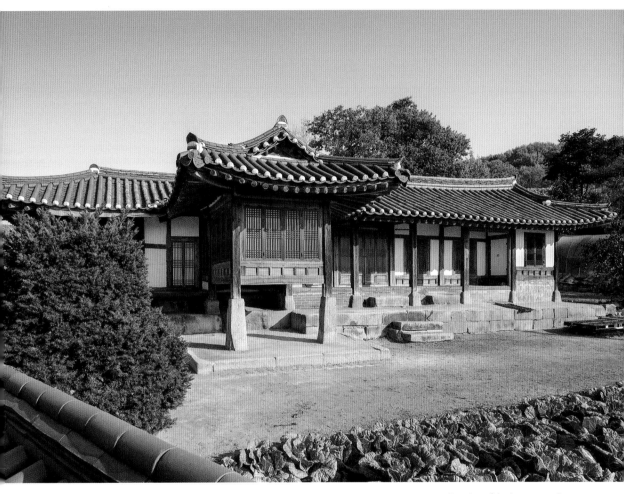

Overview of the *keun-sarangchae*.

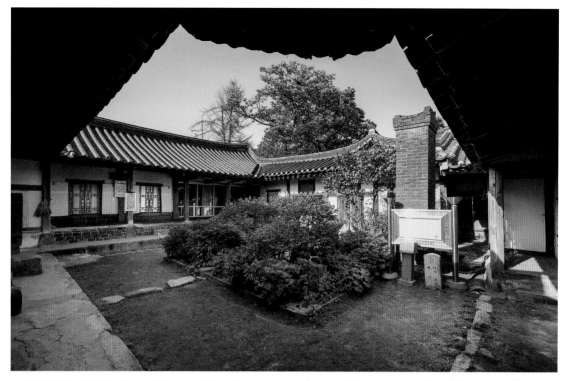

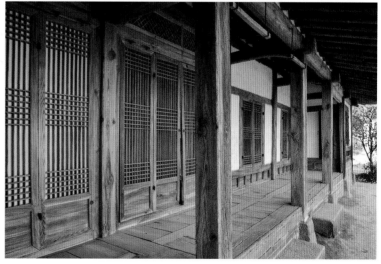

Anchae, viewed from the west of the *keun-sarangchae*. (top)
Sarangchae toenmaru. (bottom left) *Sarangchae*. (bottom right)

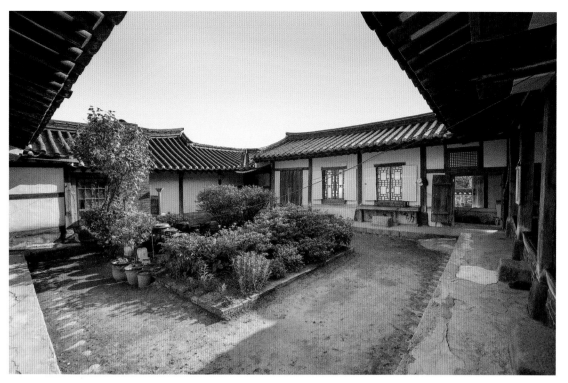

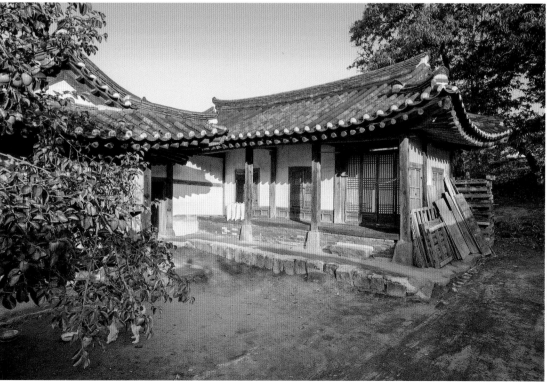

Anmadang, Inner courtyard, viewed from *anchae-daecheong.* (top)
Jageun-sarangchae. (bottom)

Residence of Baek Su-hyeon in Yangju

Built in the 19th century
65 Hyuamno443-gil, Nam-myeon, Yangju-si, Gyeonggi-do

Queen Min[1], who lived at the end of the Joseon Dynasty, had originally planned this house as hideout during dangerous times. Unfortunately, she was murdered by Japanese before the house had been completed and strangers finally resided in the complex. The grandfather of Baek Su-hyeon, Baek Nam-jun acquired the residence in 1930; as it was here that Baek Su-hyeon was later born, the house is registered under his name in the heritage listing. The backdrop to the condominium is the impressive Maebong Mountain range and the complex is enclosed by rivers on both sides: on the left flows the Jwa-cheongnyong, 'the blue dragon', and on the right side the U-baekho, 'the white tiger'.

The original housing complex comprised the traditional *anchae* (women's quarters), *sarangchae* (men's quarters), *haengnangchae* (house for service staff) and *byeoldangchae* (separate house). Only the *anchae* and the *haengnangchae* have remained of the residence. With the courtyard in the middle, the *anchae* and *haengnangchae* were constructed to form a square '口',

and this arrangement enabled comfortable, protected life with privacy. The outer complex consists of the *sarang-madang* (courtyard of the *sarangchae*), which is located in front of the *haengnangchae*, courtyard, and the backyard of the *anchae*. The final roof tile of the *haengnangchae* shows the date 1682 (King Sukjong's 8th year of reign, 21st Ganghui), however, it is possible that the roof tile originated elsewhere and was only later attached. The architectural foundation suggests that this residence has likely been built at the end of 19th century.

Even though only the *anchae* and the *haengnangchae* remain today, the residential complex is likely to have been substantially large for a private house and one indication for this are the granite steps in front of the *haengnangchae*. The *anchae*'s building material is of the highest quality.

1. Myeongseonghwanghu, consort of King Gojong, (1851-1895) was murdered in 1895 by Japanese.

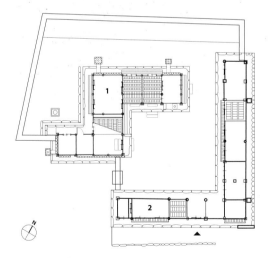

1. anchae
2. haengnangchae

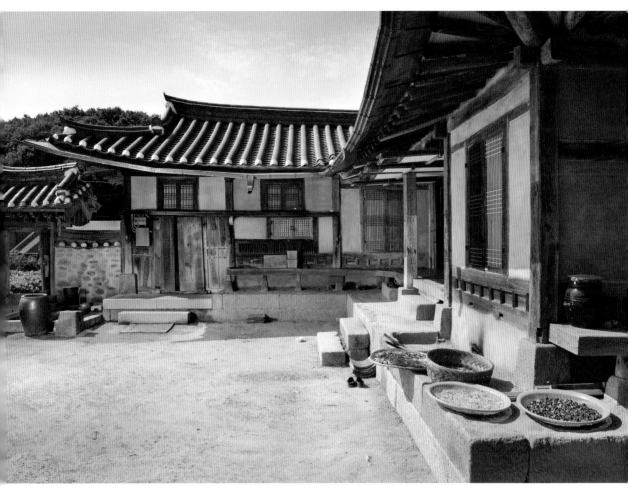

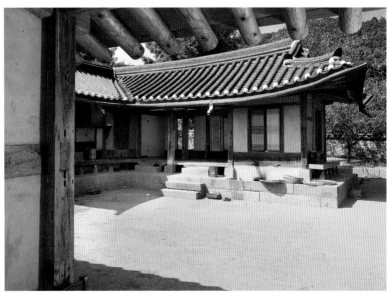

Anchae and *ilgakmun* viewed from *araechae*. (top)
Anchae viewed from *daemungan*, the entrance gate. (bottom)

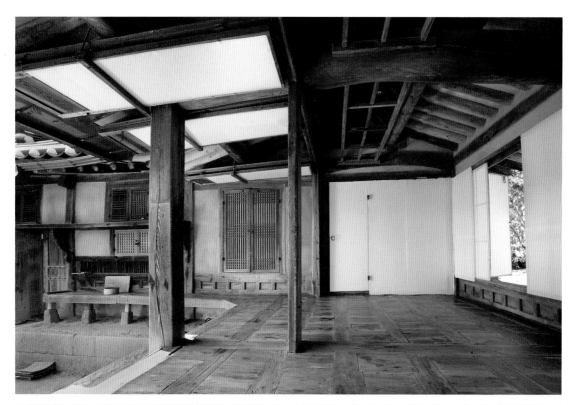

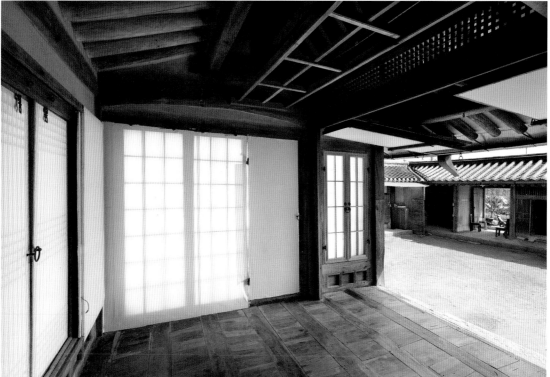

Anchae-daecheong. (top) *Geonneonbang.* (bottom)

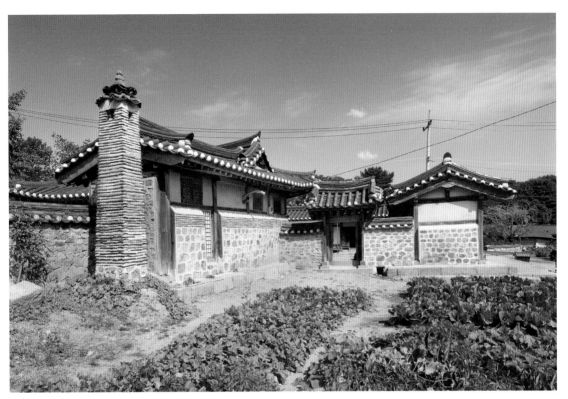

Anchae and *hangnagnchae* viewed from outside. (top)
Mangwa of yongmaru, the final roof tile of the *haengnangchae*. (bottom)

Gung-jip

Built in mid-18th century
9 Pyeongnae-ro, Namyangju-si, Gyeonggi-do

King Yeongjo presented his youngest daughter, Hwagil-Ongju, with this residential house when she was promised to Neungseongwi[1] Gu Min-hwa. The King ordered construction workers and materials to the site upon which the Princess' house was to be built, which is how the house became known as 'Gung-jip', meaning 'a house belonging to the palace'.

Princess Hwagil-Ongju lived in this house from 1765 (King Yeongjo's 41st year of reign) until her death in 1772. On a ground area of approximately 8000 *pyeong*[2], more than 10 additional buildings and an exhibition building were constructed, dominated by the Gung-jip.

Every one of the buildings was built uphill along the banks of a stream running through the middle of the estate from east to west. The actual living quarters, the Gung-jip, are located on the upper slope of the hill. They are well adapted to the natural landscape, and located among high trees, presenting a harmonic idyll.

The living quarters consist of the ⊏-shaped *anchae* (women's quarters), the —-shaped *munganchae* (gate house), and the *anmadang* (inner courtyard) and are arranged to create an ⊡-shape. Situated in a south-westerly direction is the ㄱ-shaped *sarangchae* (men's quarters). The *sarangchae* is usually placed in front of the *anchae*, in this case, however, the *sarangchae* is placed at equal height with the *byeolchae* (separate house) at a corner of the *anchae*. The reason for this deviation from the usual form is to guarantee the protection of the *anchae* and in consideration of the busy social life of the powerful regional *yangban* family owner.

Considering that the owner of the Gung-jip was a royal daughter, the house itself essentially is not an ordinary house, which can be seen in the vastness of the building concept and its noble design, wherever the rooms and floor spaces allowed such design. The *jangdaeseok* (stone stairs) are of superb quality, displayed in carefully carved base stones and excellent wood materials, that are hard to find even in the homes of normal *yangban* families.

1. Honorary title.
2. *Pyeong* is a base measurement unit. 1 *pyeong* is 3,30 m². (approx. 264,000 m² ground area)

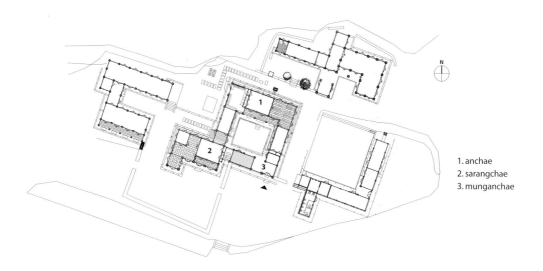

1. anchae
2. sarangchae
3. munganchae

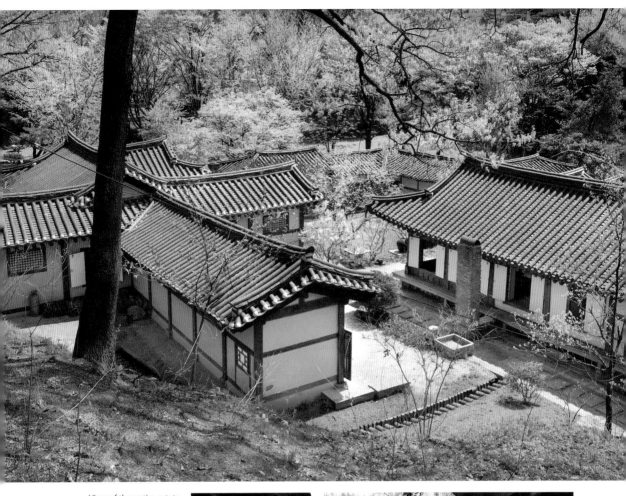

View of the entire estate
from mountain behind the
estate. (top)
The east of a*nchae madang*,
the inner courtyard. (bottom)

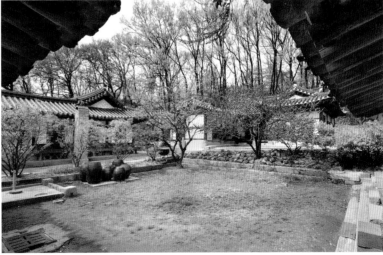

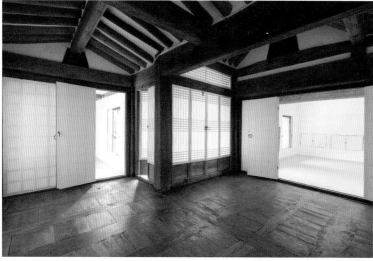

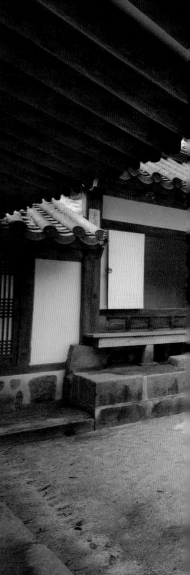

Backyard, view from *anchae deacheong*. (top)
Geonneonbang, view from the *anchae deacheong*. (bottom)
Anmadang, the inner courtyard and *anchae*. (p.29 top)
Inner view of the *anbang* (p.29 bottom)

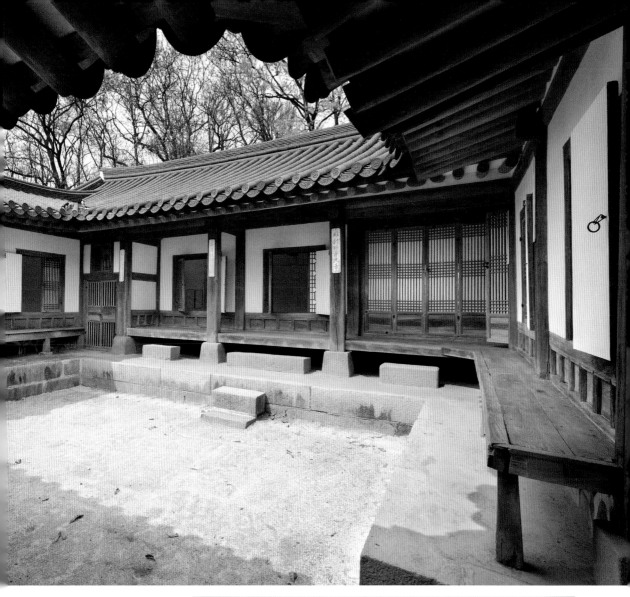

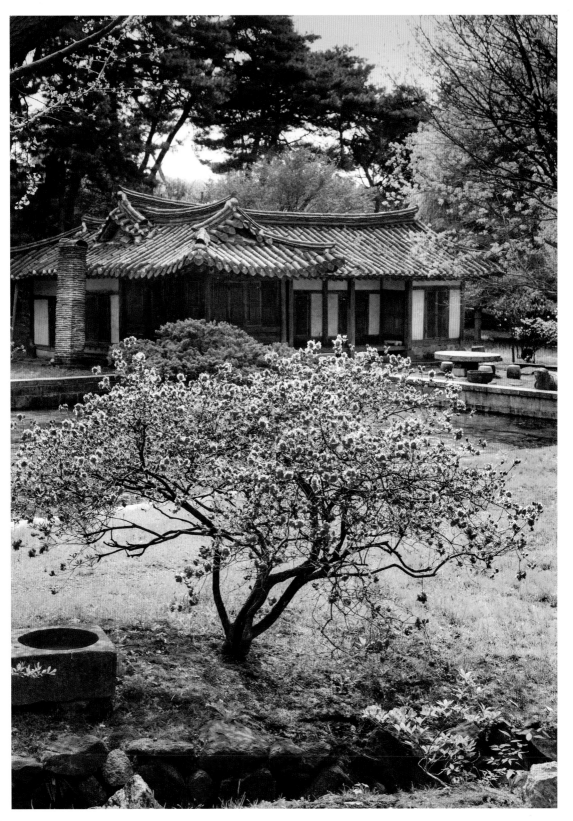

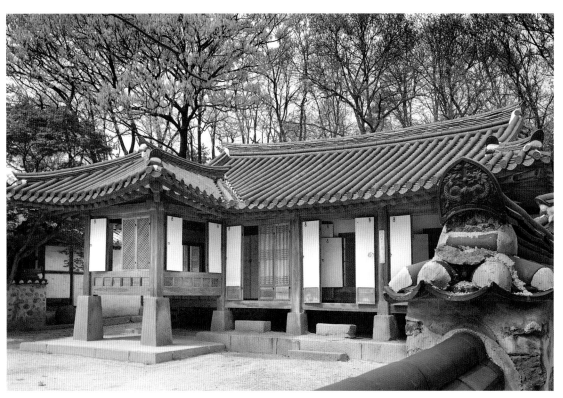

Geonneochae. (p.30)
View from the front of the *sarangchae.* (top)
Front of the *geonneochae.* (bottom)

Seongyojang in Gangneung

Built in the early 18th century
63 Unjeon-gil, Gangneung-si, Gangwon-do

The residential house Seongyojang was built at the beginning of 18th century by Mugyeong Yi Nae-beon, a tenth generation ancestor of the Prince Hyoryeong-daegun. The house was known as Baedari (pontoon bridge) House of Yi since it was only accessible via Lake Gyeongpo. In the past, the lake was both wider and bigger than it is today and in order to reach the house, one had to cross it by ferry. The residential complex consists of the *anchae* (women's quarters), the *sarangchae* (men's quarters), the *dong-byeoldang* or the eastern separate house, *seo-byeoldang* or the western separate house, the *haengnangchae* (service staff quarters) and the *jeongja*, an open pavilion. The architecture of this residence was strongly influenced by the designs used among upper class estates. The extensive sprawling housing estate showcases both the harmonious design and the spatial aesthetics with which the residents were surrounded.

The Youlhwadang has the same function as the *sarangchae*, which was built in 1815 by Yi Hu, the grandson of Yi Nae-beon. This building served as a cultural nexus for a range of intellectuals who discussed issues on science and art. Completed by Yi Hu in 1816, the Hwallaejeong was used to receive guests as well as an 'information centre' where the numerous guests could exchange the latest news. The oldest building is the *anchae*, which, compared to the other buildings, was designed in a more simplistic style thus giving it a more private atmosphere. The *dong-byeoldang* was erected in 1920 at the instigation of Yi Geun-u. It is directly connected with the *anchae*, allowing the family to spend peaceful times together without the intrusion of arriving and departing guests. The great-grandson of Yi Nae-beon, Yi Yong-gu, commissioned the *seo-byeoldang*, which was then used as the residence's library and book storeroom and restored in 1996. Another building, which was regarded as the first modern private school in Korea, the Dongjin School, was located left to the *haengnangchae* and the storehouse. Unfortunately, it was burned to the ground during the Korean War.

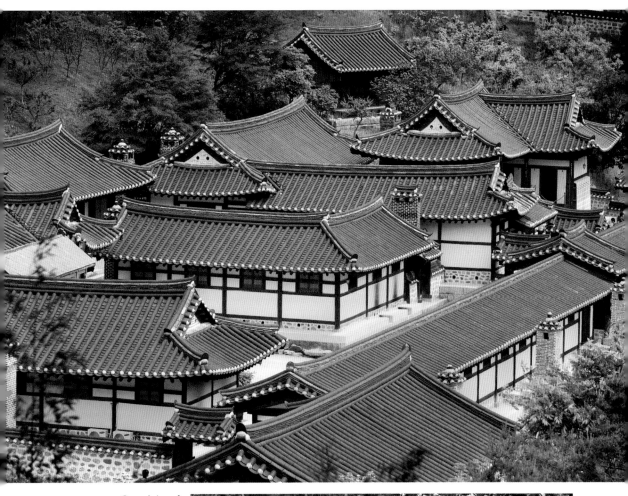

General view of
Seongyojang. (top)
General view of
Seongyojang from a
distance. (bottom)

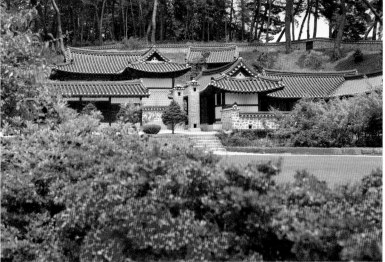

1. gotganchae
2. jungsarangchae
3. Youlhwadang
4. haengnangchae
5. seo-byeoldang
6. Yeonjidang
7. anchae
8. dong-byeoldang
9. munganchae
10. byeolchae
11. jeongja
12. sadang
13. umul
14. Hwallaejeong
15. yeonmot
16. yeonmot

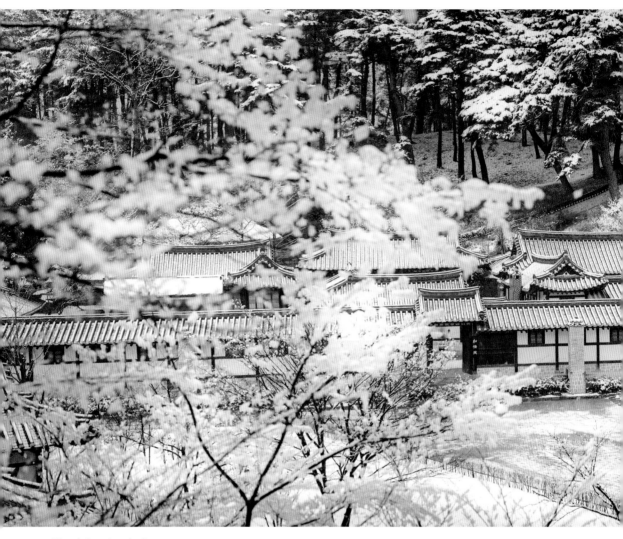

View during winter. (top)
View of Seongyojang from the mountain. (bottom)

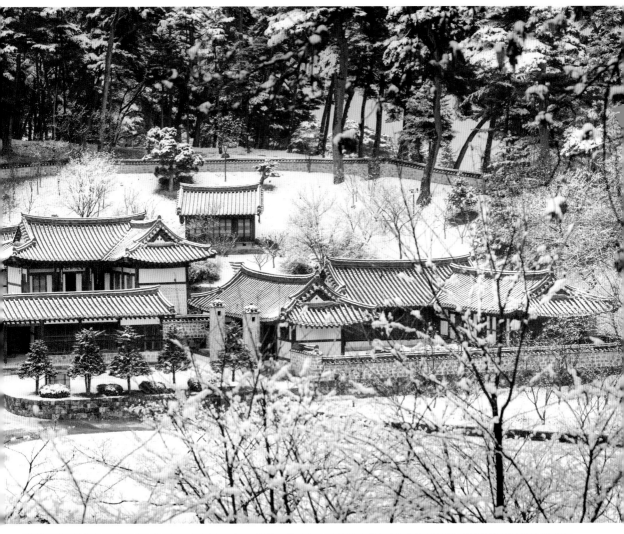

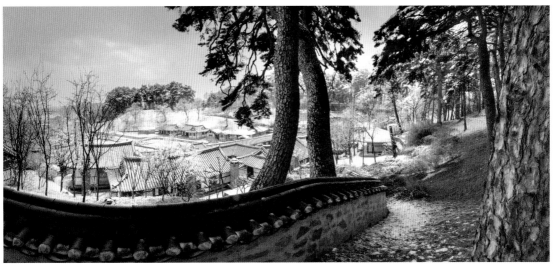

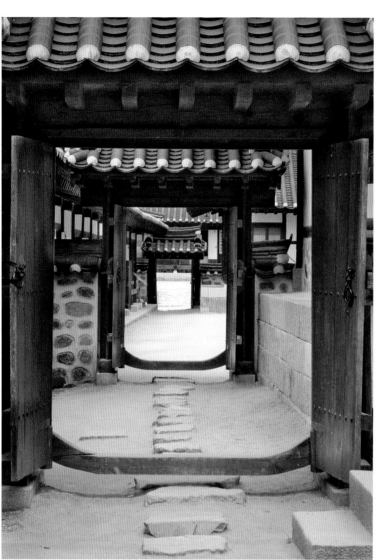

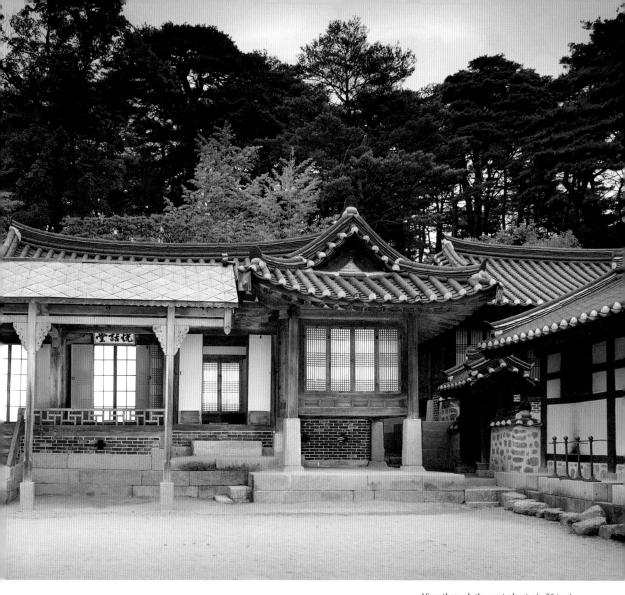

View through the central gate. (p.36 top)
House inscription of the main gate. (p.36 bottom)
Youlhwadang, the *sarangchae*. (top)

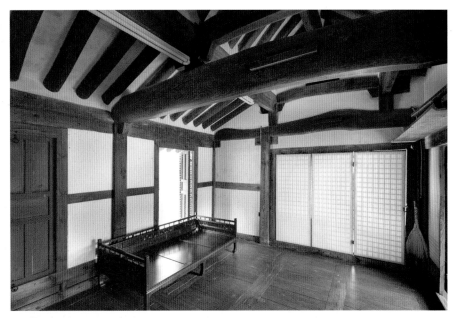

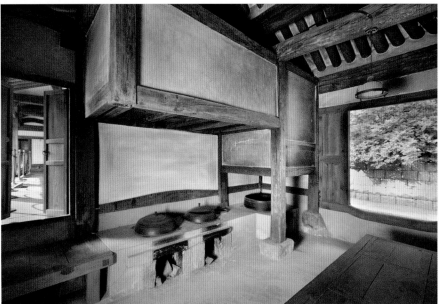

Inside view of the *anchae-daecheong*. (top) Kitchen. (bottom)

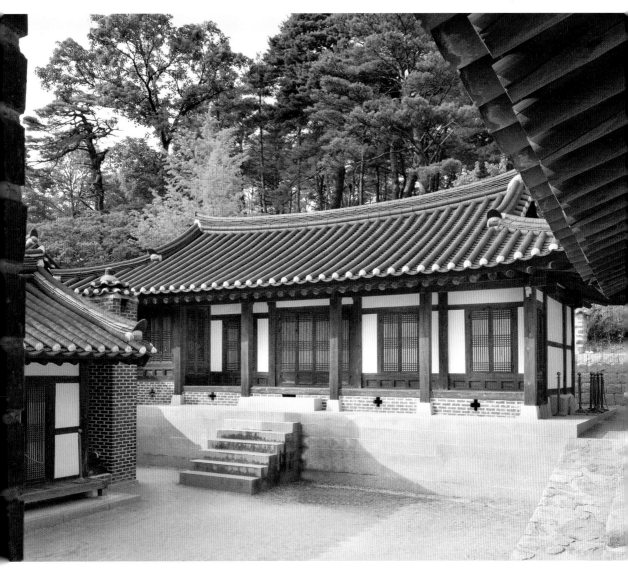

Front of the *seo-byeoldang*.

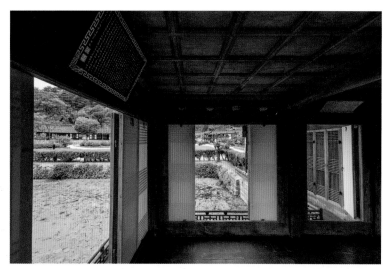

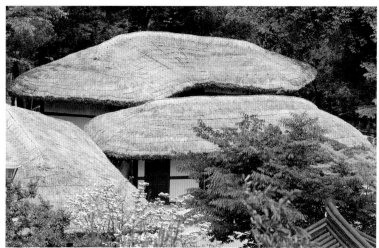

View of the pond from the Hwallaejeong. (top)
Hoji-jip. (bottom)

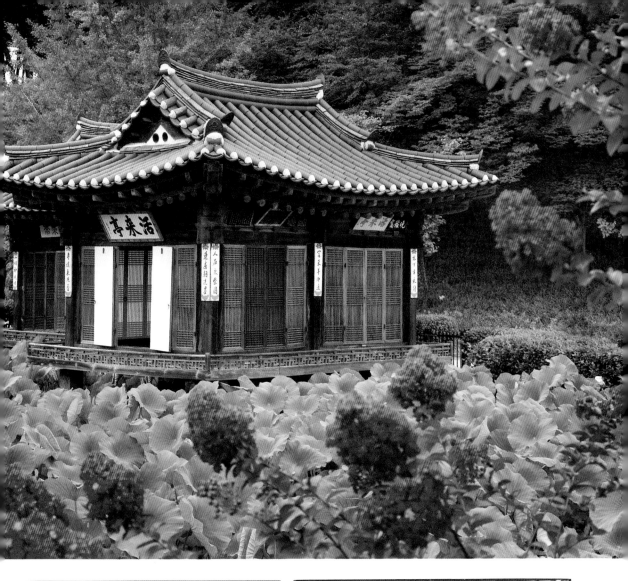

Hwallaejeong. (top)
Inscriptions of Hwallaejeong. (bottom)

Daeiri Gulpi-jip in Samcheok

Built around 1930
864-2 Hwanseon-ro, Singi-myeon, Samcheok-si, Gangwon-do

This *gulpi-jip* (oak bark-roofed house) is situated deep in the forest. The original roof was tiled with *neowa*, shingles made of red pine tree. However, as shingles became increasingly difficult to resource as building materials, *gulpi* (oak bark) were used as a substitute. Oak trees could be found everywhere and they proved easier to process than *neowa* as well.

The building plan of a *gulpi-jip* is similar to that of a *neowa-jip*, in which living quarters, workspaces and storage room are built together under one roof surrounded by an outer wall. Although this kind of merged living and working areas is practical, an important disadvantage is the issue of smells that can be disturbing. A small relief can be found in the *kkachi-gumeong*, or 'magpie hole', serving as a ventilation hole in the roof.

The *anbang*, the communal living room, features a *kokeul*, an open fireplace and a *sireong*, a hook with two poles for hanging clothes, mounted on the northern wall. Candles and oil were scarce commodities in the harsh mountain area of Gangwon-do. To compensate the scarcity of these materials, a *kokeul* where resin-rich pine twigs and branches were used as a source of fire, was installed.

In Daeiri, the *gulpi* were predominantly cut from oak trees. To be suitable as a building material, the trees had to be at least 20 years old and the bark of these trees was cut from the lower part of the trunk at 3-4 *cheok* (approx. 30,3 cm) in length and stacked on top of another. These pieces were then pressed under heavy rocks for about one month, before being cut to custom length and form and arranged on the roof.

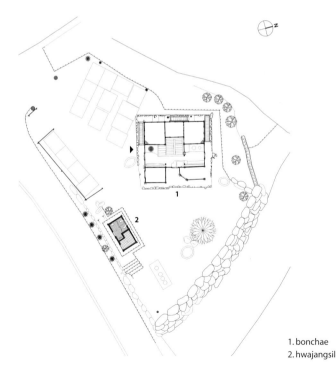

1. bonchae
2. hwajangsil

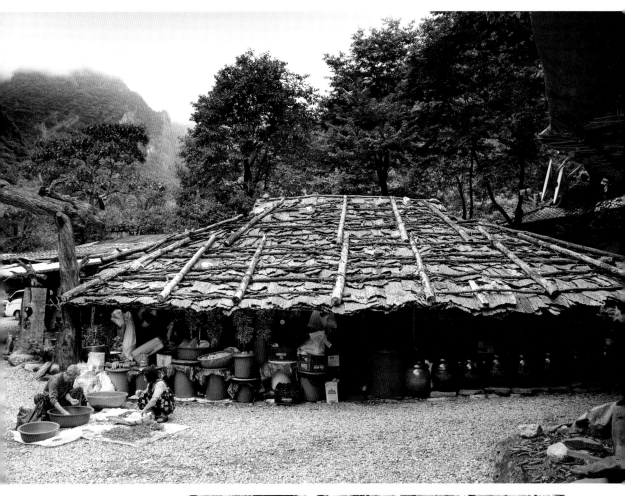

General view of *Gulpi-jip.* (top)
Details of the oak bark roof. (bottom)

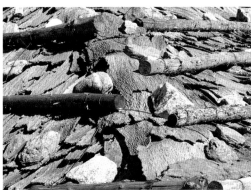

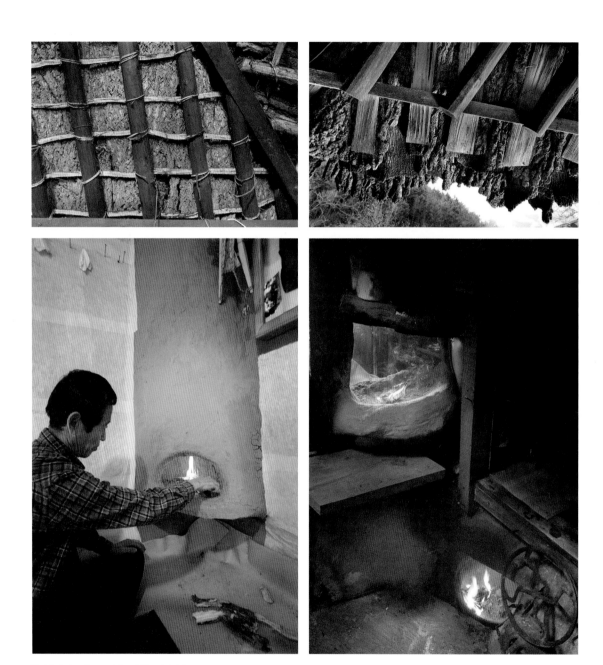

Details below the roof. (top, left and right)
Kokeul (bottom, left) and *hwati* (bottom, right).
Household goods. (p.45)

Residence of Kim Champan in Yeongdong

Built in 1769
13-5 Goemok1-gil, Yanggang-myeon, Yeongdong-gun, Chungcheongbuk-do

A date inscription of 1769 (King Yeongjo's 45th year of reign) found on the *jongdori (*ridge purlin) of the *daecheong* (main wooden-floored hall) refers to the date of construction of Kim Champan[1]'s residence. Historical records show that the house was restored during the time King Gojong's reign. The altered construction and interior design suggests that the *anchae* (women's quarters) experienced major restorations and expansions during King Gogjong's reign. Later modifications further altered the estate to today's appearance. The *munganchae* (gate house) and *gotganchae* (storage house) were added in the early 20th century.

A quite spacious courtyard is situated at the front of the estate and the rear of the residence is situated before a hilly slope. Today the *munganchae*, a further *ansarangchae* (men's quarters), the *anchae* and the *gwangchae* (storage house) are located there. The *munganchae* is located at the front; upon entering through this gate into the residential area,

the *ansarangchae* comes into view to the eastern side, the *gwangchae* – facing north-south – to the west, both buildings stand almost side by side to each other. Proceeding further into the living quarters, the ㄷ-shaped *anchae* is situated facing south-west behind the courtyard. The broad garden courtyard enclosed by a wall and featuring a generous arrangement of flowers and plants can be seen from the *munganchae*.

As the *sarangchae* has been destroyed by a fire, the estate does not seem large. The other individual buildings of the estate, such as the *ansarangchae*, the *anchae*, and the other buildings, however, create angular square shapes, a typical building plan for the Chungcheong Province.

1. Champan is a civil servant's rank title of the 6 ministries of the Joseon Dynasty; Champan is the second highest rank within a ministry, similar to today's Vice Minister.

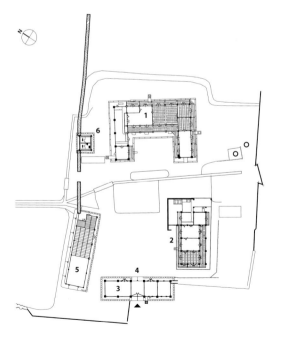

1. anchae
2. ansarangchae
3. munganchae
4. daemun
5. gwangchae
6. hwajangsil

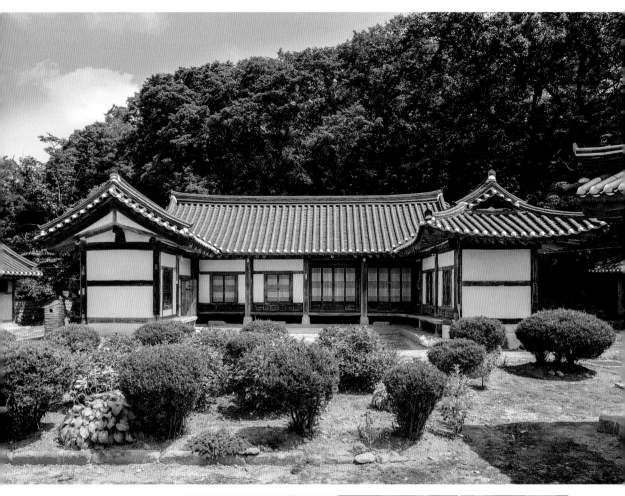

Anchae. (top)
Jwaiksa, to the west of
the *anchae.* (bottom)

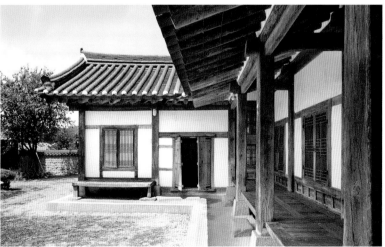

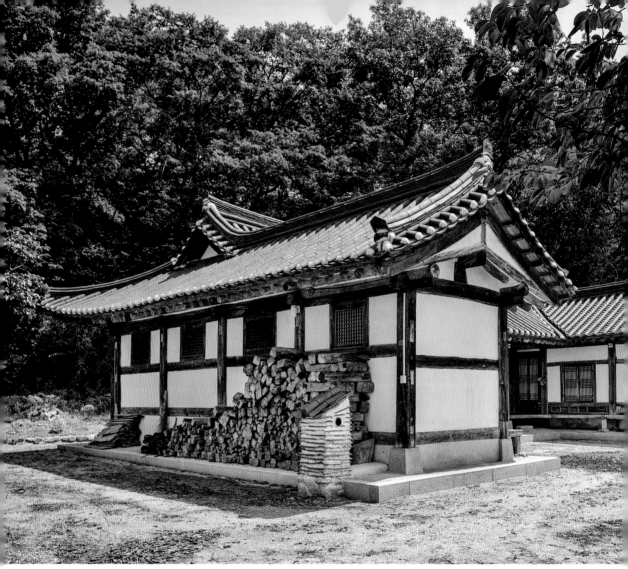

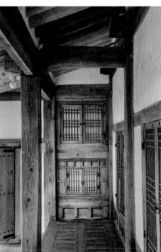

Anchae, seen from the west. (top)
Toenmaru, wooden veranda of the *anchae*'s kitchen. (bottom, left) *Dwitgan*, the toilet of *gwangchae*. (bottom, right)

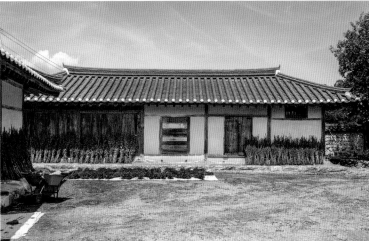

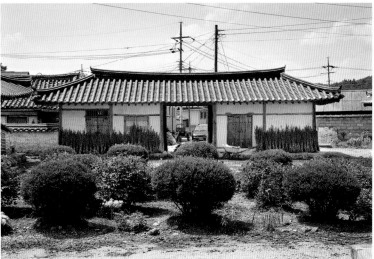

Front view of the *gwangchae* (top) and of the *munganchae* (bottom).

Residence of Yi Hang-hui in Cheongwon

Built in 1861
33-15 Witgobunteo-gil, Namil-myeon, Cheongju-si, Chungcheongbuk-do

The front section of the residence is built on a downhill slope, providing free vision because of its lower position. The rear section of the house, however, is built uphill. Documents date the construction of the *anchae* (women's quarters) to 1861 (King Cheoljong's 12th year of reign) at the end of the Joseon Dynasty; the *sarangchae* (men's quarters) was built a little later.

The estate is divided into two sections, the *sarangchae* in the front section, and the *anchae* behind the *sarangchae*. The *anchae* section with its *madang* (courtyard) is ㄱ-shaped while the *sarangchae* in front of the *anchae* is —-shaped. The buildings *gotgangchae* and *gwangchae* (storage houses) complement the estate to the east and west respectively. The *sarangchae* with its *madang* (courtyard) and the *haengnangchae* (house for service staff) behind it are built rectangular to each other.

According to these building features, the *anchae* shows a floor plan typical for the middle regions of Korea. The *anchae* features two rooms, between which the 2

kan-sized *daecheong* (main wooden-floored hall) for the reception of guests is located; the *geonneonbang* (parallel room) is adjacent to the east, the *witbang* (upper room) to the west, the *anbang* (womens' room) and kitchen are added in rectangular shapes.

The *bakkat-madang* (outer courtyard) is surrounded by neighbouring houses. A great old Hoehwa Tree[1] stands to the east; its location is where typically a surrounding wall would be built and it is part of the residence's border; from here one can leave the grounds without any obstructions. The *sarangbang* and *anbang* are covered with tiles, while the *haengnangchae* and other buildings are thatched with straw. This is a special feature of the residence.

1. A tree associated with bringing luck in Asia and seen as 'godly tree', which is only planted in special sites, such as noble houses or Buddhist temples.

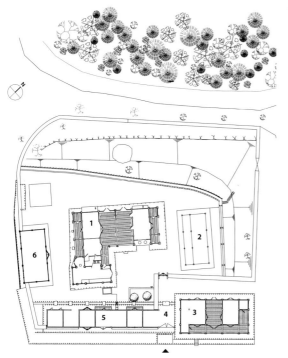

1. anchae
2. gotganchae
3. sarangchae
4. daemun
5. haengnangchae
6. gwangchae

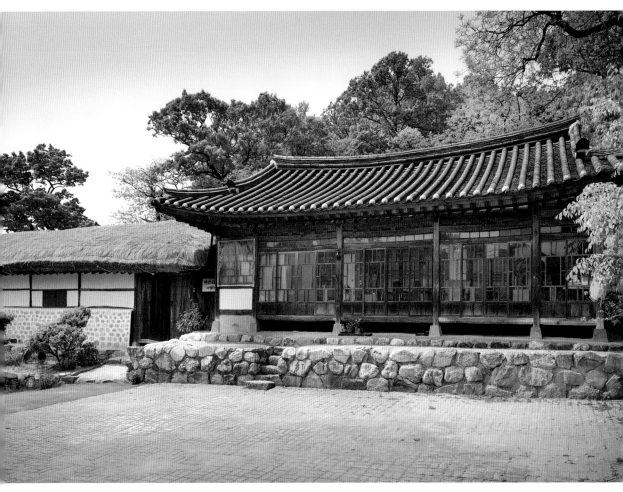

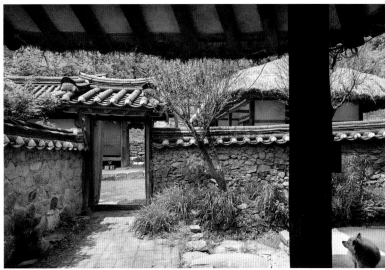

Front side of the *sarangchae* and *haengnangchae*. (top)
From the entrance gate, *daemun* towards the middle gate, *jungmun*. (bottom)

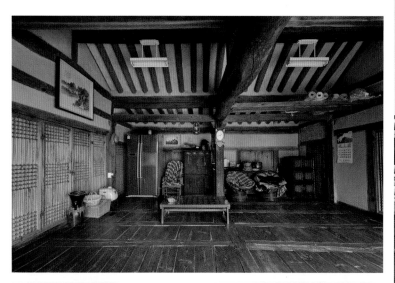

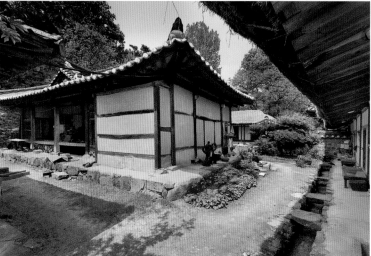

Inner *daecheong* of the *anchae*. (top)
Rear of the *anchae*. (bottom)

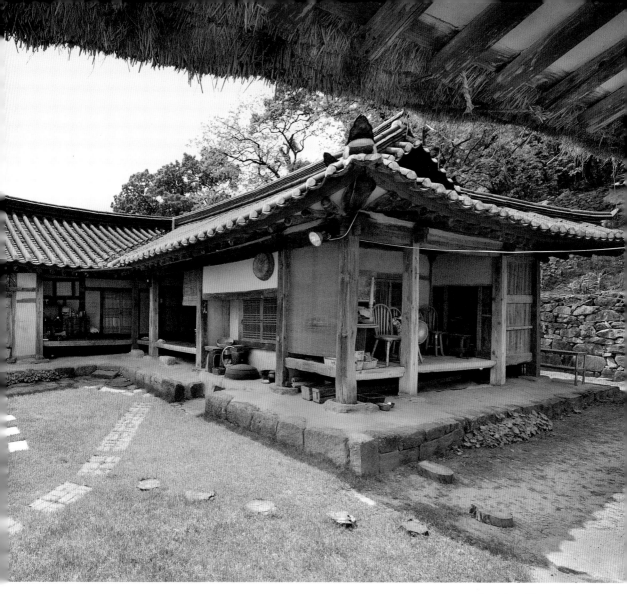

Front view of the *anchae*.

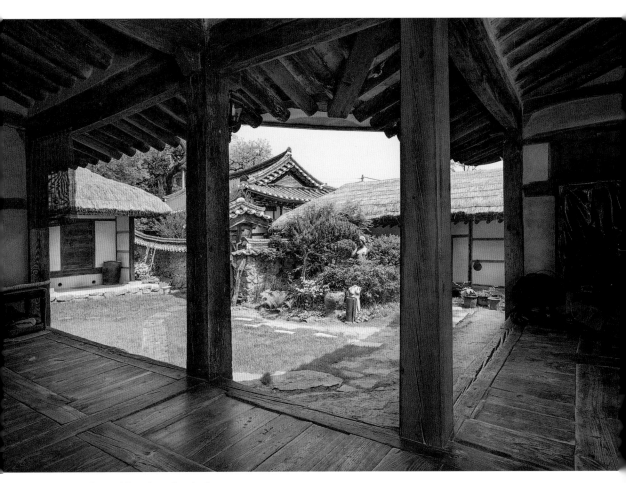

Courtyard, viewed from the *anchae-daecheong*.

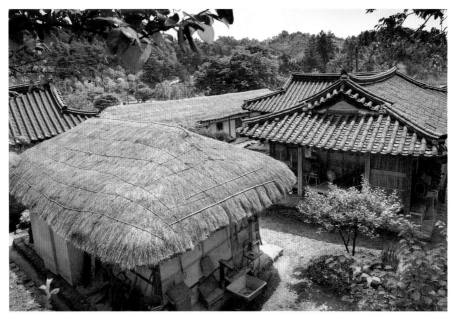

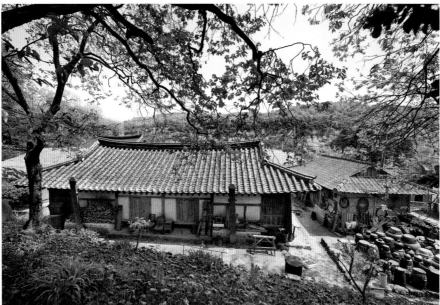

Rear views of the entire estate. (top, bottom)

Residence of Seon Byeong-guk in Boeun

Built between 1919-1924
10-2 Gaean-gil, Jangan-myeon, Boeun-gun, Chungcheongbuk-do

This residence is located in the centre of the township Boeun. A stream encircles the property and creates an island by winding itself both to the left and to the right. The house is facing south and to the east, we can see a landscape of softly rolling hills with no steep incline. Surrounding the residential home are mostly agricultural plots.

In 1903, the grandfather of Seon Byeong-guk came to this region and settled there, constructing his home in the typical fashion of a rich estate owner of the Chungcheong region over the period from 1919 to 1924. The first building to be erected was the *anchae* (women's quarters), followed by the *sarangchae* (men's quarters) and lastly the *busokchae* (additional house).

The domestic quarters are divided in three areas: the first area comprises the *sarangchae* and its *madang*, the courtyard with surroundings. The *anchae* and its *madang* belong to the second living area. Finally the third area consists of the *sadang*, or ancestral shrine, and the *sadang-madang*, its yard. Encompassing three sectors, the whole area is surrounded by a wide outer wall. Within this walled compound exist separate murals, which shield the three sectors from each other. It is particular to these living domains that the fundaments of both the *sarangchae* and the *anchae* have been built in H-form and have been erected on the same level as a duplex house. Such floor plans were usually avoided as they were regarded as a bad omen. The owner of this house, however, consciously chose this type of construction to offset the location's bad omen.

The quarters of the *anchae* and the *sarangchae* are large, and due to the special division of the buildings – by locating them separately – they appear very spacious. The generously designed *gotganchae* (storage house) showcases moreover the wealth of this landowning family.

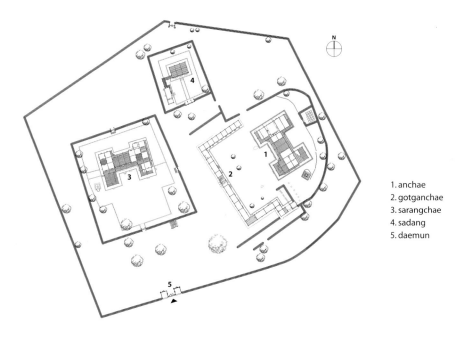

1. anchae
2. gotganchae
3. sarangchae
4. sadang
5. daemun

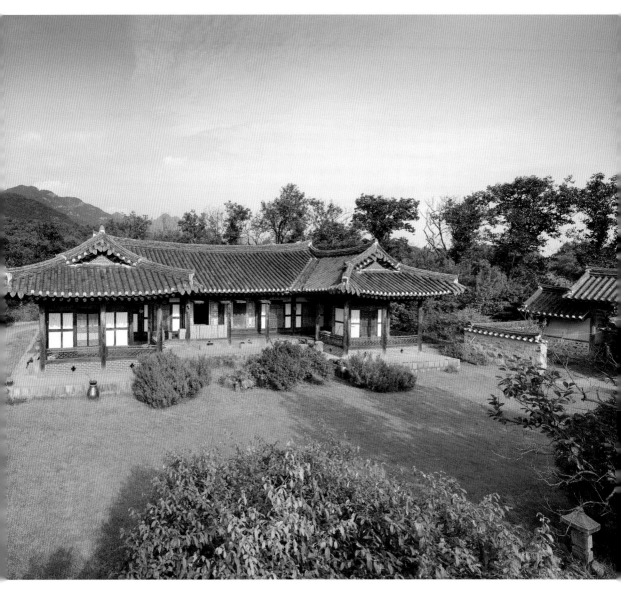

General overview.

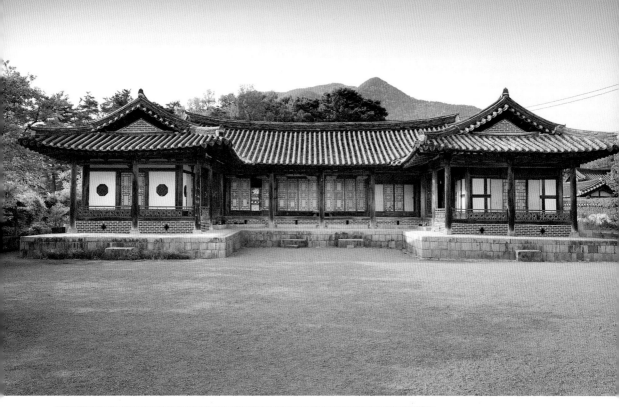

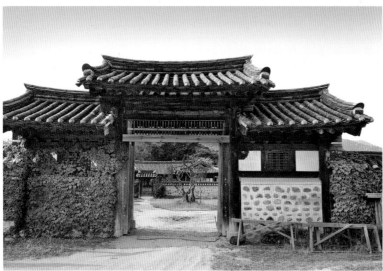

View of the *sarangchae*. (top)
Soseuldaemun, particularly high and imposing entrance gate. (bottom)

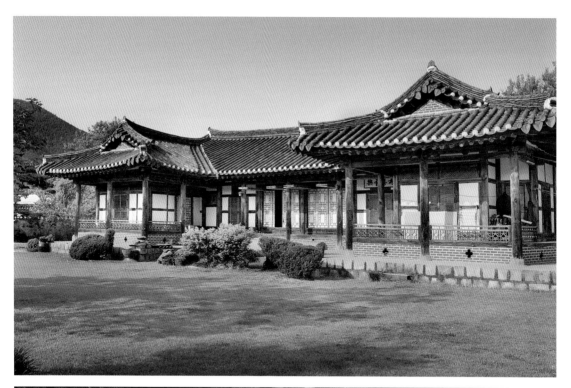

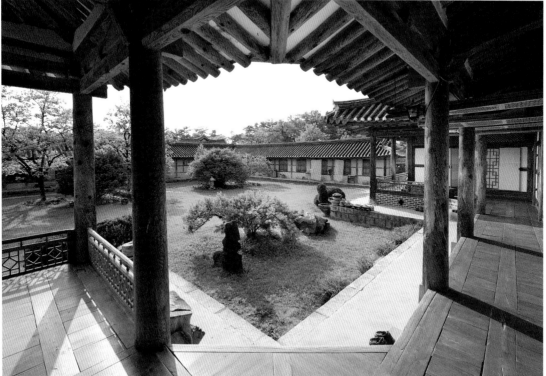

View of the *anchae.* (top)
Madang, the courtyard, viewed from the *anchae-daecheong*. (bottom)

Residence of Myeongjae in Nonsan

Built at the end of the 17th century
50 Noseongsanseong-gil, Noseong-myeon, Nonsan-si, Chungcheongnam-do

Myeongjae Yun Jeung's residence was built at the end of his life, during King Sukjong's reign at the end of the 17th century. Myeongjae[1] was a well renowned Neo-Confucist of his time.

The estate is located to the south of the village where vast fields of charlock spread into the distance, criss-crossed by the Noseongcheon River. To the village's north rises the high mountain of Isan, whose foothills protectively enclose the village.

The higher hills form the Isan Mountain range, which spreads towards the south and creates the village border. The Noseong-hyanggyo, the Noseong Confucian School is located in the west. Myeongjae's residence stands opposite the Confucian School in the east. The shrine of Confucius Gwolli-sa, housing his portrait, stands in the eastern hills above. Numerous cultural sites of the Joseon Dynasty time are located around Myeongjae's residence, amongst them the Jeongnyeo-gak memorial house.

The *sarangchae* (men's quarters), *anchae* (women's quarters), *munganchae* (gate house), *sadang* (ancestors' shrine) and *gwang* (storage) form the living quarters. A pond, with an artificial island symbolically portraying a holy mountain, is located at the front of the residence. The *sarangchae* is placed in the foreground of a hilly landscape, behind it to the east is the *sadang* and to the west lays the *anchae*.

The *sarangchae* and *anchae* buildings were not positioned on a central axis; the *sarangchae* was built slightly angular towards the east. The *munganchae* stands to the western side of the *sarangchae*, blocking the *anchae* from view. No wall surrounds the *sarangchae*, leaving the entire estate publicly accessible.

The estate is the residence of a *yangban* large estate owner and was built in a □-shape, a typical construction from the Chungcheong region. A special feature of this estate is the omission of a *byeoldang* (separate house area), and the larger than usual size of the *sarangchae*, which easily integrates the *byeoldang*'s function. Throughout the entire estate, the hierarchy of each space was considered, depending on direction, and all buildings were situated accordingly.

1. Myeongjae is a pseudonym, his actual name is Yun Jeung.

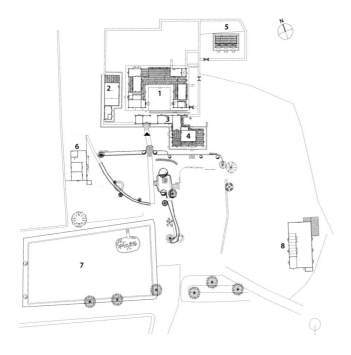

1. anchae
2. gwangchae
3. munganchae
4. sarangchae
5. sadang
6. gojiksa
7. yeonmot
8. Choyeondang

View of the entire estate seen
from the pond.

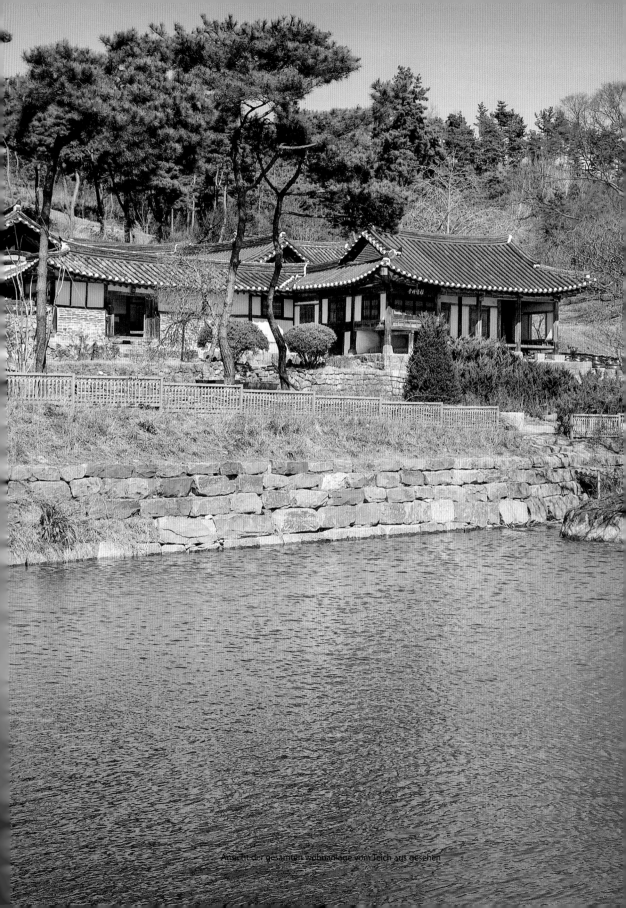

Ansicht der gesamten Wohnanlage vom Teich aus gesehen

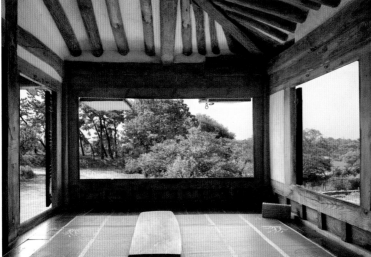

Inner view of the *numaru*. (top)
View from the *numaru* of the *sarangchae*. (bottom)

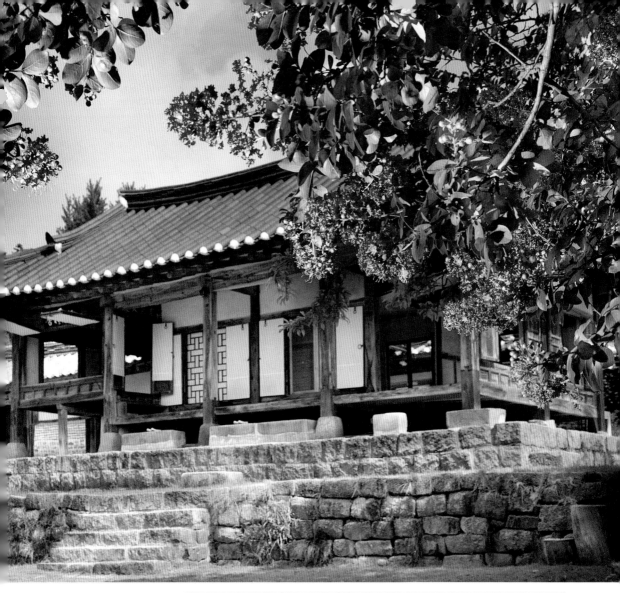

Sarangchae from the east. (top)
Front of the *sarangchae*. (bottom)

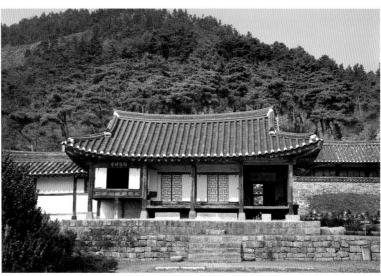

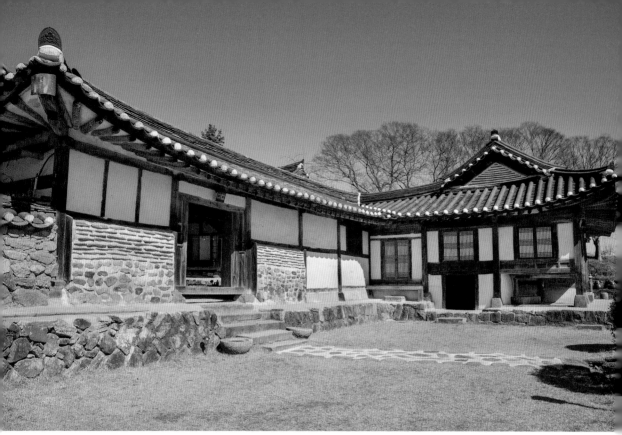

Munganchae and *sarangchae* seen from the west. (top)
Hyeopmun seen from the *sarangchae*. (bottom, left)
Toenmaru, corridor of the *sarangchae*, seen from the side. (bottom, right)

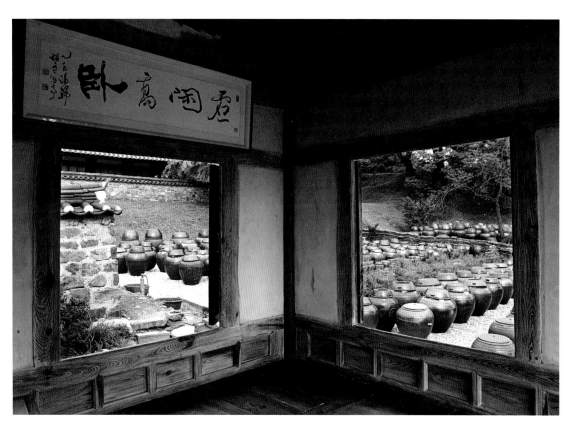

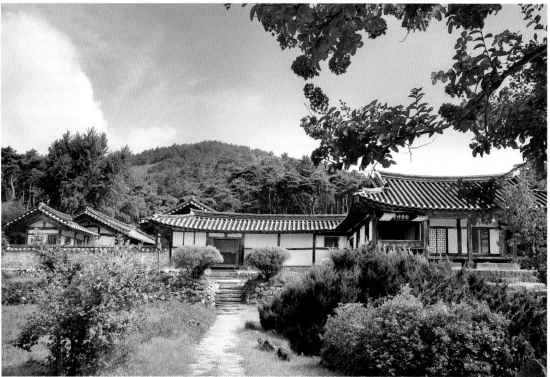

View from *sarangchae*. (top) View of the entire estate from the south. (bottom)

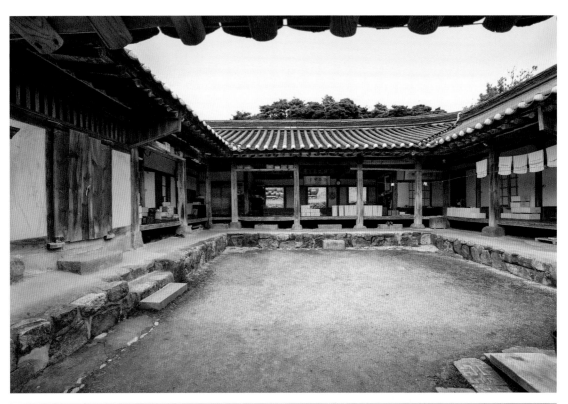

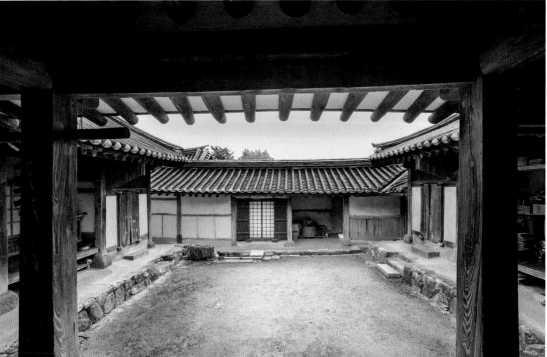

Anchae seen from *munganchae.* (top)
Munganchae seen from *anchae-daecheong.* (bottom)

Landscape to the east of the estate.

Residence of Min Chil-sik in Buyeo

Built at the end of the Joseon Dynasty
179 Wangjung-gil, Buyeo-eup, Buyeo-gun, Chungcheongnam-do

The year of construction of Min Chil-sik's residence is unknown, but it is assumed that it was built towards the end of the Joseon Dynasty and during major restaurations in 1829 (King Sunjo's 29th year of reign) an indication of the original date was found. According to oral tradition, this house is said to have been in the possession of the Yongin Yi clan of but ownership had passed to the Min family. Today, the house is owned by the city of Buyeo.

A steep slope is located behind the estate, while wide fields and grasslands spread in front of the estate, followed by the village itself. The Wangpo River flows from west to east to the village's front flowing into the Baegma River. Today, the estate consists of the *anchae* (women's quarters), *sarangchae* (men's quarters) and the *haengnangchae* (house for service staff). The high rising soseuldaemun (entrance door) is located next to the *haengnangchae*. A long-stretched, broad *dan* (stone step) is situated in the *haengnangchae*'s courtyard. Behind this step are the *anchae* and *sarangchae*. The wall adjacent to the *haengnangchae* also connects the end of the house with the *anchae*, as if to protect it. Both *anchae* and *sarangchae* are distinctly defined by a wall.

This estate forms a □-shape: both *sarangchae* and the storage house are shaped like long-stretched wings, which gives the house the name *nalgae-jip* (wing-house). While *nalgae-jip*s are common in the flat regions of the Yeongnam area, they are rare in the Hoseo region. The building construction, on the other hand, follows the typical form of the Hoseo region. In other words, the residence is a typical *nalgae-jip* of the Yeongnam region in Hoseo.

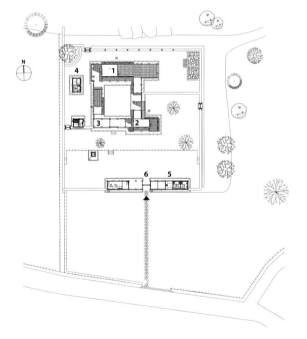

1. anchae
2. sarangchae
3. gwangchae
4. gwangchae
5. haengnangchae
6. daemun

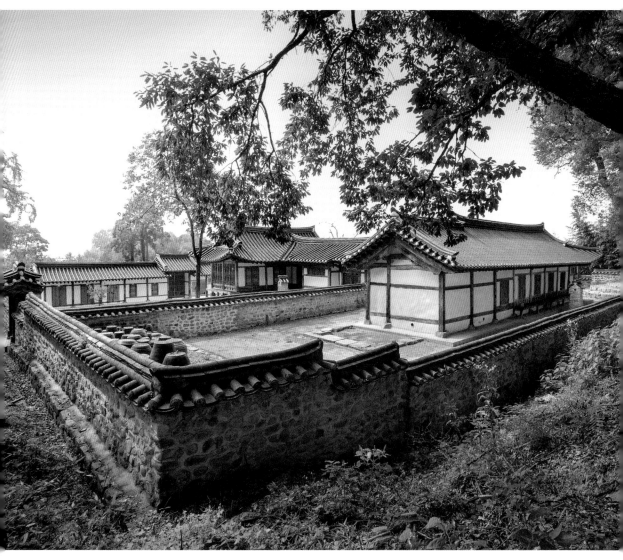

View over the entire house from the northeast.

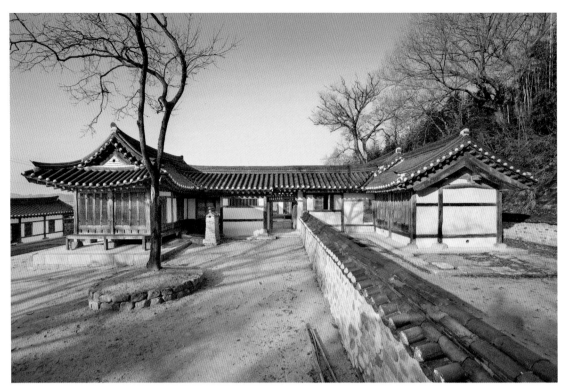

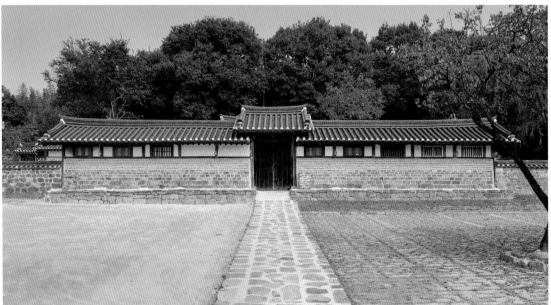

Sarangchae and *anchae* seen from the east. (top)
Front view of the *haengnangchae*. (bottom)

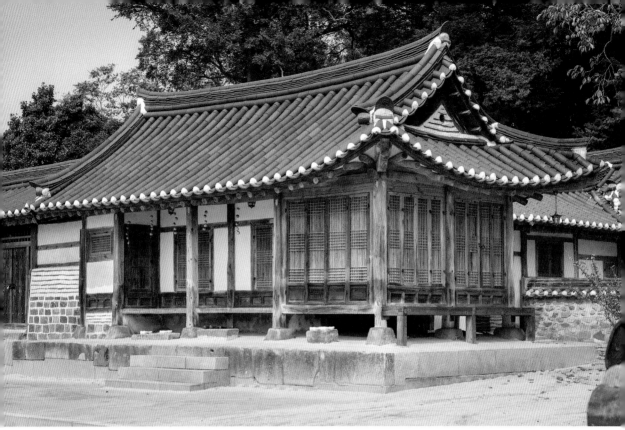

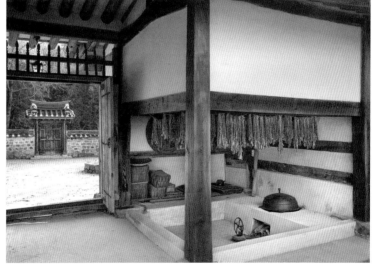

Sarangchae. (top) Toilet of *sarangchae.* (bottom, left)
Entrance door from the *sarangchae* to the *anchae.* (bottom, right)

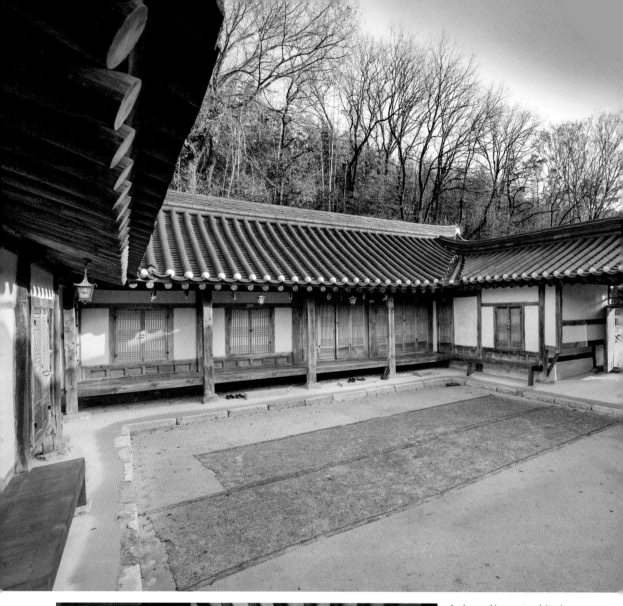

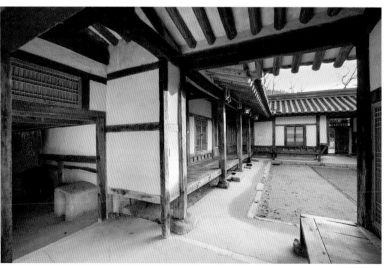

Anchae and its courtyard. (top)
Entrance door to the *anchae*
seen from the west. (bottom)

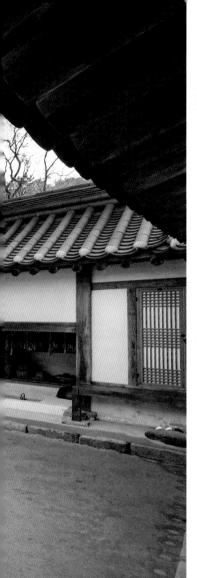

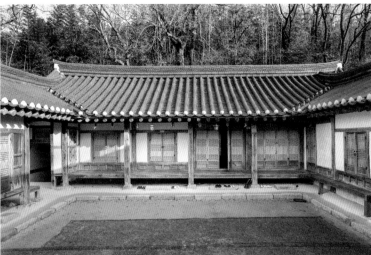

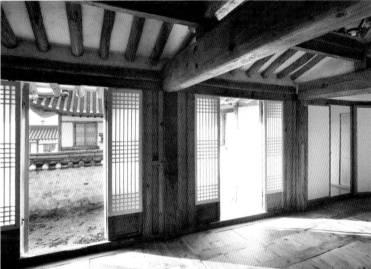

Front view of the *anchae*. (top)
View from connecting *marubang* of the *anchae* looking outside. (bottom)

Birth House of President Yun Bo-seon

Built between 1903–1907
29 Haewi-gil 52beon-gil, Dunpo-myeon, Asan-si, Chungcheongnam-do

The residence was built by Yun Chi-so, whose son Yun Bo-seon later became the President of the Republic of Korea (1960-1962). The members of the Haepyeong Yun clan in the village gradually rose in political power as they held high positions in the central government of the late Korean Empire and became powerful in this region; their descendants gradually spread to the region.

Although the successor generation of Yun built their homes close to each other, they nevertheless could not rise to the status of ancestral village community before the Yun Bo-seon's house was built. When Yun Bo-seon's own house was built opposite the family home and took up the largest building ground in the village, the region changed as though the Yun family were the most important group in the village community.

Currently, the *anchae* (women's quarters), *sarangchae* (men's quarters), *munganchae* and the *haengnangchae* (house for service staff) are located on the family's land.

Together with the other buildings, the estate forms a 巴-shape. The *munganchae* with its entrance door is located at the front. Upon entering through this gate, the courtyard of the staff quarters and *haengnangchae* come into view, parallel to the *munganchae*, facing the same direction. East of the courtyard is the *sarangchae*, surrounded by a wall. The ㄱ-shaped *anchae* is situated behind the *jungmun* (middle gate) located in the centre of the *sarangchae*. and built in such as way as if cradling the courtyard. The distance between the *sarangchae* and the *anchae* creates a *byeoldang*, reflecting the intention to use the *sarangchae* as a local cultural centre.

Special features of this *hanok* are the red tiles used as building materials. This can be explained by the time of its construction, which coincides with the arrival of western building styles in Korea and it shows the influence these styles had on Korean architecture.

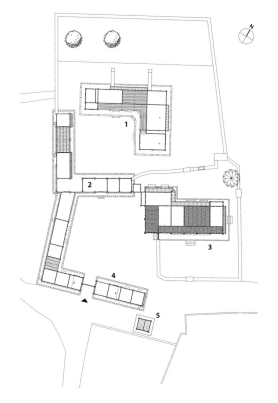

1. anchae
2. haengnangchae
3. sarangchae
4. munganchae
5. hwajangsil

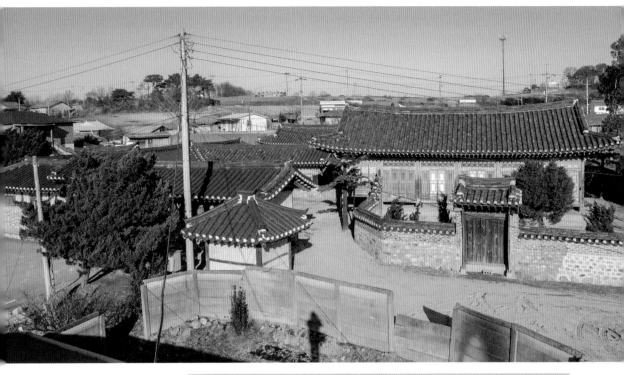

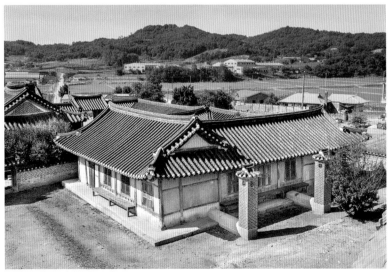

General view of the estate. (top)
Rear view of the *anchae*. (bottom)

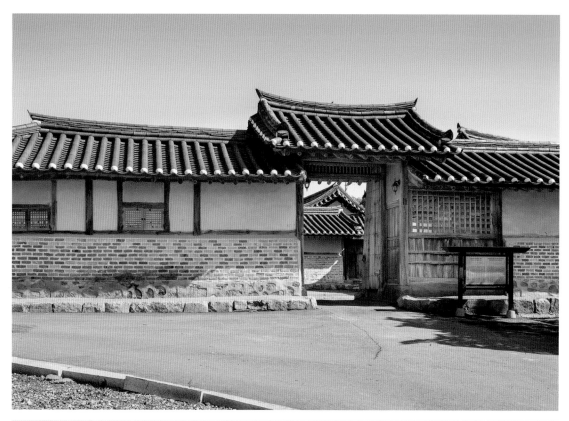

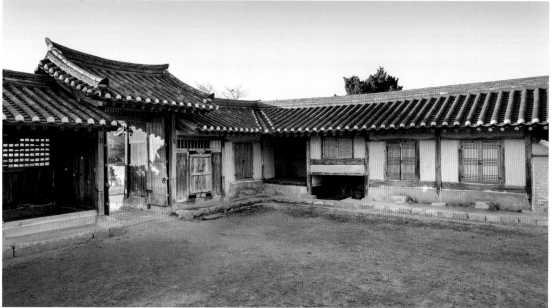

Munganchae. (top)
Munganchae seen from the *haengnangchae's* courtyard. (bottom)

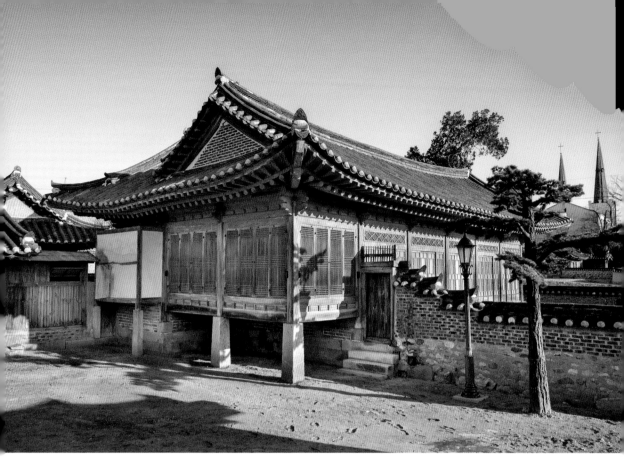

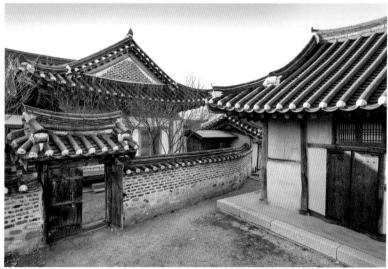

Sarangchae seen from the entrance gate. (top)
Rear gate of the *sarangchae*. (bottom)

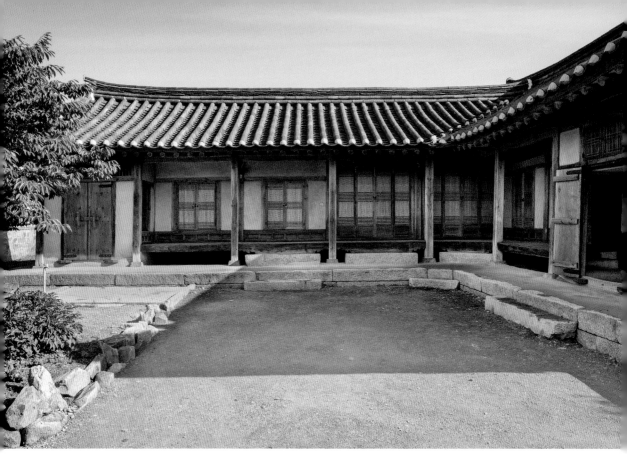

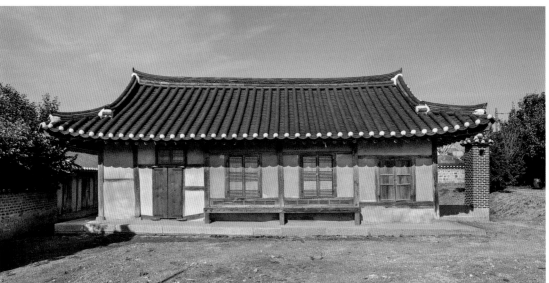

View from the middle gate towards the *anchae*. (top)
Rear side of the *anchae* seen from the east. (bottom)

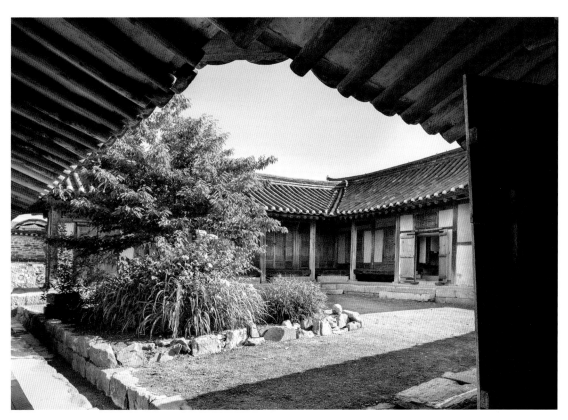

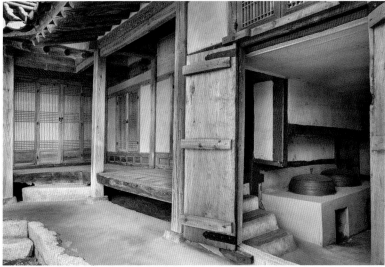

Courtyard of the *anchae* seen through the *jungmun*. (top)
Kitchen view of the *anchae* seen from the east. (bottom)

Residence of Geonjae in Asan

Built during the second half of the 19th century
19-6 Oeamminsok-gil, Songak-myeon, Asan-si, Chungcheongnam-do

This residence is located in Asan, at the edge of the village centre and faces southwest. Yi Geon-chang, who had been governor of Yeongam at the end of the Joseon Dynasty, lived here during his time in office. From this stems the residence's nickname 'Yeongam House'.

The private home, probably built in the second half of the 19th century, includes a servants' quarter, the *haengnangchae*, which had been built on the flat. Spread across a large area behind the servants' quarter are the *sarangchae* (men's quarters) and the *anchae* (women's quarters), as well as the other buildings. The outside areas of the complex are impressive in size and divided into three areas: the garden between the *sarangchae* and the *haengnangchae*, the wide courtyard between *sarangchae* and *anchae* and the backyard behind the *anchae*. The *sarangchae* is situated behind the garden.

As a special feature of a Chungcheong region *yangban* family house, the wide square courtyard, *haengnang-madang*, located in front of the entrance gate, the front part of the *sarangchae*, the *sarang-madang* and garden, the garden behind the *anchae* and the garden on the Eastern side of the estate are all larger in size than those of other common *hanoks*. The garden next to the *sarangchae* deserves a specific mention, as it has unique features not found in other houses. Its design differs slightly from the traditional arrangement: the large plot has been creatively planted with a variety of conifers and deciduous trees in order to give the impression of a naturally grown forest. Water pipelines run along the outer and inner walls, which feed a one *ja* (approx. 30,3 cm) high waterfall. The waterfall then flows into the garden pond and from here the water is transported along the southern wall to the outside. This interesting garden design shows the owner's love of nature.

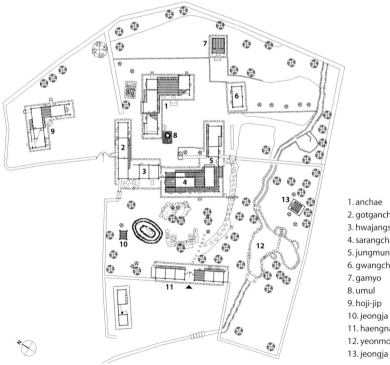

1. anchae
2. gotganchae
3. hwajangsil
4. sarangchae
5. jungmun
6. gwangchae
7. gamyo
8. umul
9. hoji-jip
10. jeongja
11. haengnangchae
12. yeonmot
13. jeongja

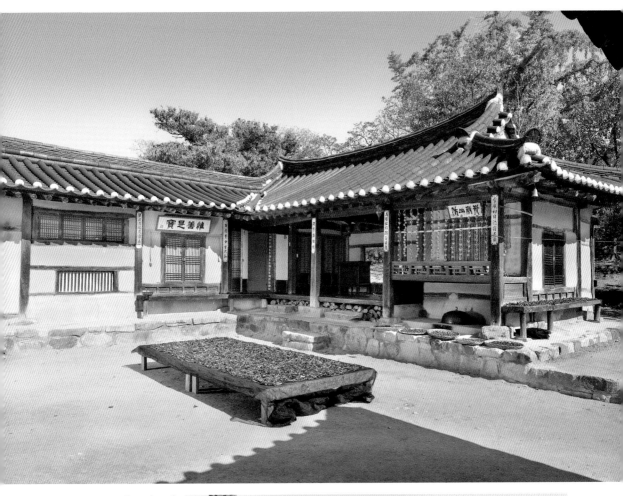

Front view of
the *anchae*. (top)
Entrance gate *daemun*.
(bottom)

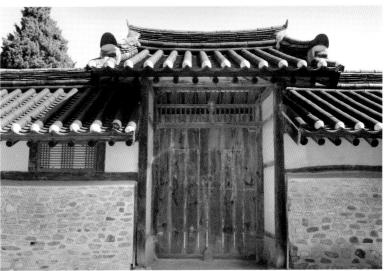

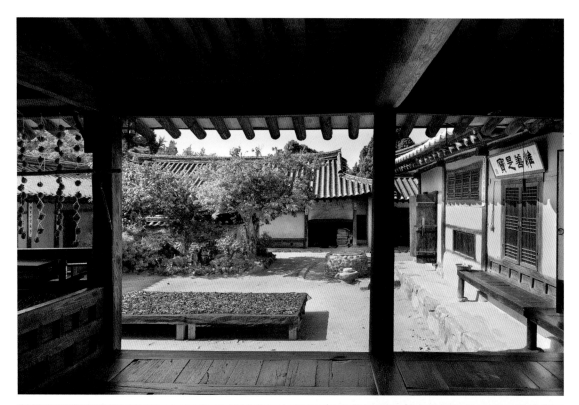

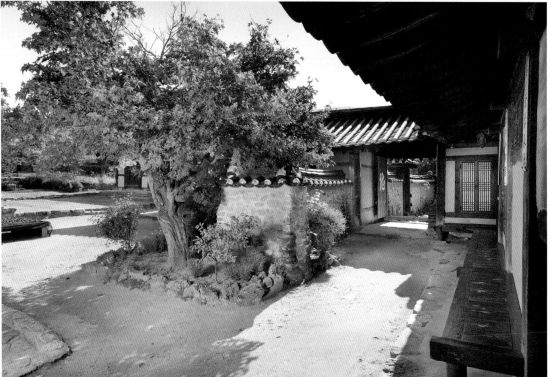

View from the *anchae-daecheong*. (top)
Jungmunganchae, with outer and inner wall. (bottom)
Interior view of the *anchae-daecheong*. (p.83)

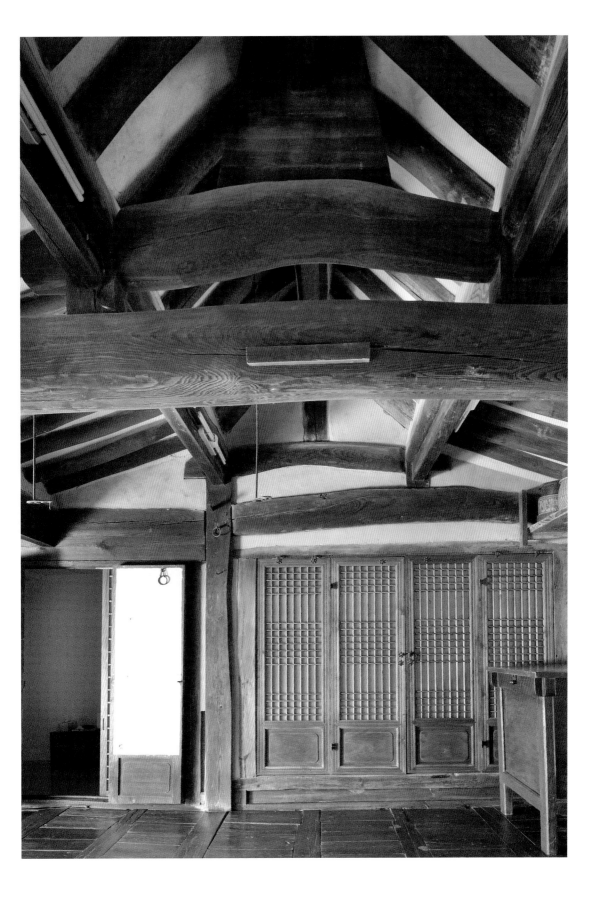

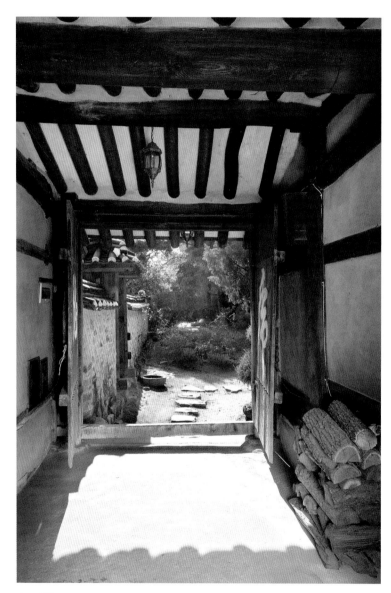

The middle gate, *jungmun.*

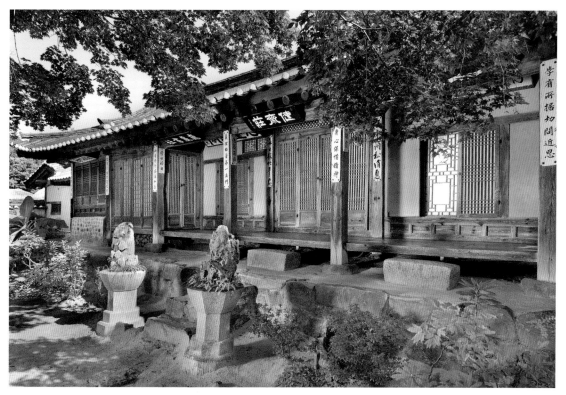

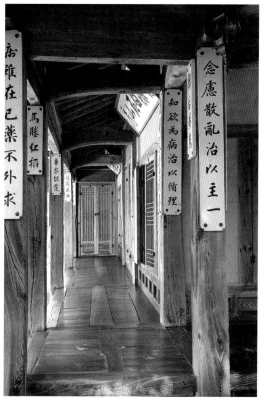

View of the *sarangchae*. (top) Interior of the *anbang*. (bottom, left) Lateral view of the corridors in the *sarangchae*. (bottom, right)

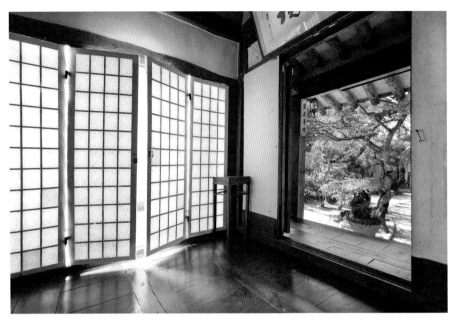

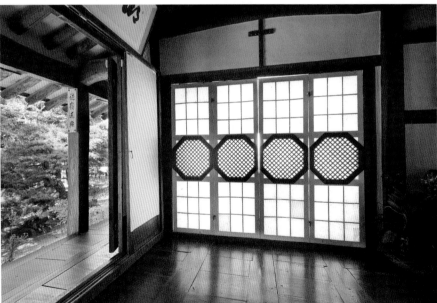

Door of the *jageun-sarangbang.* (top)
Door of the *keun-sarangbang.* (bottom)

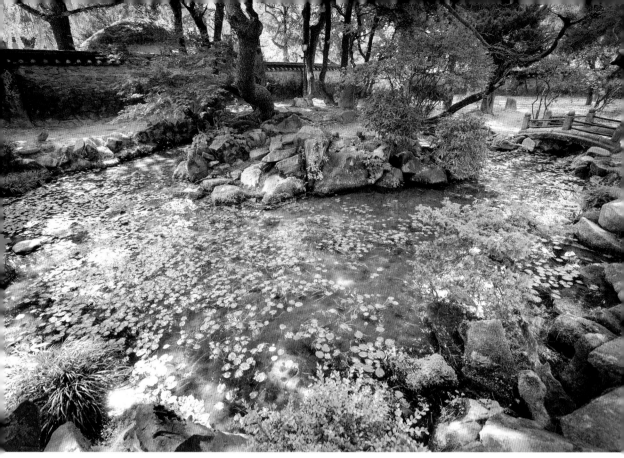

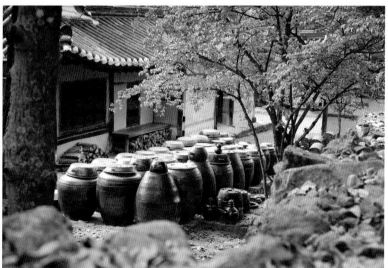

Pond in the garden of the *sarangchae*. (top)
View of the condiments bay, *jangdokdae*. (bottom)

Residence of Yi Ha-bok in Seocheon

Built at the end of the Joseon Dynasty
32-3 Sinmak-ro 57beon-gil, Gisan-myeon, Seocheon-gun, Chungcheongnam-do

The residence lies in a village, which is protected by a high mountain in the north. The front of the village opens up to fine distant views whereas a landscape of broad fields spreads along its southern side. From a geomantic perspective, the 'guardian mountain' behind the village that stretches from the Jangunbong peak, turns to the east, creates the U-Baekho (white tiger), while the mountain range from Oknyeobong peak is stretching to the west, creating the Jwa-Chongryong (blue dragon).

The house is a typical wealthy landowner's farmhouse. The owner, Yi Byeong-sik, held the rank of Uigwan[1] at the court in Jungchuwon. During his time, he had the 3 *kan*-sized *anchae* (women's quarters) built. His son Yi Ha-bok had the *sarangchae* (men's quarters), *anchae* and *witchae* (upper house) built in their current appearance. Yi Ha-bok's pseudonym was Cheongam. He was an activist against Japanese rule in the country and emerged as leader of the Gwangju student rebellion. He worked as a teacher at the Boseong College[2] but resigned after being forcibly renamed by the Japanese and in protest against the forced conscription of young Korean men. He returned to his home town of Seocheon and lived in this house, where he became a reformer in the Enlightenment movement for rural communities.

Due to its ideal positioning according to geomantics, the house has retained the typical atmosphere of a traditional straw house to this day. The *anchae* and *araechae* (outer-wing house), *sarangchae*, *gwangchae* (storage house) and *heotganchae* (storage house) were built on the estate's grounds, arranged in a □-shape around the *anmadang* (courtyard). Looking at the arrangement of the buildings, it almost seems as if the *araechae* is the *sarangchae*, and the *sarangchae* takes the position of the *byeolchae* (separate house). The *gwangchae* and *heotganchae* are located at the rear of the grounds and can be reached by entering through the entrance gate between the *araechae* and *sarangchae*.

Today the house is maintained by the Cheongam Historical Heritage Society, founded in memory of Yi Ha-bok.

1. Member of parliament in today's sense.
2. Currently Korea University, Seoul.

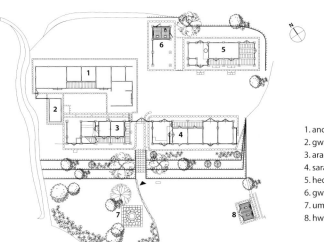

1. anchae
2. gwangchae
3. araechae
4. sarangchae
5. heotganchae
6. gwangchae
7. umul
8. hwajangsil

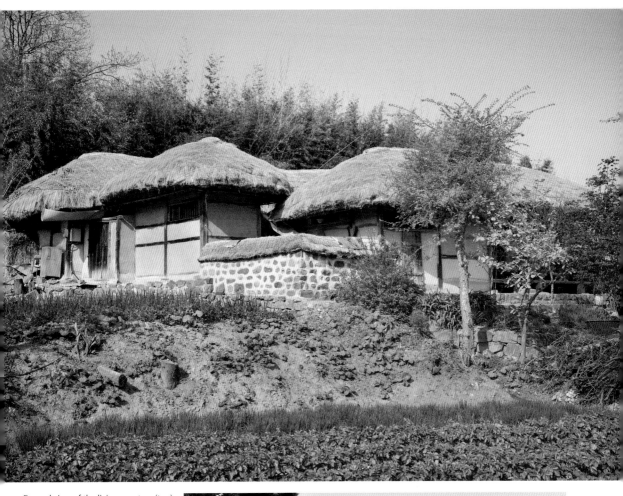

General view of the living quarters. (top)
Middle gate between *araechae* and
sarangchae. (bottom)

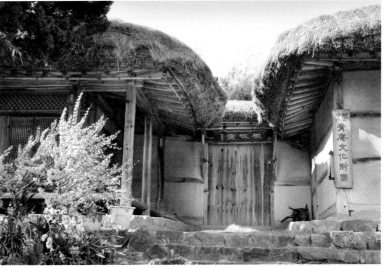

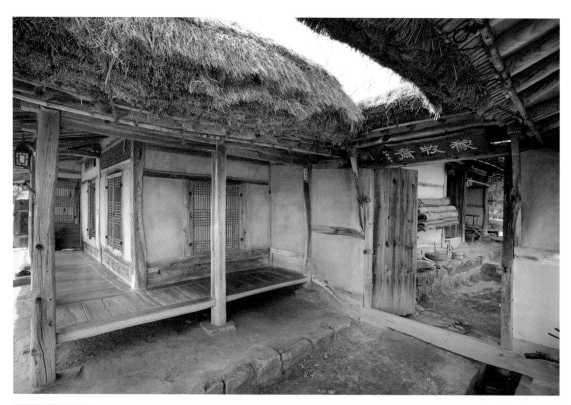

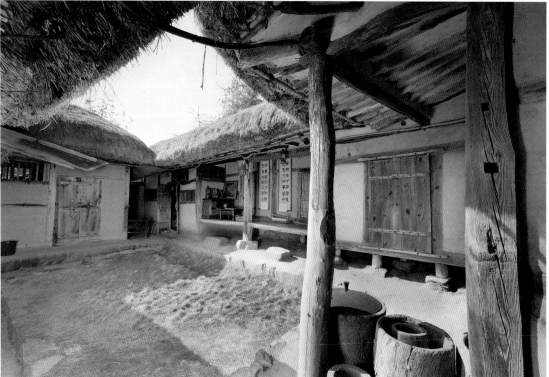

Araechae and *jungmun.* (top)
View of the *araechae* and *anmadang.* (bottom)

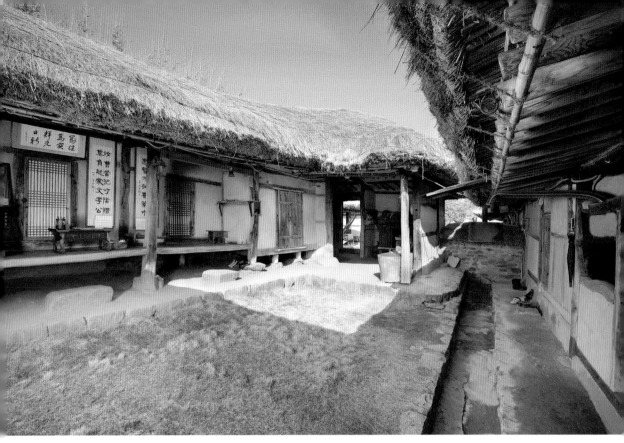

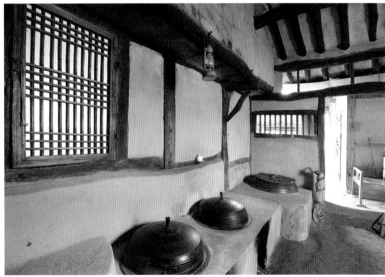

View from the *gwagchae* towards the *anchae* and *anmadang.* (top)
Kitchen of the *anchae* (bottom)

Yeongnam Area

Original Family House of the Gyeongju Choi Clan in Dunsan-dong, Daegu

Built in 1630
541 Dunsan-gil, Dong-gu, Daegu Gwangyeok-si

The family residence is situated in the last row of houses in the village, but with best view towards the south. The first residential buildings were built in 1630 (King Injo's 8th year of reign). In 1694 (King Sukjong's 20th year of reign), the *anchae* (women's quarters) was altered in restoration works and the *daemyo* (ancestors' honorary shrine) erected. The Bobondang (ancestors' shrine) was built in 1742 (King Yeongjo's 18th year of reign). Since then, numerous restoration and expansion works were conducted on the estate, and in 2005 the Sungmogak was founded as a museum for the Choi Family.

The house is entered by the —-shaped entrance gate. The —-shaped *sarangchae* (men's quarters) are located in the foreground and the ⊓-shaped *anchae* stands in the background, forming an angular ⊔-shape. A wall runs to the left and right of the *anchae* and together with the courtyard, it provides the women's quarters with an undisturbed atmosphere and with an entrance from the courtyard through the *hyeopmun* (side gate) to

a little stream running in the western part of the estate. To the left of the *anchae* and located next to the *anchae* kitchen, is the —-shaped *gobangchae* (storage house). The *daemyo* stands behind the *momchae* (main building) to the right. To the *daemyo's* right are the Bobondang, where preparations for ancestors' ceremonies took place and the *byeolmyo* (shrine for other side spirits). All of the shrines stand separate from each other.

This family home consists of a main building, a storage building, a *daemunchae* (entrance gate house), a *jecheong* (room in which the ancestors' rituals are held) and two ancestors' shrines, each displaying individual characteristics in line with Confucian ideology. The traditional building construction of the *anchae* and its beautiful design follow the geomantic symbolism of 'Yin and Yang' (negative and positive) and the *sarangchae's* display of architectural perfection of the five elements can be clearly seen in his house.

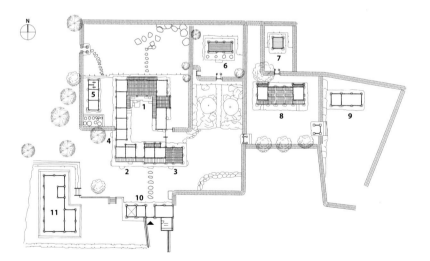

1. anchae
2. jungsarangchae
3. keun-sarangchae
4. jungmun
5. bangaganchae
6. daemyo
7. byeolmyo
8. Bobondang
9. posa
10. daemunchae
11. Sungmogak

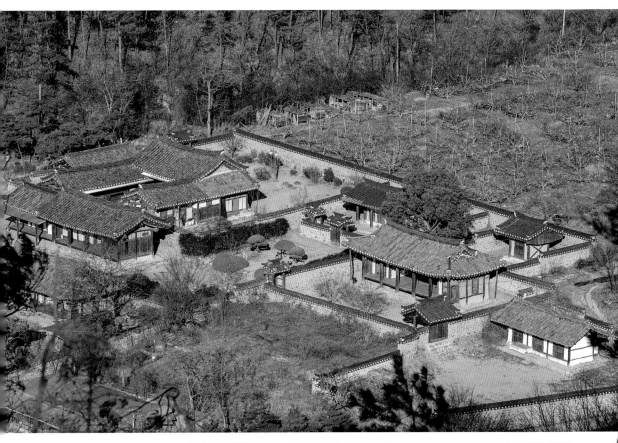

View over the estate. (top)
Daemyo, ancestors' honorary
shrine. (bottom)

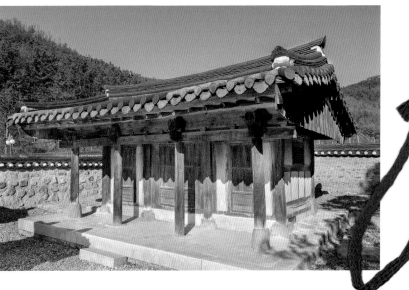

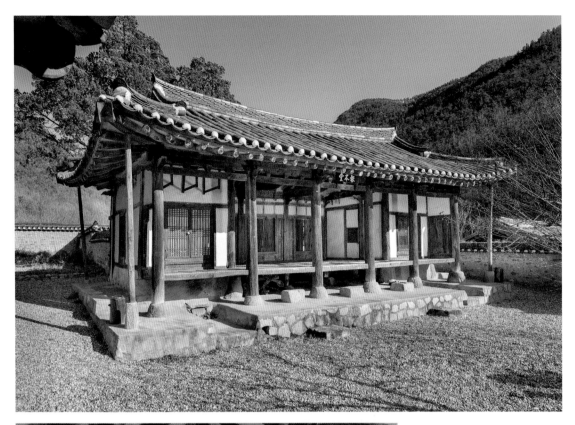

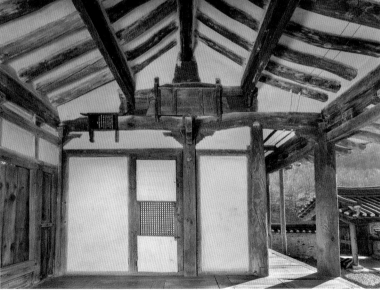

Bobondang. (top) Interior view of Bobondang. (bottom)

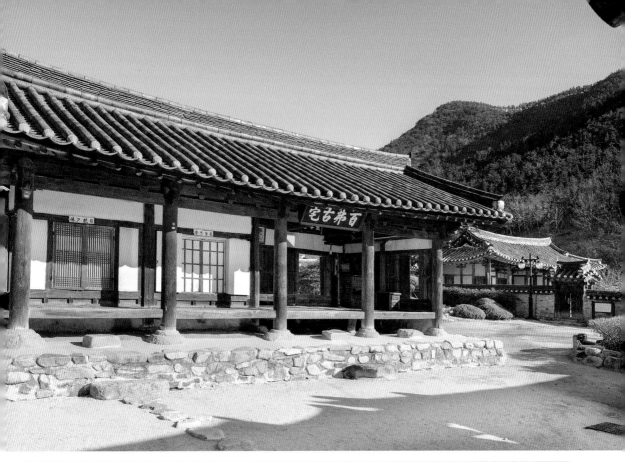

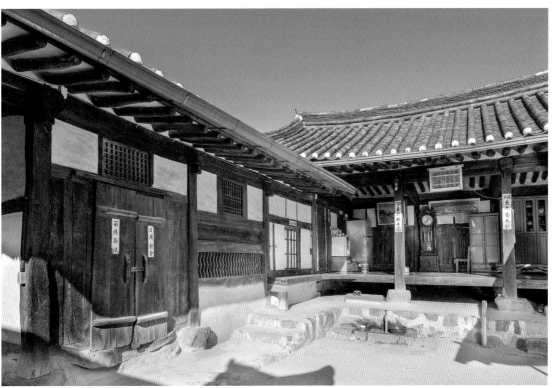

Sarangchae (top) and *anchae*. (bottom).

Seobaekdang in Yangdong

Built in 1454
75-12 Yangdongmaeulan-gil, Gangdong-myeon, Gyeongju-si, Gyeongsangbuk-do

The Seobaekdang estate stands on a hill in south-westerly direction. It is located in a deep valley on the side of a mountain range stretching south from Seolchang Mountain, the guardian mountain protecting the village.

The 22 year-old Son So built the residence in the village of Yangdong at the beginning of the Joseon Dynasty in 1454 when King Danjong was in his second year in power. The house is considered the ancestral home of the Son family of Wonseong and is especially famous for being the birthplace of esteemed Confucian scholar Son Jung-don and Yi Eon-jeok, grandson of Son So.

Located on a steep incline, the complex was built on a base wall consisting of various plain, small stones. The residential quarters consist of the —-shaped entrance gate *daemunchae*, the □- shaped main residence *momchae,* the ancestral shrine *sadang*, the *sinmun* (door) as well as the storehouse *gotganchae*. An external mud brick wall encloses the building complex.

While the front plot is on a relatively low land, the plot at the rear lies on a steep incline; as a result, the □-shaped main building and the *daemunchae* have been erected on opposite sides on the sloping plot facing and face in south-westerly direction. The wall, *dam*, the *daemunchae* and the *momchae* have been built in particularly close proximity. One possibility for this arrangement is the steep incline of the plot.

The similarly steep upper part of the *sarang-madang* is supported by a high mud brick wall. The ancestral shrine *sadang* and the *sinmun* have been placed a certain distance from each other. The *gotganchae* lies to the north-west of the *momchae*.

These buildings date from the 15th century and were predominantly used by aristocratic families from the Yeongnam area. They are therefore regarded as particularly important site of architectural history. The architectural style of creating separate gendered domains and including ancestral shrines reflect the Confucian philosophy: modestly and unassuming, the design marks the house as one of an aristocratic family from the early period of the Joseon Dynasty.

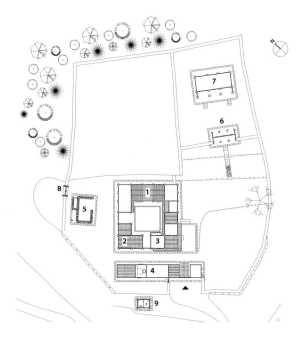

1. anchae
2. araechae
3. sarangchae
4. daemunchae
5. gotganchae
6. oesammun
7. sadang
8. hyeopmun
9. hwajangsil

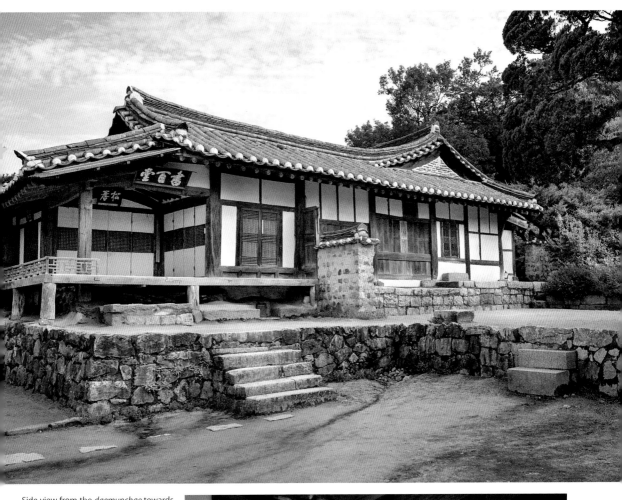

Side view from the *daemunchae* towards the *sarangchae*. (top)
Interspace between *daemunchae* and *momchae*. (bottom)

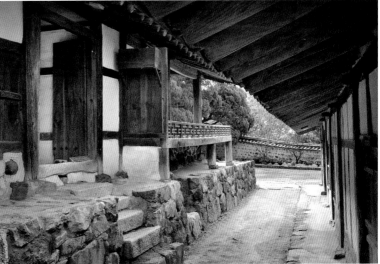

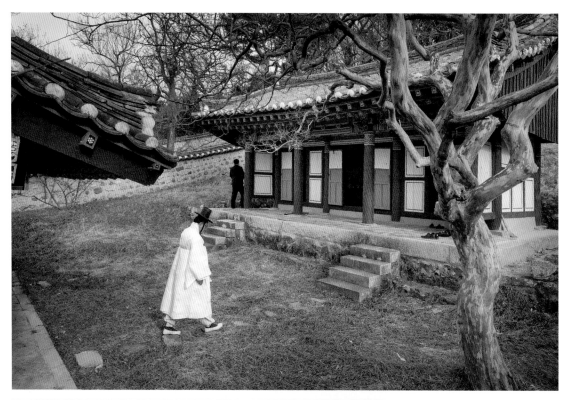

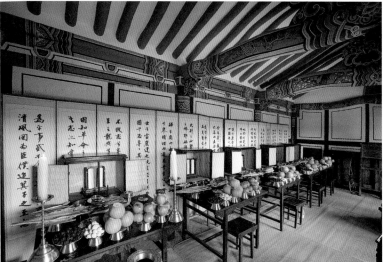

The *sadang.* (top)
Interior view of the *sadang.* (bottom)

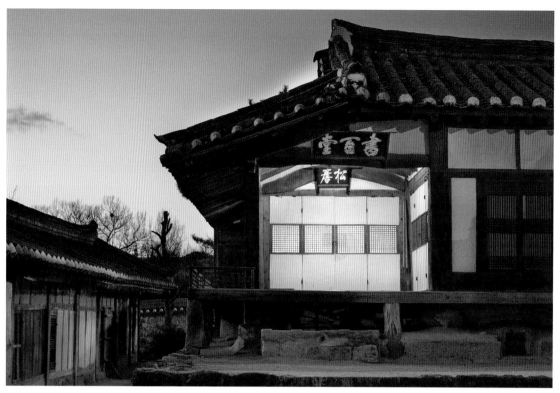

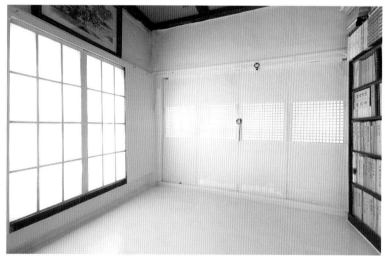

Sarangchae in evening light. (top)
Maru of the *sarangchae* (bottom, left) Interior view of the *sarangbang* (bottom, right)

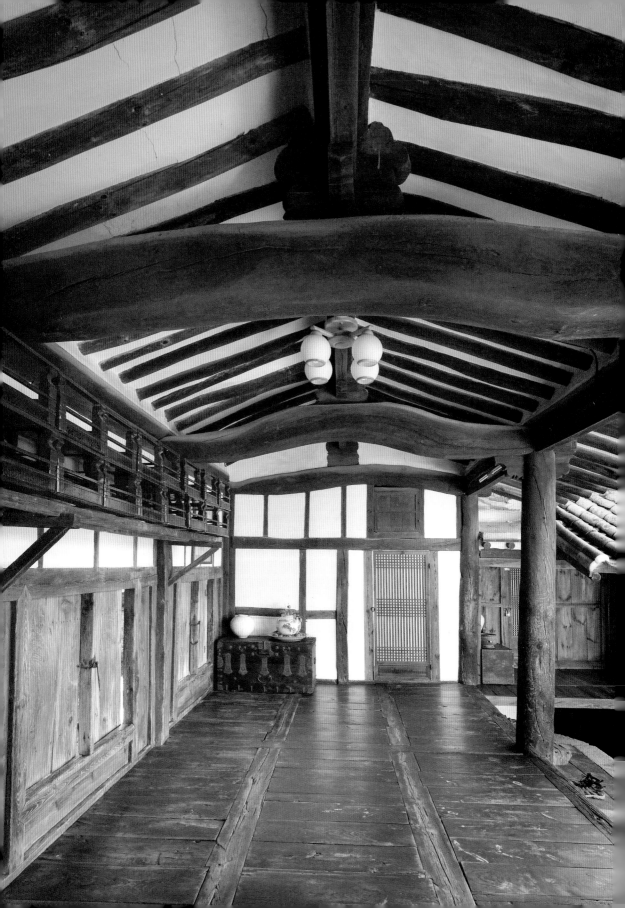

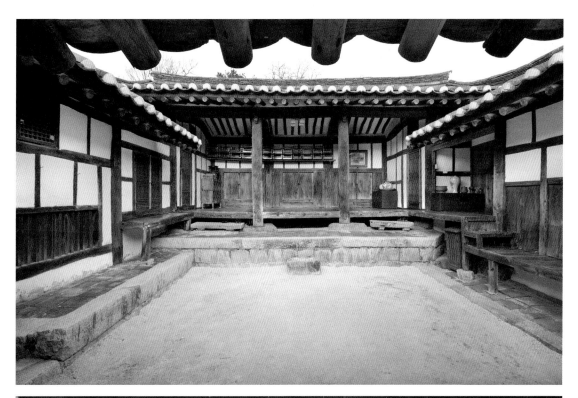

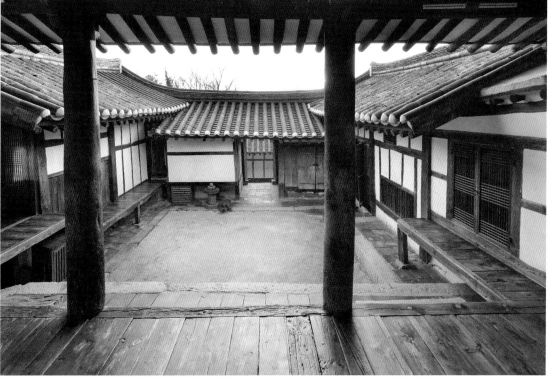

Interior view of the *anchae-daecheong*. (p.102)
Complete view of the *anchae*. (top) View from the *anchae-daecheong*. (bottom)

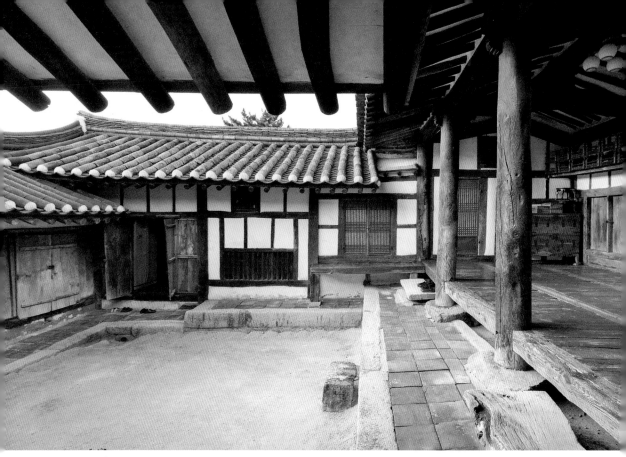

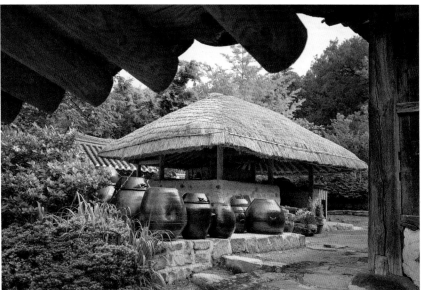

View of the *anchae* viewed from the rear of the *sarangchae*. (top)
Jangdokdae. (bottom)

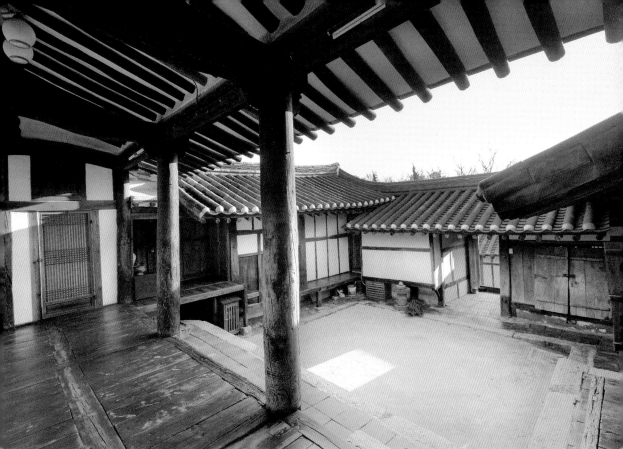

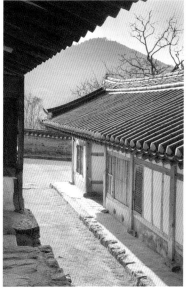

View from the *anbang.* (top)
View of the *daemunchae,* as seen from the gate of the *anchae.* (bottom, left)
Daemunchae, opposite the *momchae.* (bottom, right)

Residence of Sahodang in Yangdong

Built around 1840
83-8 Yangdongmaeulan-gil, Gangdong-myeon, Gyeongju-si, Gyeongsangbuk-do

The owner of this residence, Yi Neung-seung, who was also known under the pseudonym Sahodang, had passed the state examination for literary licentiate (Jinsa). His house was located on the hillside of the upper village and had been erected in the late Joseon Dynasty around 1840 (King Heongjong's 6th year of reign). It is an average aristocratic residence from this village and was built in ㅁ-shape on a flat surface.

In the centre of the residential complex and connected to each other, are the ㅡ-shaped *haengnangchae* (service staff quarters), the ㄷ-shaped *anchae* (women's quarters) and the ㅡ-shaped *sarangchae* (men's quarters). From a slightly inclined angle, they represent a ㅁ-shape with the *sarangchae* protruding towards the east. Built as an aligned entity are the ㄷ-shaped *anchae* and the ㅡ-shaped *sarangchae* as well as the ㅡ-shaped *haengnangchae*, which stands on the forecourt of the *anmadang*. Generally, this estate is an excellent example of good use of space and well-designed outer living areas as well as a beautiful finish of the buildings.

The wide *sarang-madang* (courtyard) spreads in front of the *sarangchae*. At the bottom of a hill to the front of the estate, a *garab-jip* (straw house for servants) remains, that belonged to the estate in the past.

One specific characteristic is an *ansarangchae* with *numaru* (open, roofed two-storey structure with a raised wooden floor) built on elevated foundation stones in the *anchae* area. The house also features a *marubang* (a room with a wooden floor) that has been added to the *geonneonbang* and connects to the *sarangchae*. The *sarangchae* houses another two special features, a *gamsil* (a chest in which the family's genealogical tree is kept) and a *jecheong* (site for the ancestral ritual). Short, beautifully carved *marudaegong* (beams) in the *sarangchae*'s roof, a round column between the *maru* and the representative room for hosting guests are also a distinctive feature of the Sahodang.

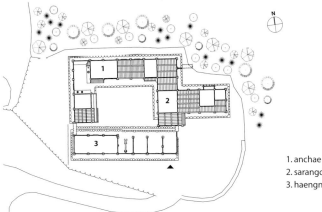

1. anchae
2. sarangchae
3. haengnangchae

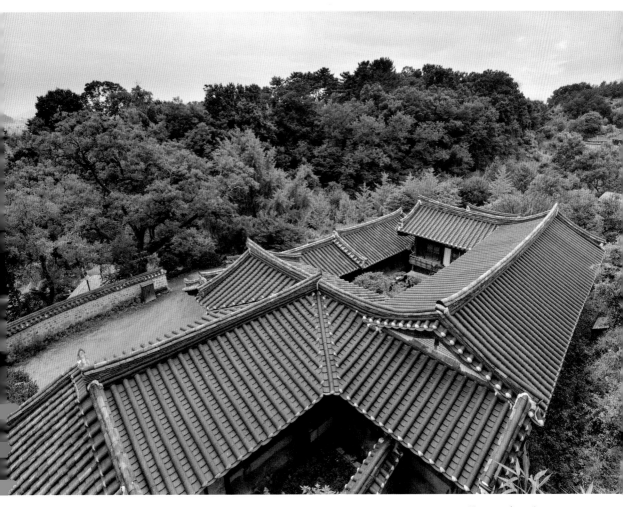

View over the entire estate.

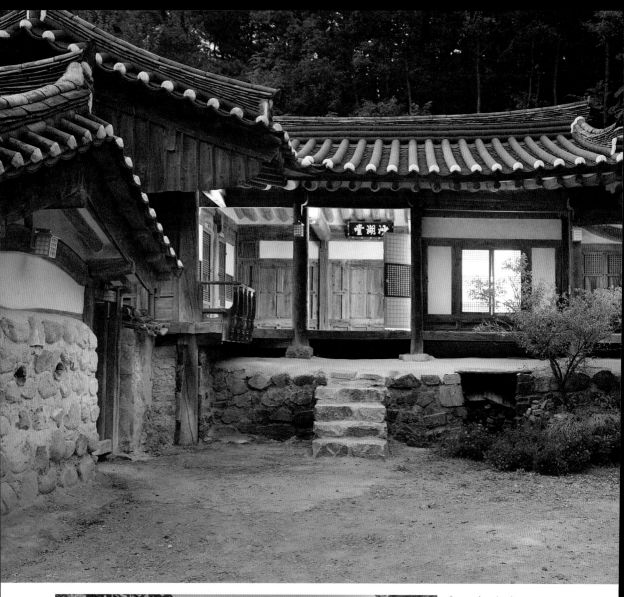

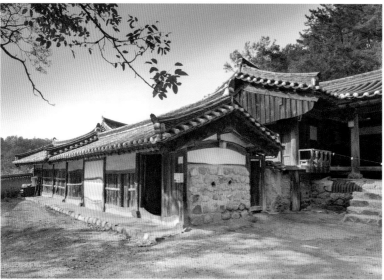

Sarangchae. (top)
Haengnangchae. (bottom)

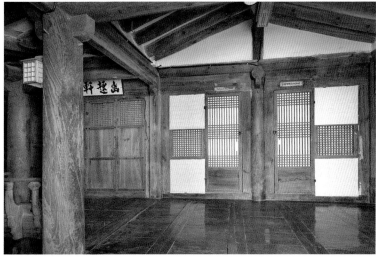

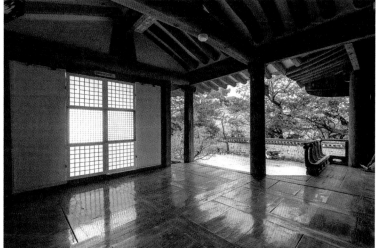

View of the *ansarangbang* (top) and *sarangbang* (bottom) seen from the *sarangchae-daecheong*.

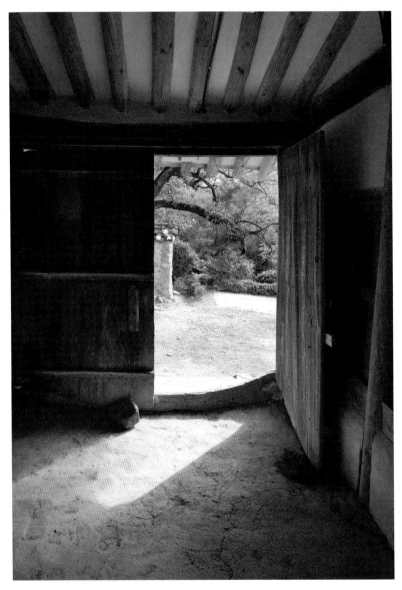

Front door of the *haengnangchae.*

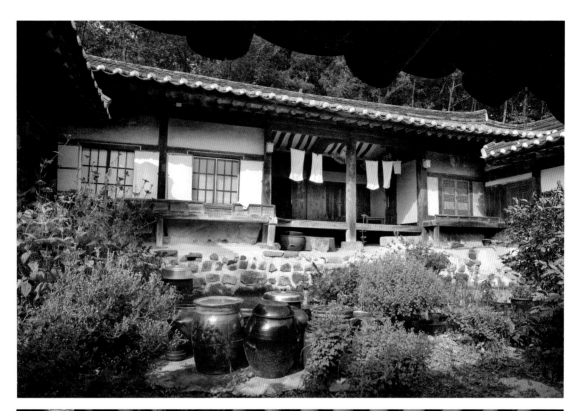

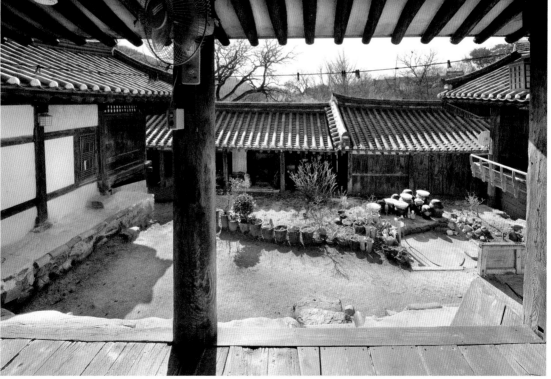

Anchae. (top) View from the *anchae-daecheong.* (bottom)

Residence of the Gyodong Choi Clan in Gyeongju

Built around the middle of the 18th century
39 Gyochon 1-gil, Gyeongju-si, Gyeongsangbuk-do

Built during the middle of the 18th century, this residential home had been known under the nickname 'home of the wealthy Choi clan'. During the time of its construction, the plot comprised around 2,000 *pyeong* a back garden of about 10,000 *pyeong* and residential buildings 99 *kan*, which appears to have been an enormous estate for its time. Unfortunately, in 1970 a fire destroyed considerable parts of the estate including the *sarangchae* (men's quarters), the *haengnangchae* (house for service staff) and the *saesarangchae*, the newly attached men's quarters, leaving only the *munganchae*, *anchae*, *sadang* (ancestral shrine) and *gotganchae* (storage house) intact. The reconstruction process took until 2006 but successfully restored the estate in its entirety.

The house stands on a flat surface and can be reached via a long, wide lane, which leads the visitor through the *soseuldaemun*, a large entrance gate, into the actual living area *daemunchae*. This area simultaneously serves as the *haengnangchae*, which consists of one small chamber and a larger storeroom. The inner building complex consists of the ㄱ-shaped *sarangchae*, the ㄷ-shaped *anchae*, and the —-shaped *jungmungan-haengnangchae*, which had been a later addition. Moreover, the estate includes the *sadang*, the ancestral shrine, as well as the *gotgan*, or storehouse.

The construction has been designed in such a way that the —-shaped *jungmungan-haengnangchae* and the ㄱ-shaped *sarangchae* run parallel to the south side of the *anchae*; from a bird's eye perspective, this composition thus appears to be organised in a tapered and slightly inclined ㅁ-shape. Both the *anchae* and the *sarangchae* are facing south-east, and the back of these buildings are facing north-west.

The estate reflects the typical architectural design of aristocratic homes from Gyeongsang Province, where a family's wealth was customarily measured by the quality of the building materials and the exceptional beauty of its architecture. It is for these reasons that this residence represents a very valuable example and research object of late Joseon period architecture.

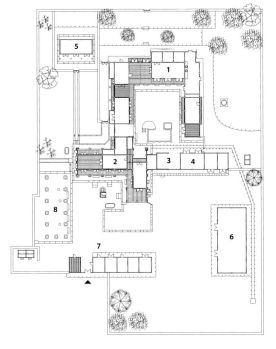
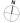

1. anchae
2. sarangchae
3. jungmungan
4. haengnangchae
5. sadang
6. gotganchae
7. daemunganchae
8. saesarangchae teo (site)

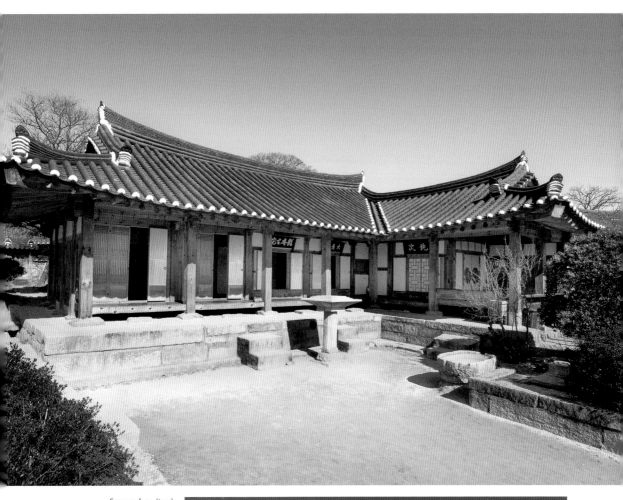

Sarangchae. (top)
Gotganchae. (bottom)

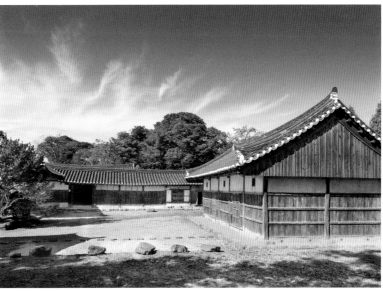

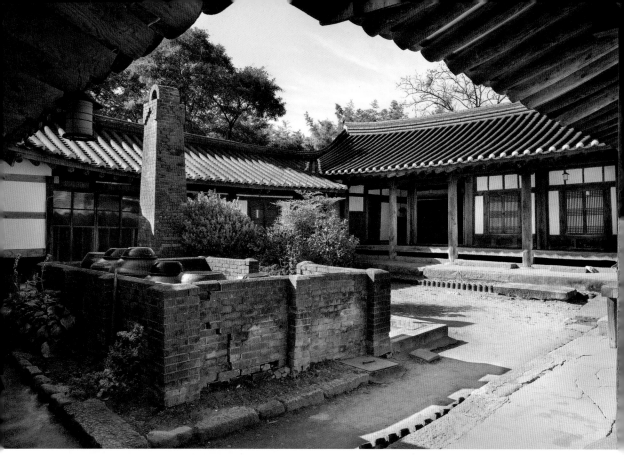

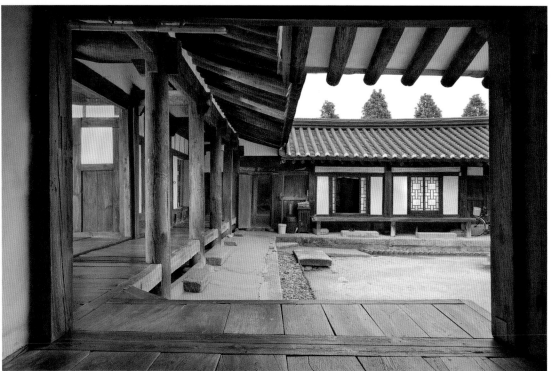

Anchae, viewed through the *jungmun*. (top)
Anchae, viewed from the *seoiksa*. (bottom)

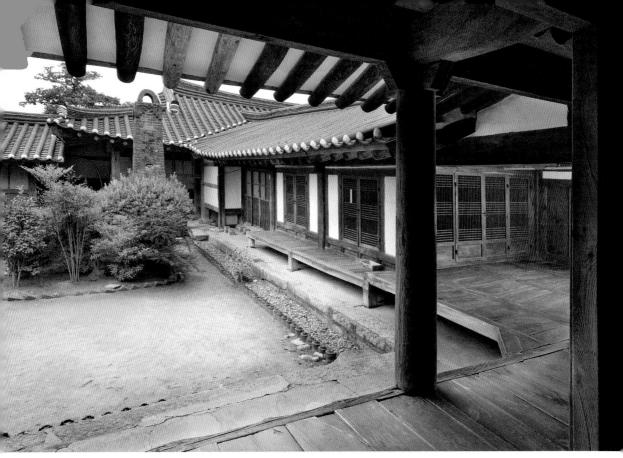

Seoiksa, viewed from the *anchae-daecheong*. (top)
Interior view of the *anchae-anbang*. (bottom)

Residence of Bukchondaek in Hahoe

Built in 1862
7 Bukchon-gil, Pungcheon-myeon, Andong-si, Gyeongsangbuk-do

This residence is situated on an extensive plot of land in the centre of the village and is regarded as the most important homestead in the northern area of the township. The principal owner of the estate, Ryu Do-seong, had held the position of provincial governor in Gyeongsang province and commissioned the building of his residence in 1862 (King Cheoljong's 13th year of reign).

When entering the living area through the entrance gate *soseuldaemun*, the visitor sees the *sarangchae* (men's quarters) and the *anchae* (women's quarters) in the foreground and viewed together, they create a □-shaped *momchae* (main building). Located to the right is the *byeolchae* (separate house), and at the rear of the right *momchae*, we can see the ancestral shrine, which is situated outside the main living area.

The *sarangchae* and *anchae* are situated on both sides of the *momchae*, which has been enclosed by a double wall linked to the external wall. A further wall had been erected at the rear of the kitchen to shield the *anchae* from strangers.

Situated within the walls of the estate are the *sarangchae,* the *anchae* and the *byeoldangchae*. All three buildings are designed with the most ornate type of Korean roof, the *paljak-jibung* (hipped-and-gabled roof). The front of the *andaecheong*, as well as the front and rear part of the guest house's *daecheong* were decorated with round columns whose top, inner surface had been engraved with flower motifs. By connecting the library of the *keun-sarangchae* and the exterior wall of the *byeoldangchae*, the roof tiles and the *hapgakbyeok* join together in beautiful geometric forms, which accentuate the significance and meaning of the guest house.

The *jungmun* (middle gate), the upper section of the kitchen, *anbang* and the *byeoldangbang* were all furnished with storerooms, *darak*. In addition, a number of *maru* were installed in many places around the residence to increase the convenience of movement between the buildings.

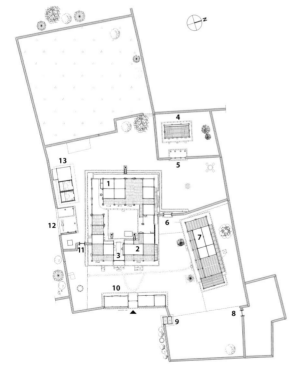

1. anchae
2. sarangchae
3. jungmun
4. sadang
5. sadang sammun
6. Heonchunmun
7. byeoldangchae
8. hyeopmun
9. hwajangsil
10. daemunchae
11. hyeopmun
12. bangagan
13. hwajangsil

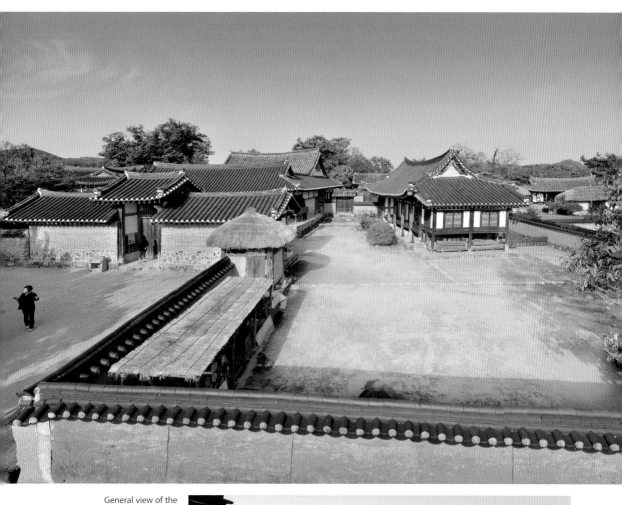

General view of the
residential complex. (top)
View of the *sadang*, the
ancestral shrine. (bottom)

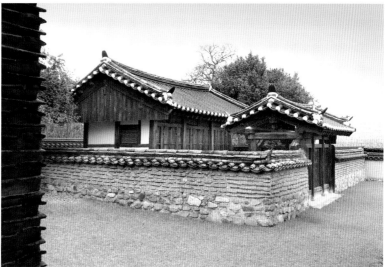

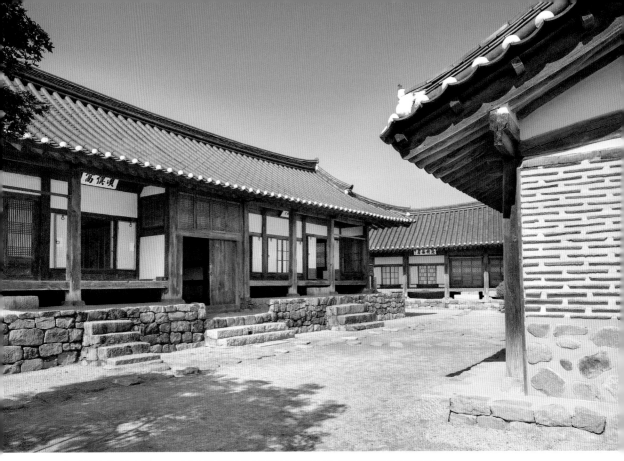

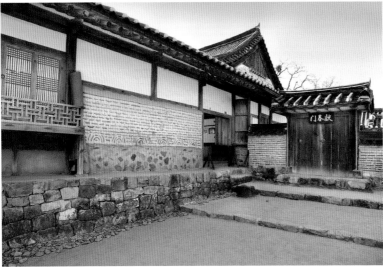

Lateral view of the *sarangchae*. (top)
View of the Heonchunmun, leading between the *hwabangbyeok* and the *sadang*. (bottom)

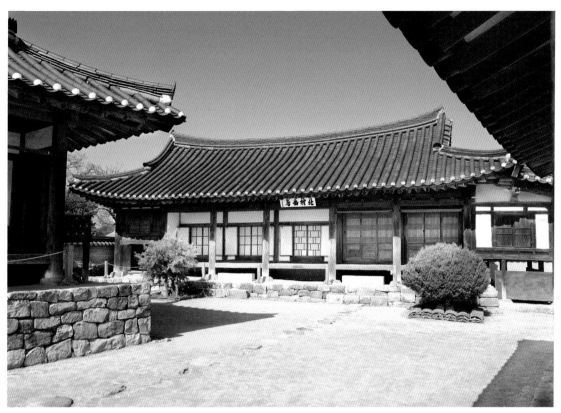

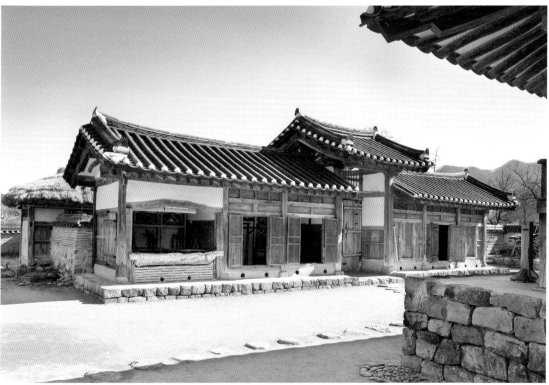

Byeoldangchae, view from the *sarangchae*. (top) *Daemunchae*, lateral view from the *sarangchae*. (bottom)

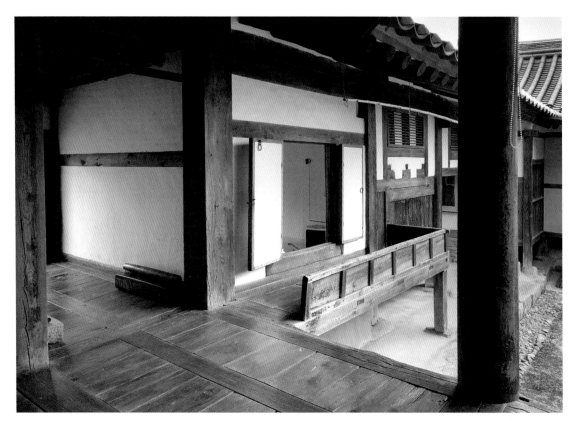

Second room of *anchae*, viewed from the *anchae-daecheong*. (top) View of the *anbang*. (bottom)

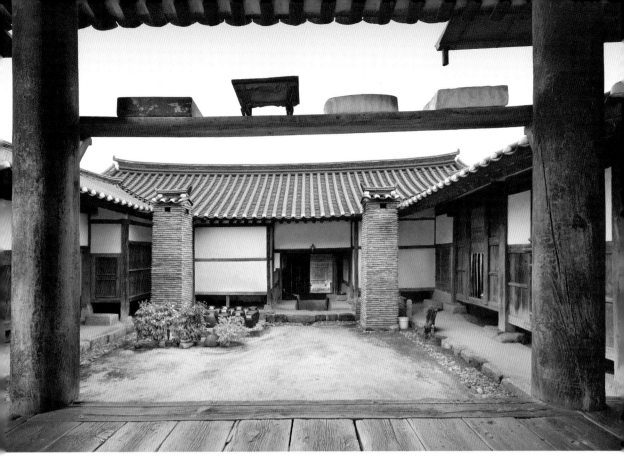

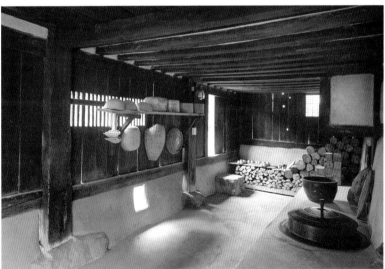

The courtyard, view from the *anchae-daecheong*. (top) Interior of the kitchen in the *anchae*. (bottom)

Wonji-jeongsa in Hahoe

Built in 1573
17-7 Bukchon-gil, Pungcheon-myeon, Andong-si, Gyeongsangbuk-do

Situated at the rear end of the central Bukchon region and facing south-east, stands the pavilion Wonji-jeongsa and looks out over the meandering 'flower' river Hwacheon. When Ryu Seong-ryong's father died in 1573 (King Seonjo's 6th year of reign), he retired to the countryside and built this as a place for study and rest; he called this place Wonji-jeongsa. Another pavilion, the Yeonjwaru, was repaired in 1781 (King Jeongjo's 5th year of reign). Both pavilions had been renovated in 1979 and the Gate of the Spirits, the Sajumun, was thereby newly built as well.

In the foreground and located behind a stonewall, is the Jeongsa building, which rests on a fundament made from different small stones. To the left is the *maru*, the *maru* and to its right are two rooms. The front of the

maru is kept open, probably to allow for air circulation. The doors, *ttijangneolmun*, at the left side and at the rear of the *maru* have been installed for the same reason. Situated between the *maru* and the *ondol* rooms, is the door *deulmun* and a sliding door has been incorporated between two *ondol* rooms, which conveniently allows to enlarge or reduce the size of the space.

To the right of the Joengsa lies the Yeonjwaru, a two-storeyed pavilion complete with the *paljak-jibung*. The pavilion rests on round columns on its basis, which was made from many small stones. The centre of the room is carried by columns, which are located beneath the *maru* to allow for better use of the space. In order to reach those upper rooms, a staircase is located on the left side.

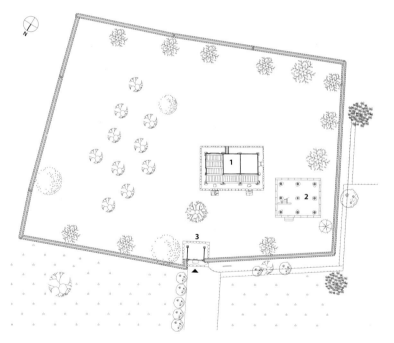

1. Jeongsa
2. Yeonjwaru
3. sajumun

Wonji-jeongsa, as seen
from Buyongdae.

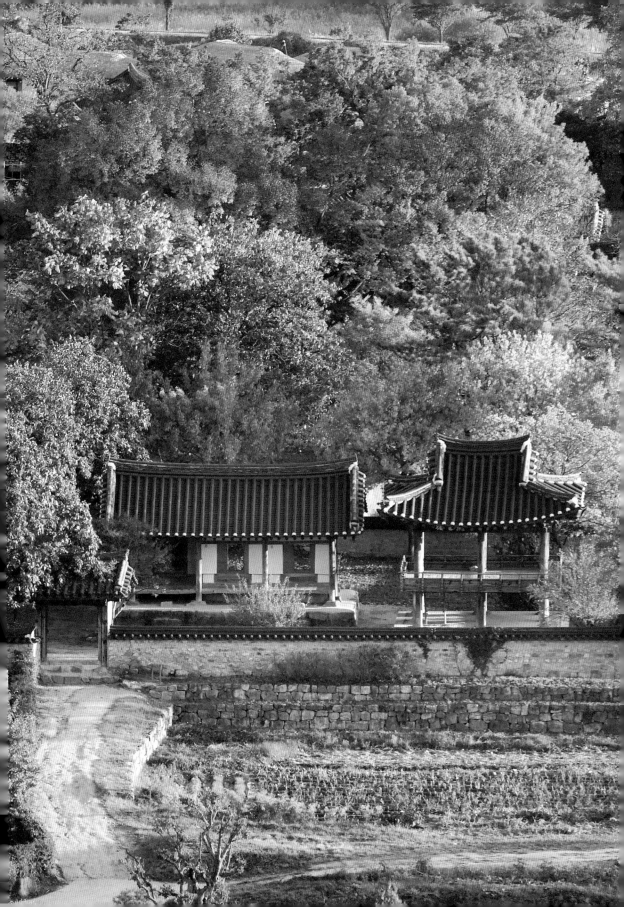

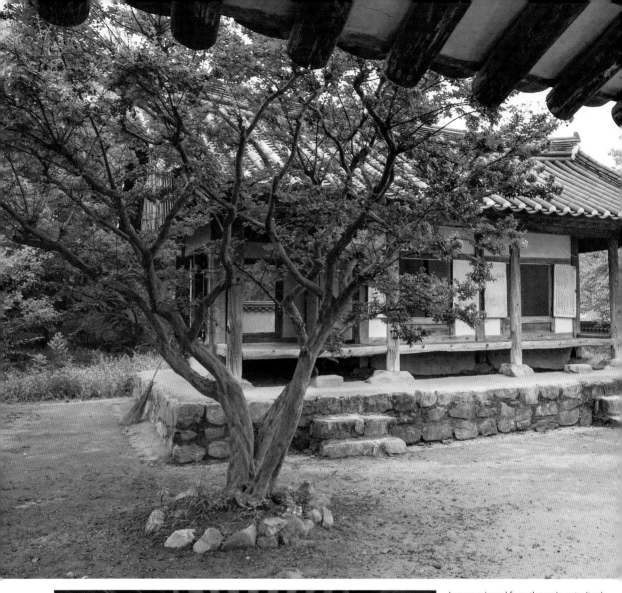

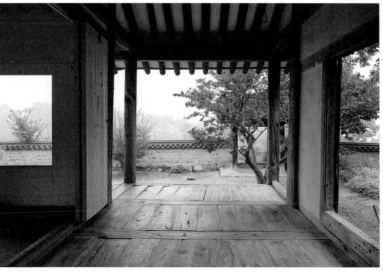

Jeongsa viewed from the main gate. (top)
Maru of Jeongsa. (bottom)

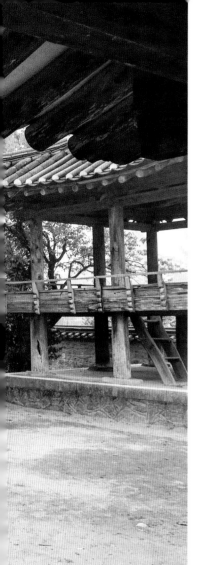

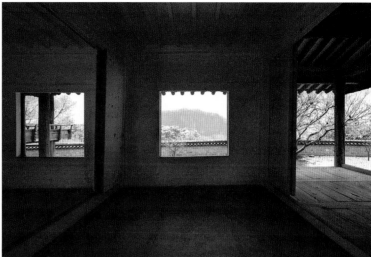

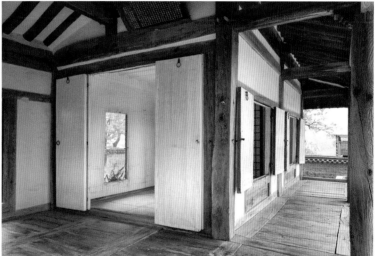

Interior view of the *ondol* room. (top)
Ondol room, viewed from *maru* of Jeongsa (bottom)

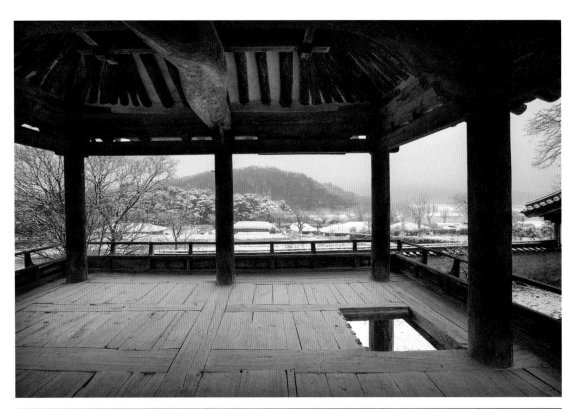

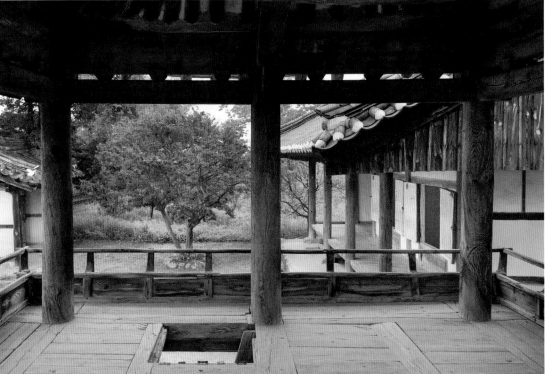

Maru of upper room of Yeonjwaru. (top)
View from the *maru* of Yeonjwaru. (bottom)

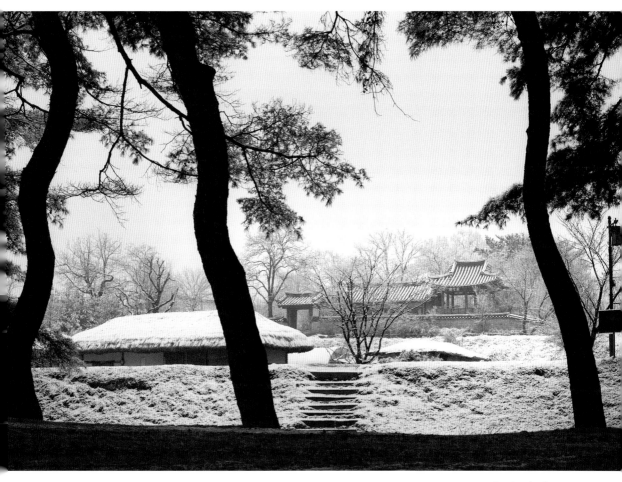
Jeongsa in winter landscape.

Ancestral Shrine of the Andong Gwon Clan in Neungdong

Built in 1653
87 Gwontaesa-gil, Seohu-myeon, Andong-si, Gyeongsangbuk-do

The private home *jaesa* had been built in honour of the progenitor Gwon Haeng of the Andong Gwon clan. Gwon Haeng was one of the three *taesa* instrumental in the founding of the Goryeo Dynasty of Wanggeon (918-1392 AD). During the ninth year in power of King Hyojong, 1653, the governor g*wanchalsa* Gwon U consulted the clan elders and comissioned the Neungdong ancestral shrine, consisting of *bang* (room), *maru* and *gotgan* (storage). During King Sukjong's ninth year in power, the governor Gwon Sigyeong added a pavilion to the construction. The ancestral shrine was completely devastated in a fire in 1743 (King Yeongjo, 19th year of reign) but was soon rebuilt. The shrine was destroyed once again by fire in 1896 (King Gojong, 33rd year of reign); however, it was fully reconstructed in the same year and has survived in this form until the present day.

The ancestral shrine *jaesa* is situated on a steep incline of a mountain and faces north-westward, thus offering an unobstructed view of the mountain valley. On the left side at the front and standing on a high stone pedestal, is the two-storeyed pavilion Chuwonru. Behind it is the *jaesa-keunchae* (main shrine). To the right

and left of the main ancestral shrine are the *dongjae* (eastern shrine) and *seojae* (western shrine), encircling the □-shaped courtyard in a slightly inclined fashion. Built on a plot slightly above the *keunchae*, we can see the —- shaped *imsacheong* where the preliminary rites are performed. An elongated courtyard lies ahead of the *imsacheong* while the *jeonsacheong* and *jusa* lie to the right of the building, forming a ∟-shape. The *jusa* is a type of kitchen used specifically to prepare food offerings used for ancestral rites. Forming an integral part of the ancestral rites, these buildings surround the courtyard and form a 日-shaped basic structure.

The *keunchae* stands on a coarsely carved stone foundation, resting on square columns and the roof structure is the highly ornate *paljak-jibung* (a hipped and gabled roof). The front side as well as the right and left sides of the ground level Chuwonru have been enclosed with thin, wooden planks; the front had been left openly accessible in order to use the space as a storeroom. With its extraordinarily large 日-shape, this *jaesa* is unique. We can only imagine what great ancestral ceremonies must have been held in this former shrine.

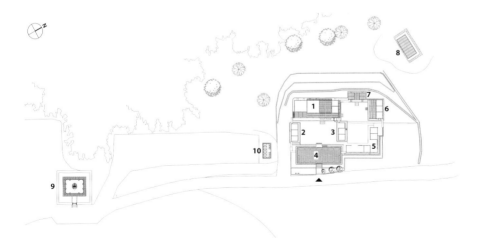

1. jaesa-keunchae
2. seojae
3. dongjae
4. Chuwonru
5. jusa
6. jeonsacheong
7. imsacheong
8. Bopangak
9. bigak
10. hwajangsil

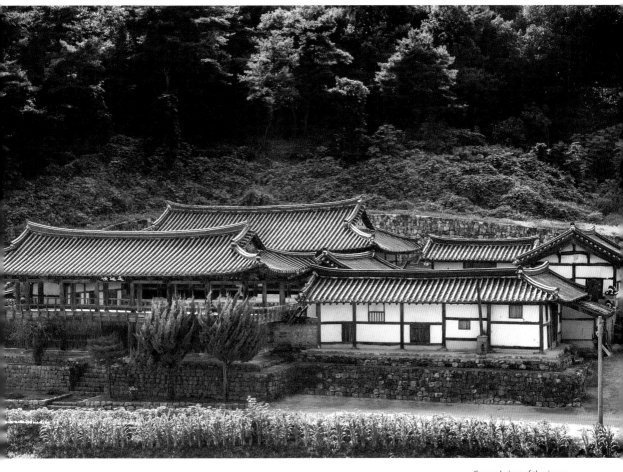

General view of the *jaesa*.

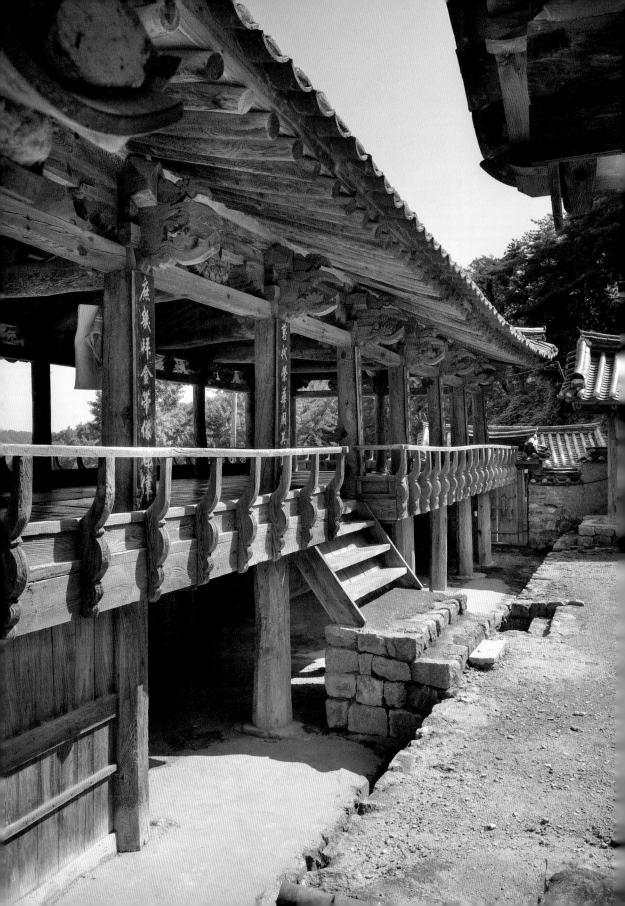

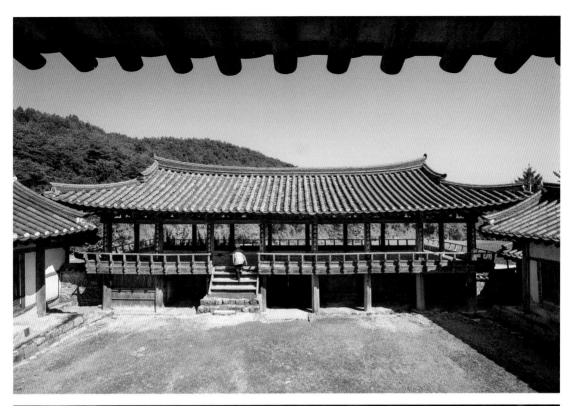

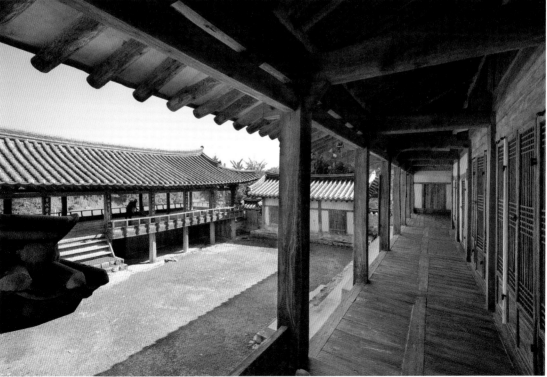

Lateral view of the Chuwonru. (p.130)
Chuwonru, viewed from the *keunchae*. (top)
View from the *dongjae* towards the *maru* of the *keunchae, seojae* and Chuwonru. (bottom)

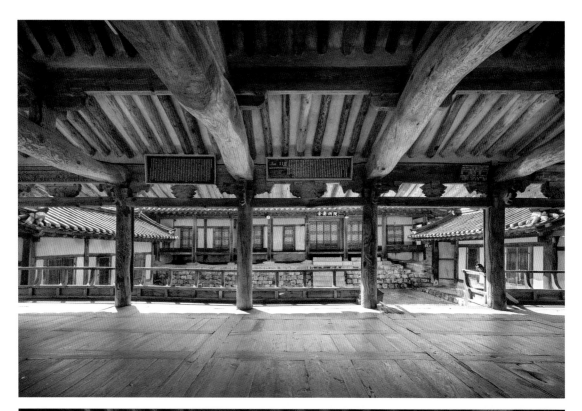

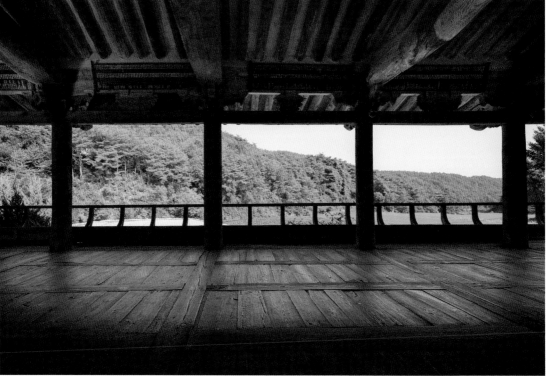

View of the *jaesa* from the Chuwonru *maru*. (top)
External view of the *jaesa*. (bottom)

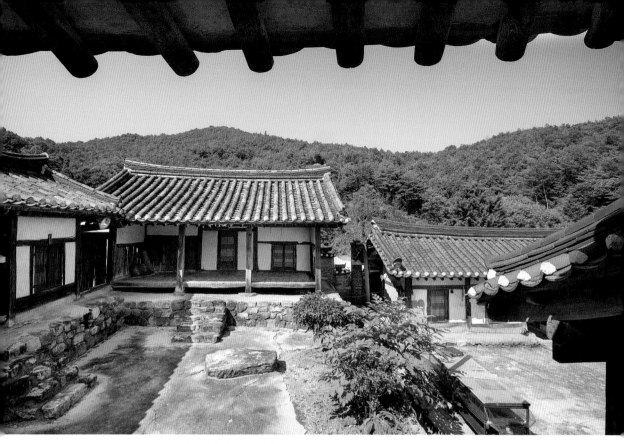

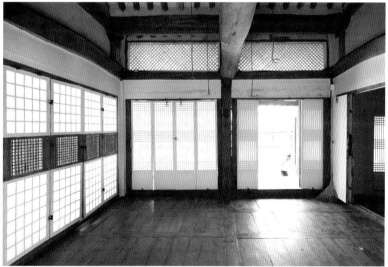

Lateral view of the *jeonsacheong*. (top)
Daecheong-maru of the *keunchae*. (bottom)

Original Family House of the Goseong Yi Tapdong Clan in Beopheung-dong

Built around 1700
103 Imcheonggak-gil, Andong-si, Gyeongsangbuk-do

The ancestral home is located on a rural property, stretching from east to west at the eastern hillslope of the Yeongnam Mountain in Beopheung-dong and facing south-east. Yi Hu-sik, who held the rank of a Jwaseungji[1] during the reign of King Sukjong first began with the building of the *anchae* (women's quarters). His grandson Yi Won-mi completed the construction of the unfinished master residence, the *sarangchae*, and added at this occasion the Yeongmodang.

One enters through the main gate *soseuldaemun* at the most south-western corner of the *daemunchae* and finds the square-shaped, large pond in the centre of the courtyard. Placed at the other side of the pond is the Yeongmodang. On the right side of the pond is the building reserved for women, *anchae*, and the building for the men, *sarangchae*.

The *sadang* (ancestral shrine) stands next to the women's quarters on a sharp incline. A wall was built around the shrine to protect the 'sacred' site. This placement of the ancestral shrine is unusual, as it is usually placed at the rear of a property to the right of the *anchae* on a raised structure. At level with the forest is a creek-side pavilion (*bukjeong*), which is located at some distance from the Yeongmodang. Outside to the right of the exterior wall towers the country's largest stone pagoda from the Unified Silla-era[2]. The Yeongmodang is an *byeoldang*, whose front side as well as left and right side are connected conveniently by a *jjok-maru* (wooden deck). The *marubang* (connecting room with hallway) has oversized 井-shaped doors, which is quite unusual; they open to the outside and first need to be pulled upright from their vertical position in the floor.

This ancestral home is built in a manner that completely cordons off the men's quarters *sarangchae* from the *byeoldang*, which together encircle the pond. On an upward slope at the rear there is another pavilion. The exterior design and the different interior elements, as well as the spaciously designed living spaces inside the property and the old door designs, suggest that the owners were quite wealthy.

1. A high-ranking official in the realm of Joseon.
2. Between 7th and 8th century B.C.

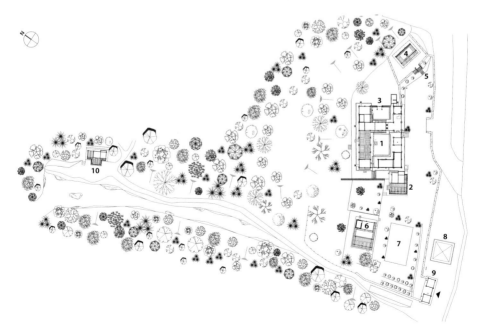

1. anchae
2. sarangchae
3. sajumun
4. sadang
5. sajumun
6. Yeongmodang
7. yeonmot
8. Chilcheung Jeontap
9. daemunchae
10. bukjeong

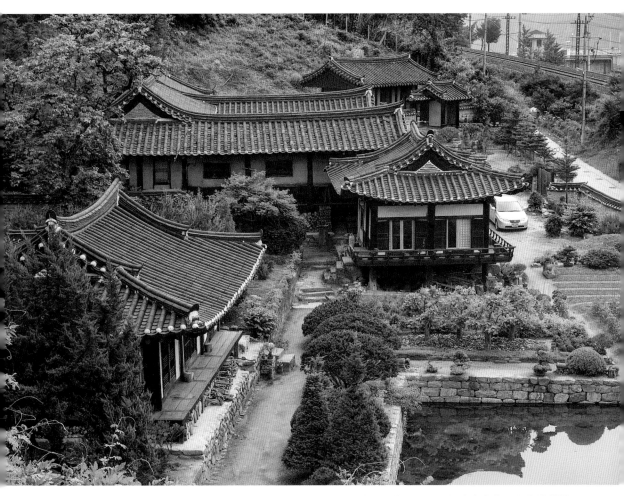

Total view of the ancestral home. (top)
Daemunchae and
Chilcheung Jeontap,
the Seven Store High Stone
Pagoda.(bottom)

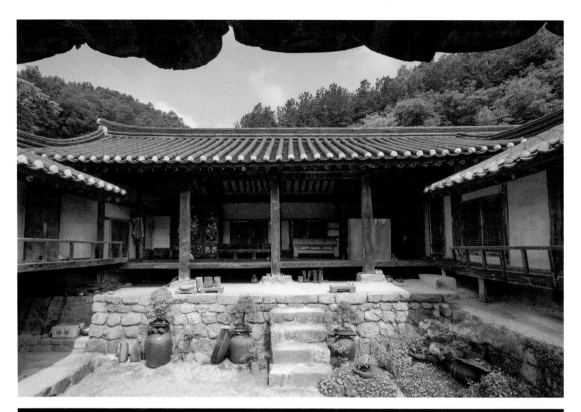

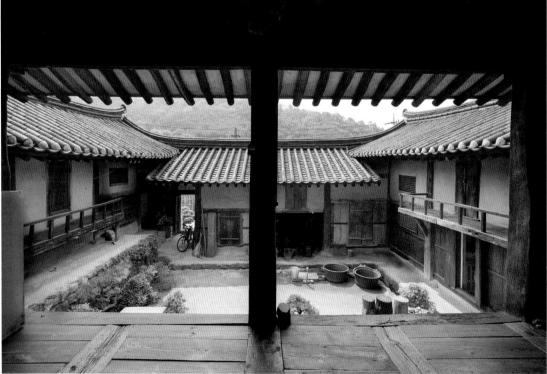

Front side of the *anchae*. (top)
View from the *andaecheong*. (bottom)

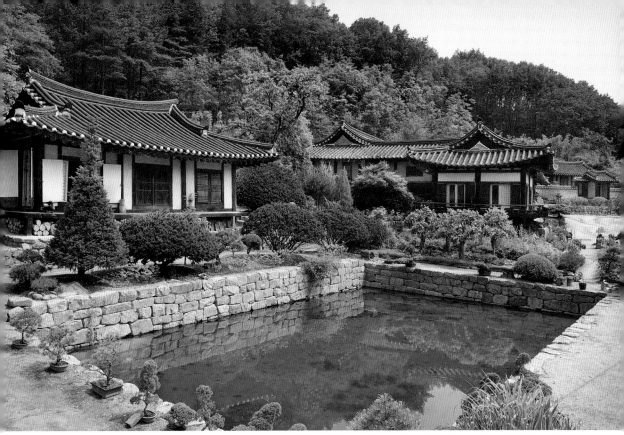

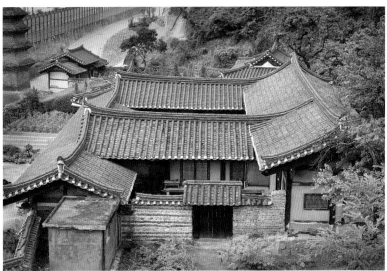

Pond and Yeongmodang. (top) Bird's eye view of property. (bottom)

Seoseokji in Yeongyang

Built in 1613
16 Seoseokji3-gil, Ibam-myeon, Yeongyang-gun, Gyeongsangbuk-do

Seoseokji means a pond made of 'the lucky stone'. In 1613 (King Gwanghaegun, 5th year of reign[1]) the pond Seoseokji and the pavilion Gyeongjeong were built, the latter of which served as a meditation space and was built by Jeon Yeon-bang. Jeon Yeong-bang had passed his state exam Gwageo in 1605. He did, however, not follow the usual career path and came back to his old home town. He had the residence constructed within the property as well as the pavilion, and the pond Seoseokji.

Located on the southern hillside of the Jayang Mountain, the pond Seoseokji is designed in two parts, one inside the wall which comprises of the *naewon* (living area) and one area outside the wall where the *yeonji* (pond), the Gyeongjeong (main residence) and the Juiljae (library) are located.

One enters the four-sided Sagakmun (gate), which stands to the left, and walks around the pond to find the living quarters Gyeongjeong facing south-east. One can also see the pond from there. To the right of the Gyeongjeong is the Juiljae. Hanging on the walls of the Juiljae *maru* are plates with engraved poetry by scholars. Behind the Gyeongjeong there is a *sujiksa*, a janitor's house. An earth-layered wall defines and separates the interior from the exterior areas.

The Seojseokji pond is a representative garden monument and had originally emerged from private houses of the Joseon Dynasty. It is fairly small yet the planned landscape around the pond, which is meant to represent paradise, is very beautiful. The pond was not dug out from a plane surface, but its forms come from a multitude of little rocks and boulders, a typical design for Korean gardens.

1. The King who was deposed because of his tyranny on the people ruled from 1608 to 1632.

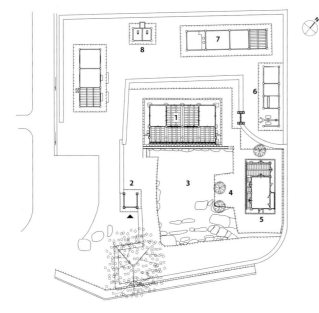

1. Gyeongjeong
2. sagakmun
3. yeonji
4. Saudan
5. Juiljae
6. gwallisa
7. sujiksa
8. hwajangsil

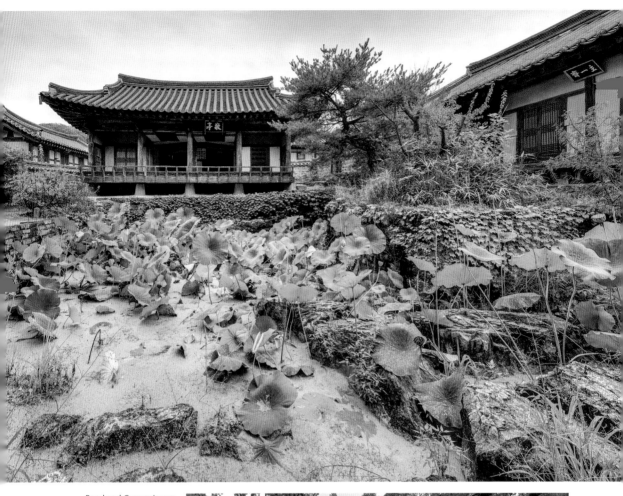

Pond and Gyeongjeong.
(top)
Sagakmun and earth-layered
wall. (bottom)

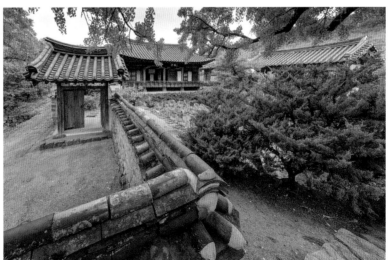

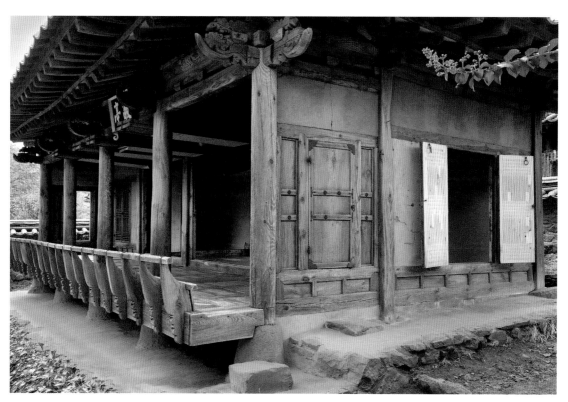

Side view of the Gyeongjeong from the Sagakmun. (p.140)
View of the Gyeongjeong from the library Juiljae. (top)
Partial view of the upper part of Gyeongjeong. (bottom)

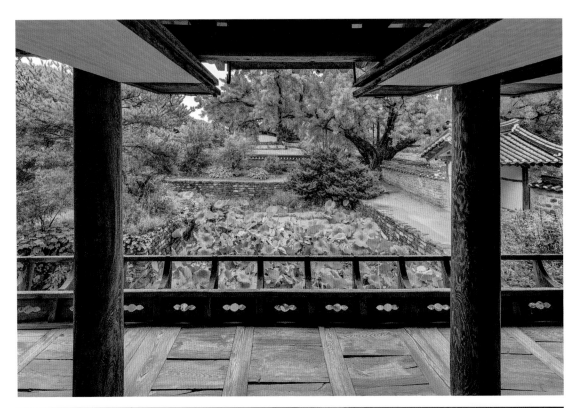

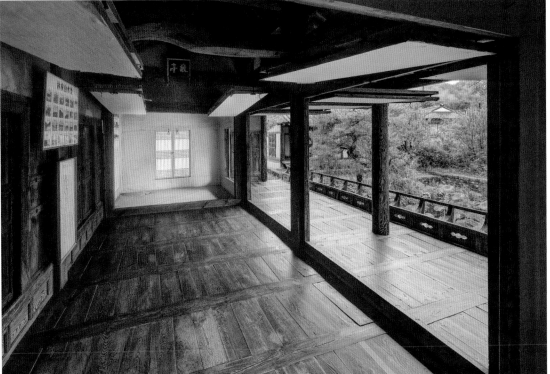

View of the garden from the Gyeongjeong. (top) Interior of the Gyeongjeong. (bottom)

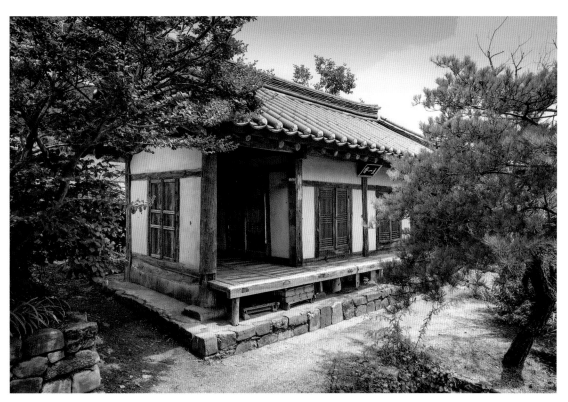

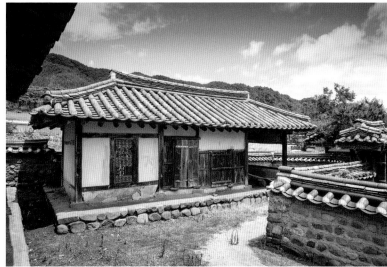

View of Juiljae from the Gyeongjeong. (top) *Gwalisa*, small guardhouse. (bottom)

Chunghyodang in Yeongdeok

Built during the 15th century
48 Inryang6-gil, Changsu-myeon, Yeongdeok-gun, Gyeongsangbuk-do

The Chunghyodang was commissioned in the middle of the 15th century by the patriarch of the Jaeryeong Yi clan, Yi Ae. In 1576, his direct descendent Yi Ham built the parent home, which is located on a hill behind the original house. Even today, the residence fulfils its function as an educational establishment.

The village of Inryang, in which the Chunghyodang is located, was home to a number of scholars, including Yi Hyeon-il, who had been born there during the reign of King Sukjong. The southern foothills of the Deungun Mountain form a natural, protective wall at the end of the village. The river Songcheon meanders through the meadows to the south of the village, flowing from east to west mirroring the layout of this residence. This valley resembles the shape of a bird with extended wings and has thus been named accordingly, Naraegol or 'winged valley'.

The residence had been erected on a slightly raised plot and faces southward. On the right hand side stand the ㄱ-shaped *anchae* (women's quarters). They are situated opposite to the ㄴ-shaped middle building with its *jungmunchae* (entrance gate to the living area). The *sarangchae* (men's quarters), features a plaque giving the house name as Chunghyodang. The *sarangchae* had been built after Imjinwaeran, the Japanese invasion (1592-1598) and had been designed in the style of a pavilion. Located on a steep incline between the Chunghyodang and the *anchae* is the ancestral shrine, the *sadang*, surrounded by a wall; to the right of the shrine is a bamboo grove.

According to its size and architectural design, this residence must be considered as the most dignified of all parent homes. The layout of the *anchae, sarangchae* and the *sadang* show the distinct building distribution of an aristocratic home from the Joseon period. The residence is furthermore designed in the typical regional �口-shape, which separates the men's quarters from the other buildings.

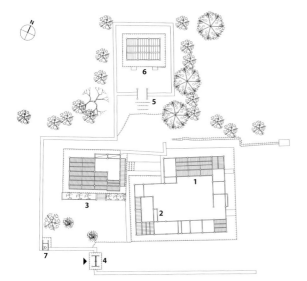

1. anchae
2. jungmunganchae
3. Chunghyodang
4. sajumun
5. sajumun
6. sadang
7. hwajangsil

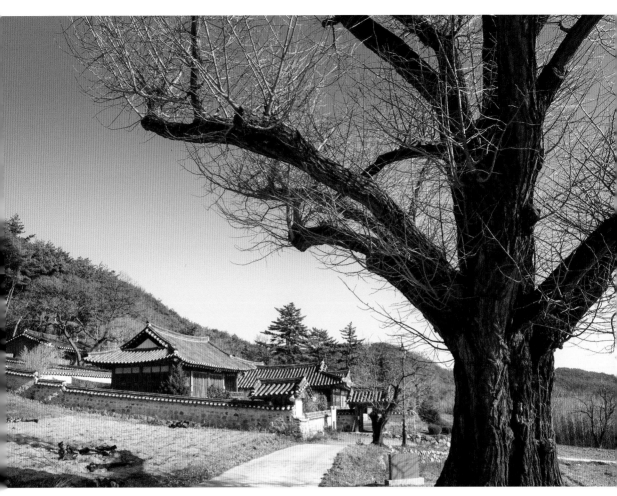

General view of the
Chunghyodang. (top)
View of the
jungmunganchae. (bottom)

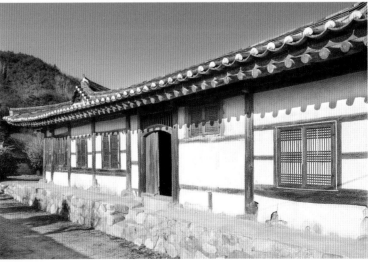

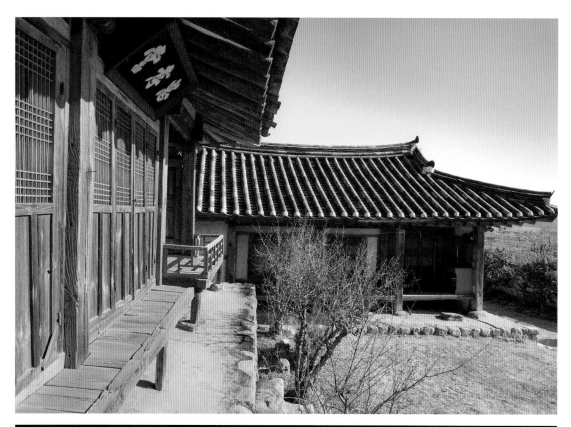

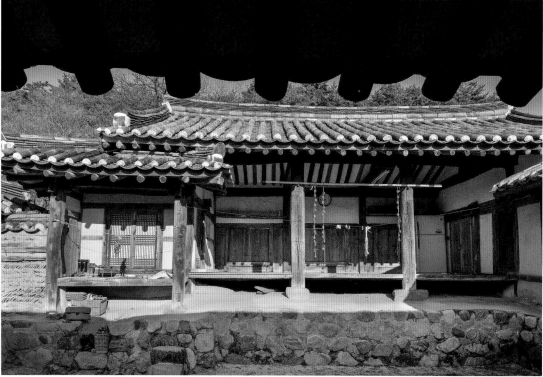

Chunghyodang with its *toenmaru* and the laterally positioned *jungmunganchae*. (top) View of the *anchae*. (bottom)

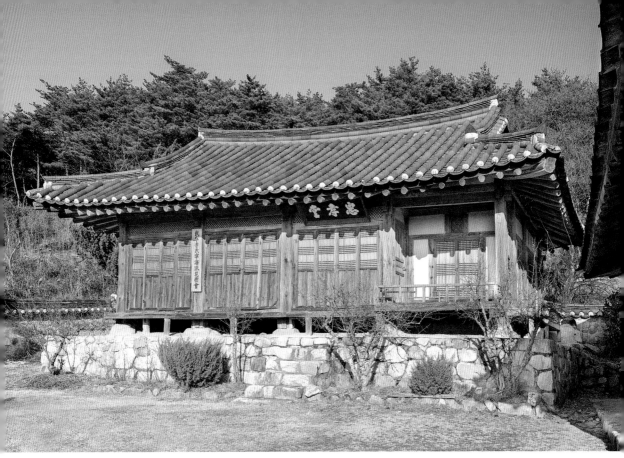

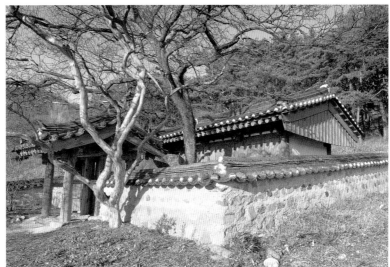

View of the Chunghyodang. (top) *Sadang*, the ancestral shrine. (bottom)

Segyeop Kkachi-gumeong-jip in Seolmae-ri, Bonghwa

Built around 1840
50-12 Seolmae2-gil, Sangun-myeon, Bonghwa-gun, Gyeongsangbuk-do

This *segyeop kkachi-jip*[1] faces south-west and lies in a valley at the front of the lower mountain range of the Oknyeobong peak at the northern edge of the village. The year of construction is unclear but oral sources, passed down through the generations, state the construction date as 1840. The house was originally covered with straw but around the early 1970s, the straw roof was replaced with concrete roof tiles. These, however, were removed in 1996, when the roof was replaced by straw again and the house was returned to its original condition.

The house is a *kkachi-gumeong-jip* with three magpie holes and three folds at the front and the back of the house. The courtyard is located in front of the house and there are no surrounding walls. Located at this property were until the early 1980's at the west side of the courtyard the *dueom* (straw silos used for fertiliser) and the *cheukgan* (toilet), and at the front the straw-thatched *gobang* (little storage cabin).

When entering through the entrance gate, which is in the middle part of the front façade, one walks across the *bongdang*[2], a soil floor. On the inside, the cow pen is situated on the left side and the kitchen on the right. Behind the *bongdang* one enters the *maru* (wooden-floored room). From there to the left are the *sarangbang* (men's quarters) and the *saetbang* (small extra rooms in the front and in the back) and to the right lies the *anbang* (women's quarters).

The relatively large cow pen was located on the left side. Also, in the upper part of it is a *darak*, which serves to store agricultural tools. The kitchen has attached to it a small belfry-like *toetgan* (little storage house) towards the front of the building, where the eating utensils and food leftovers were kept. A door leads outside on the right side of the kitchen.

This house is one of the few remaining examples of a *segyeop kkachi-gumeong-jip*, showing us the duplex building-like extension towards at the back.

1. The name of this house means 'threefold' magpie hole, which relates tot he openings in the roof. They allow for ventilation of the inner rooms. Birds would fly inside the house through them every now and then.
2. The stomped-down soil has the same function as the *daecheong-maru* between the *anbang* and the exterior deck. (See last image.)

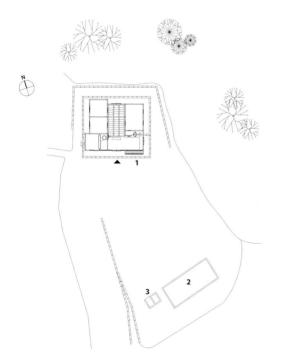

1. kkachigumeong-jip
2. chuksa
3. hwajangsil

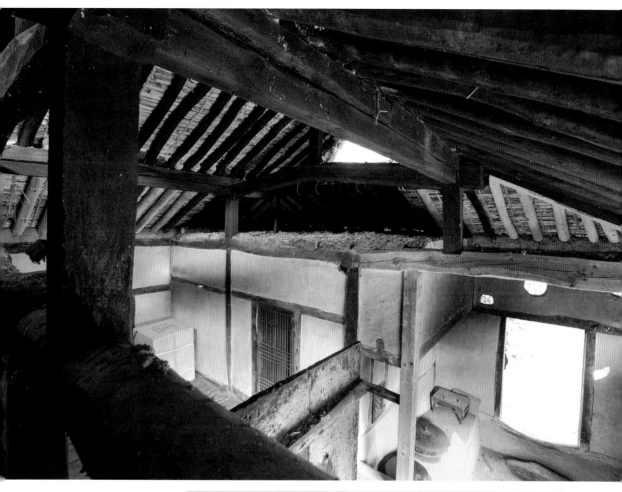

Interior view with rooftop. (top)
Comprehensive view of the property as seen from the rear. (bottom)

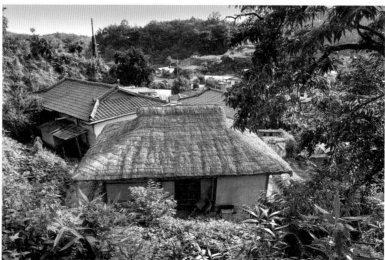

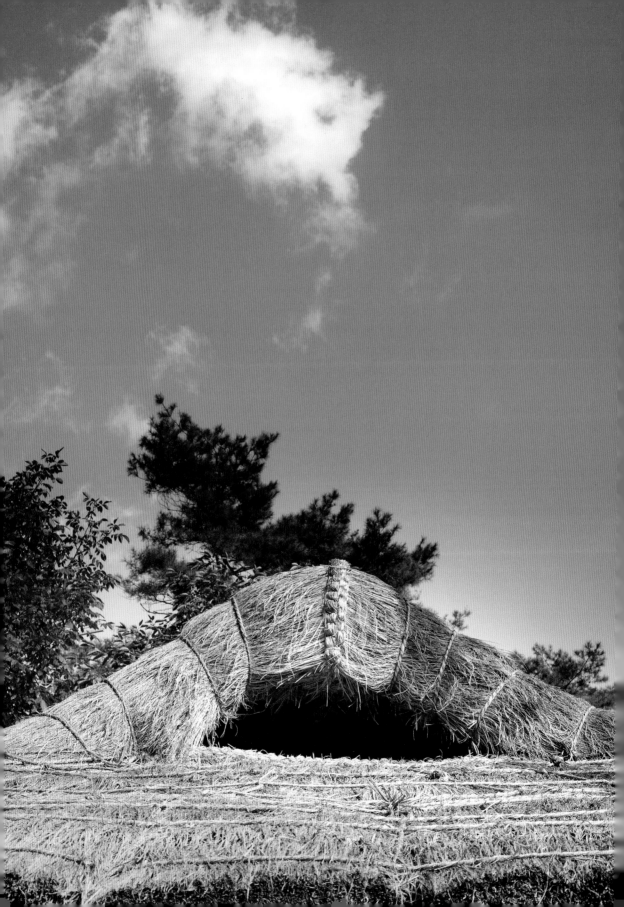

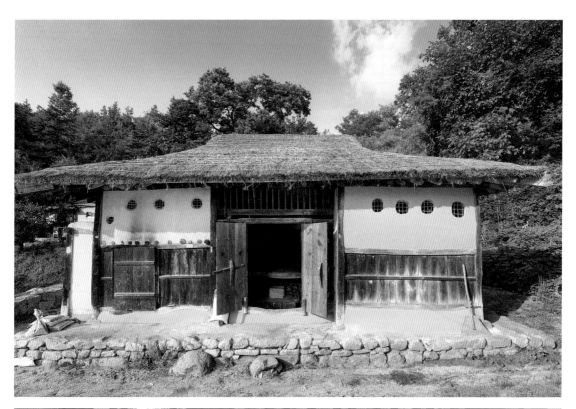

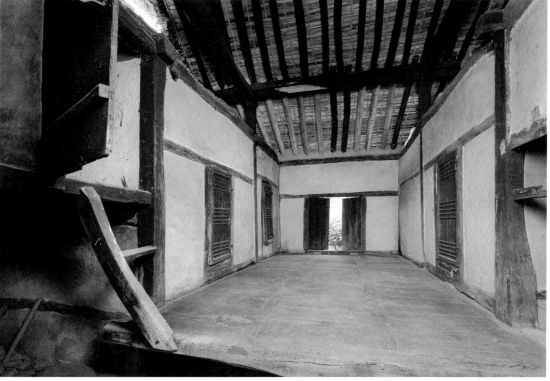

Magpie hole on the roof. (p.150)
Front of the house. (top) Inner view of *maru*. (bottom)

Original Family House of the Yecheon Gwon Chogan Clan

Built in 1589
43 Jukrim-gil, Yongmun-myeon, Yecheon-gun, Gyeongsangbuk-do

This house was owned by Gwon O-sang, who built this *yangban* family house in 1589 (King Seonjo's 2nd year of reign) and who was the grandfather of Chogan[1] Gwon Mun-hae, a scholar from the middle of the Joseon Dynasty period. This house is of great historical value, because it is a rare house built before the Imjinwaeran, the Japanese invasion between 1592-1598. Because of this, the house is said to be in its current state a prime object for the scientific study of early architectural styles. The house is surrounded by a mountain in the shape of a crescent moon which borders to the left and to the right to Baegma Mountain and Ami Mountain.

The whole property stands on a slightly sloped plane with a low mountain in the back and faces east. The *sarangchae* (men's quarters), which is constructed as *byeoldang* (separate house), protrudes to the front. To the left in the back are the □-shaped *momchae* (main building), connected to the *byeoldang*. Next to the *daemunganchae* and the *sarangchae*, a *busokchae* (added complex) was originally located on the left, which has been demolished. The *daemunchae* that originally stood in front of the *byeoldangchae* with the function of a *haengnangchae* (house for service staff) does not exist anymore today. It burned to the ground during the Imjinwaeran.

The ancestral shrine *sadang* stands – protected by a wall – behind the *byeoldang* in a square-shaped separate area. To the south of the *byeoldang* stands the Baekseunggak, a little cabin with inscriptions, where the *pangak*, a memorial inscription, rests.

One very important special detail that can be seen in this house is the *yeongssang-chang* (door) on the back of the wall of the *andaecheong* (main wooden-floored hall for reception of guests in the women's quarters). This *yeongssang-chang* was built by placing a *jungganseolju*, a slender wooden beam, between the door frame and window sill, so that additional doors could be created.

Similar features can be seen in the lattice window of the *darak* and the cross-section of the *jungganseolju* of the *sadang*, which is T-shaped and can be pushed up and taken off.

Doors with *jungganseolju* was a design mainly used in the early to middle Joseon Dynasty architecture. This is thus a valuable material for architectural studies looking into the history and development of Korean doors and windows.

1. Chogan is the additional name or artistic pseudnonym of Kwon Mun-hae.

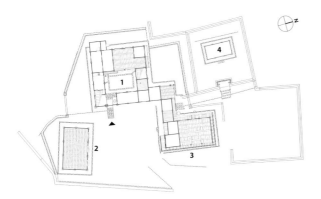

1. anchae
2. Baekseunggak
3. byeoldang
4. sadang

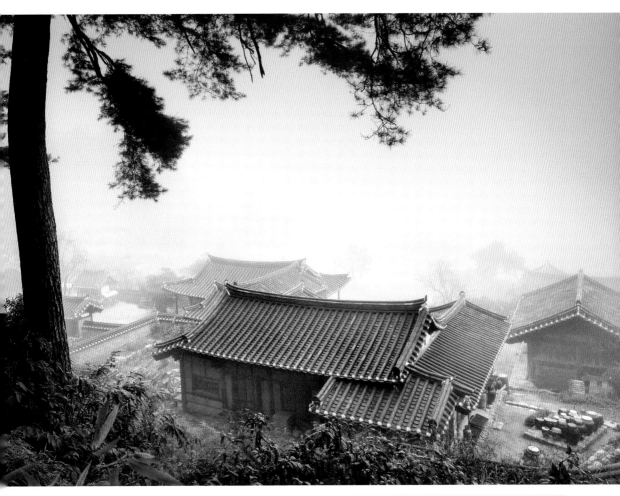

Rear view. (top)
Lateral view. (bottom)

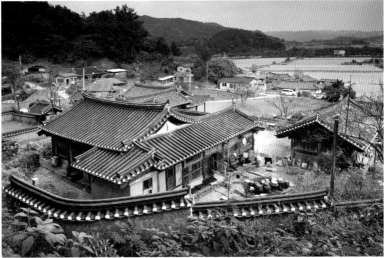

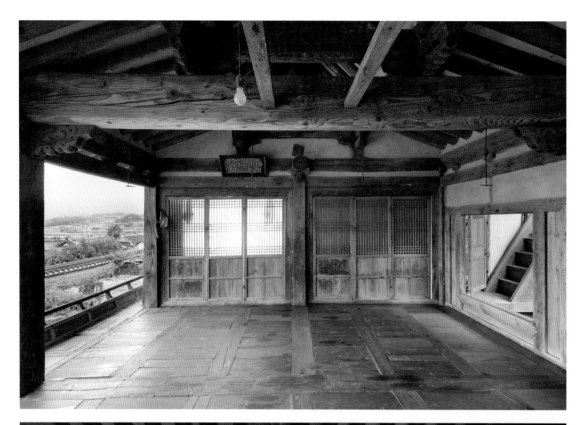

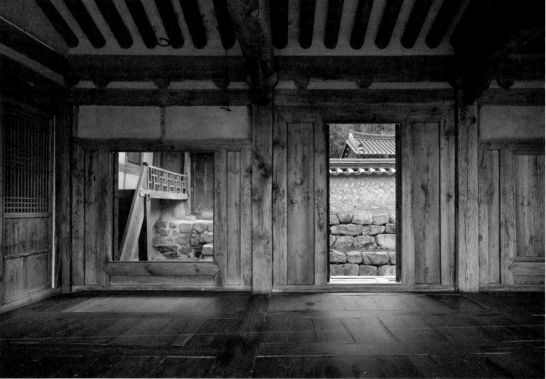

Interior view of the *byeoldang-daecheong*. (top) View from the door to the *ansarangchae*. (bottom)

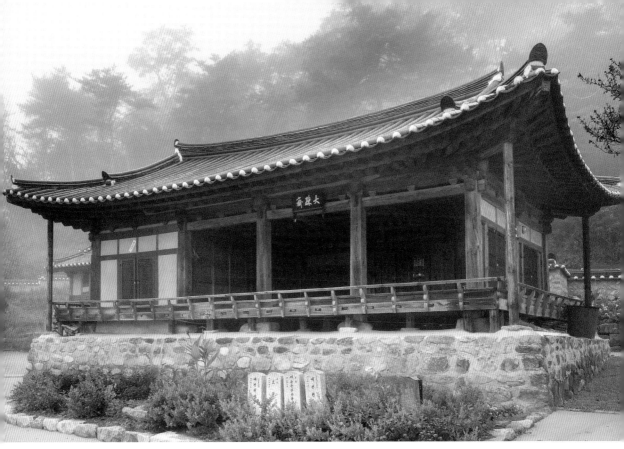

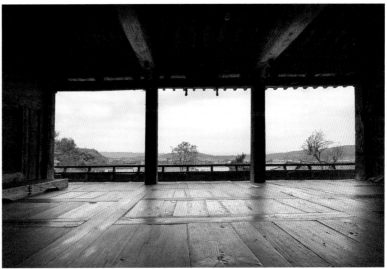

View of the *byeoldang*. (top) View of the landscape from the *byeoldang-daecheong*. (bottom)

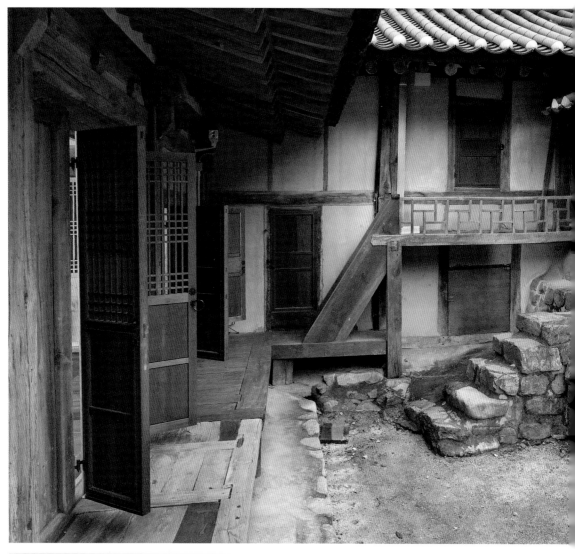

Hyeopmun (gate to the side) and corridor connecting *byeoldang* to *ansarangchae*. (top)
Door leading from *andaemun* to *anchae*. (bottom)

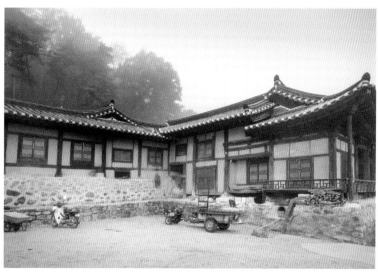
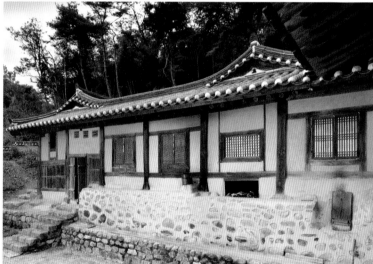

Lateral view of the *byeoldang*. (top) *Andaemun* and *ansarangchae*. (bottom)

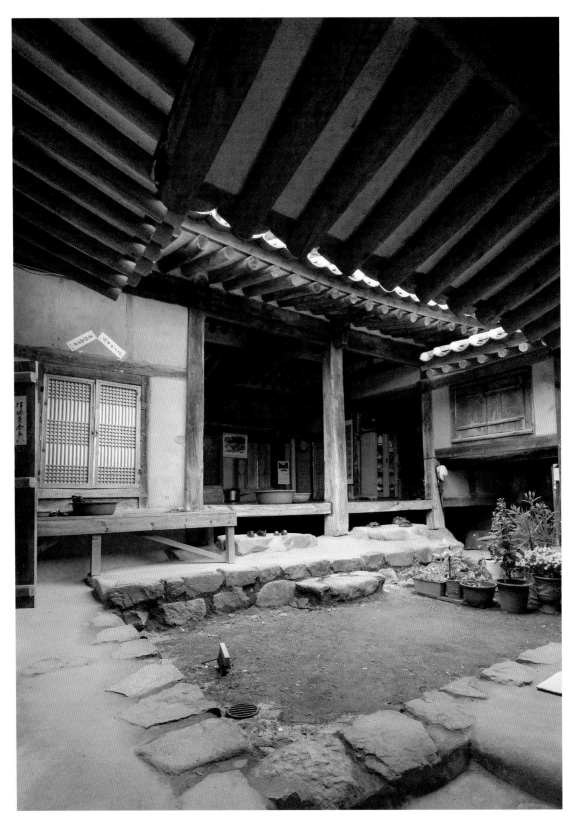

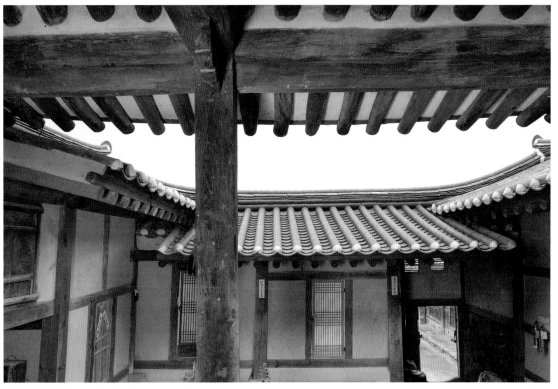

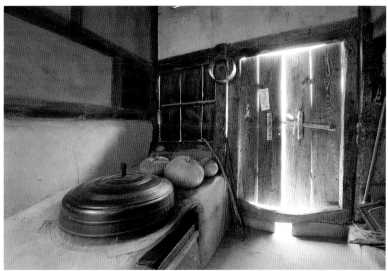

View of the *anchae*. (p.158)
View from the *anchae-daecheong*. (bottom) Kitchen of *andaemungan*. (bottom)

Soudang in Uiseong

Built at the beginning of the 19th century
65 Sanun-gil, Geumseong-myeon, Uiseong-gun, Gyeongsangbuk-do

The Sanun-maeul (Sanun village), where the ancestral Soudang home is located, lies amidst a hilly landscape on the planes of the Changideul between the northern cliffs of Geumseong Mountain and the surrounding flat planes. The village became the residence of the Yeongcheon Yi clan, after the first clan leader had come back to his hometown during the reign of King Myeongjong (1534-1567) and had built the first house of the estate. Sou Yi Ga-bal is said to have built the *sarangchae* (men's quarters) on the Soudang property in the early 19th century. The *anchae* (women's quarters) is said to have been remodelled in the 1880's.

The Soudang was divided into two sections: one became the *salimchae* (where most of the social life took place), and the other turned into the *byeoldang* (separate house) and the *ansarangchae* (additional men's building).

The plans of the property show that the *momchae* (main building) with its �口-shaped design faces south. To the south of the *momchae* stands the ㅡ-shaped *daemunchae* (gate house) and to the west of the *momchae* (main building) the *byeoldang* area is located.

The ㅡ-shaped *daemunchae* is located to the south of the property as are the *gwang* (storage space),

daemungan, munganbang and *gobang* connected with each other from east to west. The entrance gate was built according to the design of a *soseuldaemun*. The ㄴ-shaped *sarangchae* stands to the left of the *jungmungan; sarangchae* and *sarangmun* are facing south, as well as the ㄱ-shaped *anchae* along with *bueok* (kitchen), *anbang* and *daecheong*.

Around the courtyard of the *anmadang* (courtyard) of this property are mainly located the *anchae*, the *sarangchae* and the *daemunchae*. One enters the *anchae*, which sits at the eastern end of the *sarangchae* through the *jungmun* (middle gate). All of these parts of the building are more or less standing on the same level. This is a typical feature of segmentation during the architectural period of the late Joseon Dynasty according to the designs of an aristocrat mansion. Around the main living area of the *anchae* and *sarangchae* on the western side was a great and broad terrain, fortified through an earthen wall, which secured the *byeolseo* area. In the middle of the garden are the *ansarangchae* or a building called *byeoldang;* to their south are the pond and the forest, which are connected by a man-made walkway.

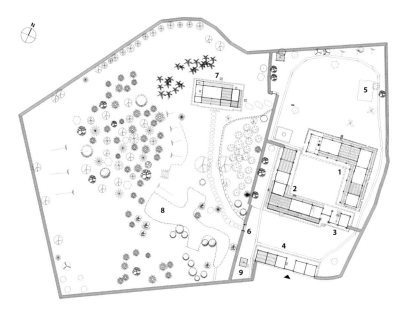

1. anchae
2. sarangchae
3. jungmunganchae
4. daemunchae
5. jangdokdae
6. hyeopmun
7. ansarangchae
8. yeonmot
9. hwajangsil

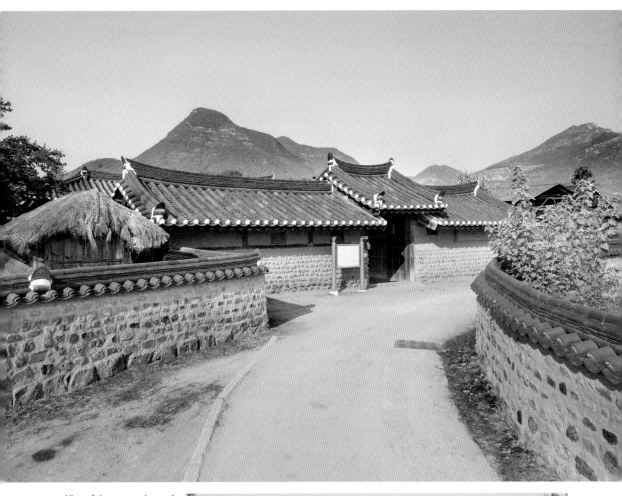

View of *daemunganchae* and
soseuldaemun. (top)
Complete view, as seen across the
wall. (bottom)

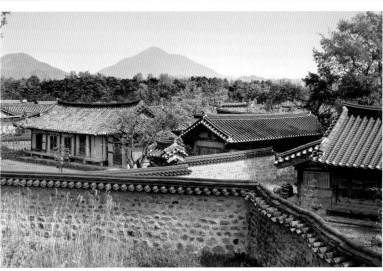

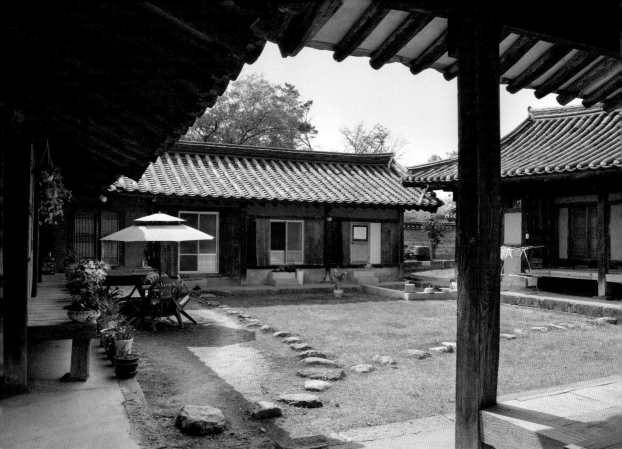

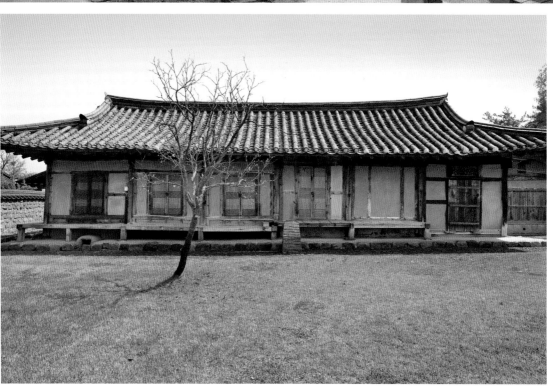

Anmadang and *sarangchae*, viewed from *jungmungan*. (top) View of rear of *anchae*. (bottom)

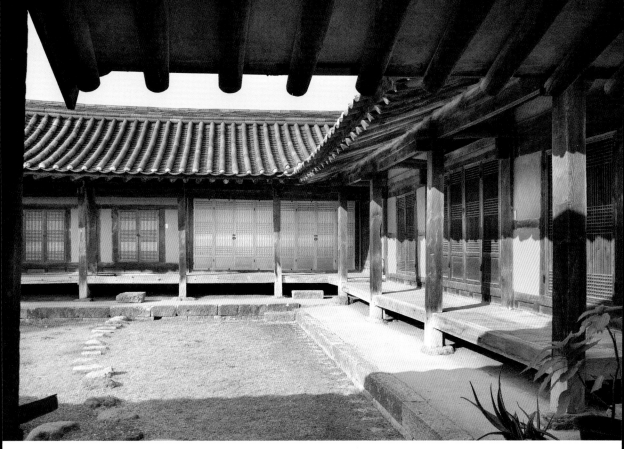

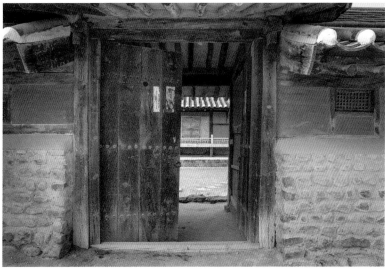

Anchae, viewed from *jungmungan*. (top) View of the *daemun*. (bottom)

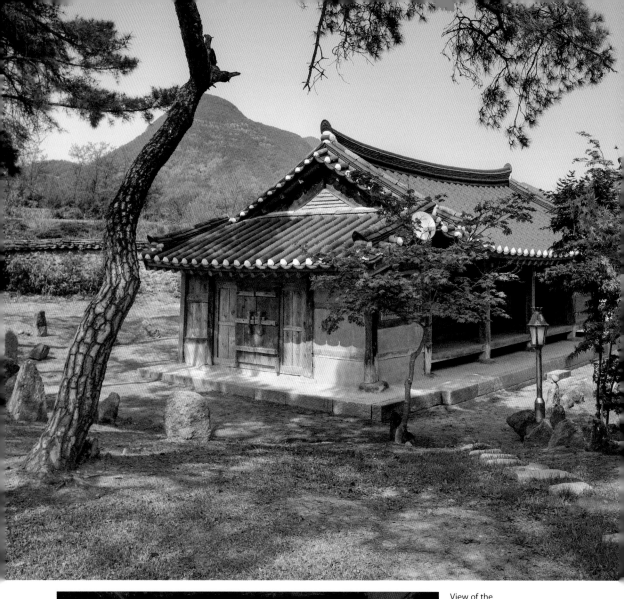

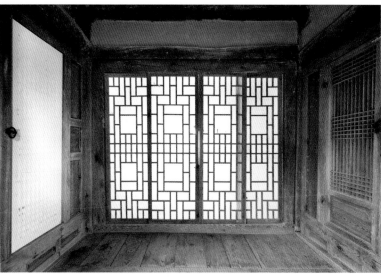

View of the
ansarangchae. (top)
Interior view of the
ansarangchae-daecheong.
(bottom)

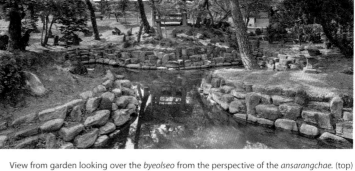

View from garden looking over the *byeolseo* from the perspective of the *ansarangchae*. (top)
Pond of *byeolseo*. (bottom)

Tumak-jip in Nari-dong, Ulleung Island

Built around 1945
71-316 Nari-gil, Buk-myeon, Ulleung-gun, Gyeongsangbuk-do

This *tumak-jip*[1] is situated in a slight swale of the surroundings and faces towards the south-west. On the right side of the estate is a small separate toilet house.

The supporting structure of the outer walls consists of wooden logs, similar to a blockhouse. Perimeter walls comprising of so-called *udegi* (reed material) are positioned as non-loadbearing walls on all four sides fixed on a timber framework. These are constructed in such a way, that the rush mats can be rolled up as required. According to the building concept, the site plan features the *jeongji* (kitchen) in the centre, the *keunbang* (main living room) and the *meoritbang* (small living room) were placed to its right. Next to it, to the left was the cowshed. The kitchen is slightly lower than the base level of the house. On this lower level, the hearth was installed, from which hot steam is channeled through pipes under the floor serving as underfloor heating. The construction of the outer and inner room walls – consisting of 10 horizontally layered wooden logs, interlocked at the corners – rests on large natural stones on all four sides. Clay and moss covering the gaps between these logs were applied as a finish to the wall. The house's entrance door was cut from the wooden walls in full size. Both reveals are fitted with frames suitable for the assembly of a simple, wooden door leaf for a door constructed from wooden planks.

Thin supporting rods are integrated into the outer walls around the entire building below the eave; only the entrance area was left open. The *udegi* walls are interconnected with thin wooden poles. On the *udegi* walls, several *geojeokmun* (straw mats hung as doors) were installed. The bundles of reed were tied tight onto the thatched roof with strong ropes, made from long stems of kudzu or Siberian Goosberry, to prevent the wind from tearing it open. Single areas of the roof can also be rolled up as required.

This *tumak-jip* on Ulleung Island was built exclusively from local materials and is still preserved until today. It shows a simple way of housing which was adapted to enable people to overcome the challenges of Ulleung Island's unique natural environment. This *tumak-jip* is of very high cultural and historical value for the region.

1. A *tumak-jip* is a house built with wooden logs, clay and rush mats.

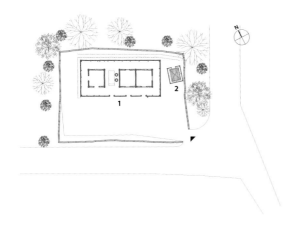

1. bonchae
2. cheukgan

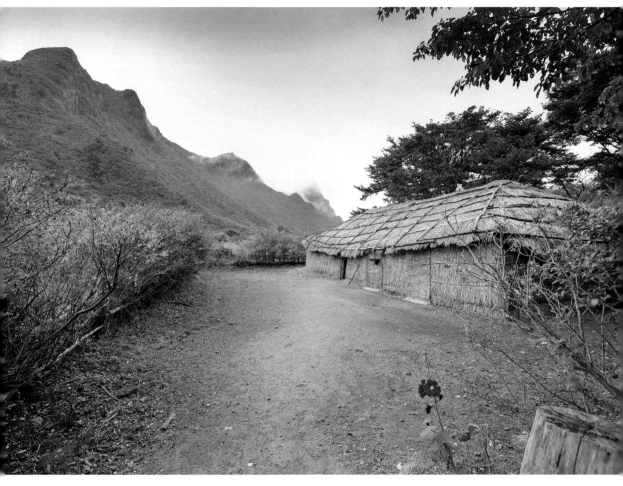

Complete view.

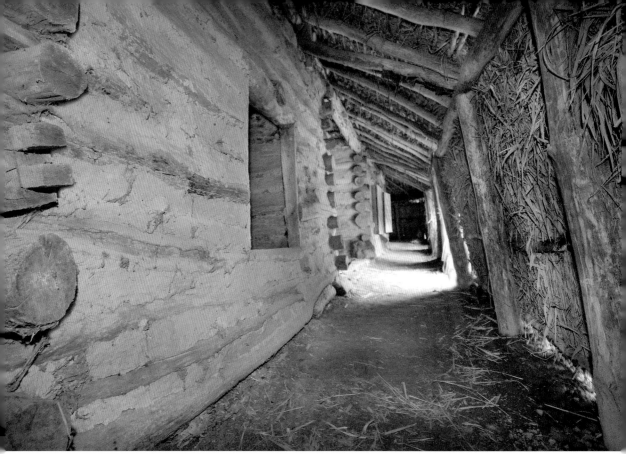

Corridor inside the building. (top) Interior view of the *ondolbang*. (bottom)

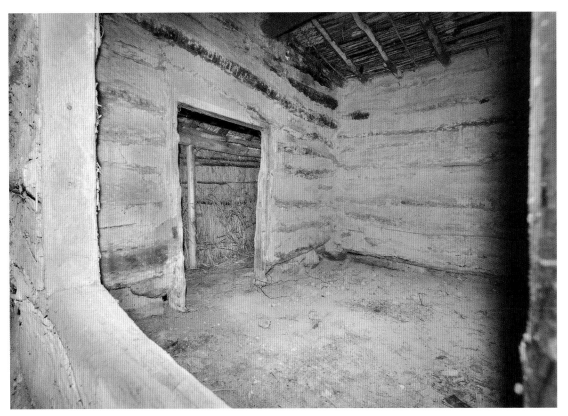

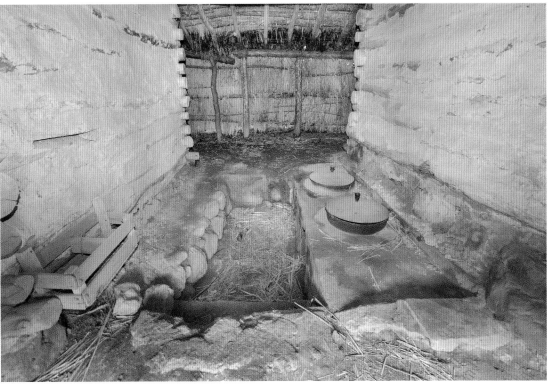

View onto the stable. (top) Interior view of the kitchen. (bottom)

Residence of Jeongon Seonsaeng

Remodeled around 1820
13 Gandong1-gil, Wicheon-myeon, Geochang-gun, Gyeongsangnam-do

Jeongon was a high-ranking civil servant around the middle of the Joseon Dynasty. He was also known under the pseudonym of Donggye and the name Mungan, which was given to him posthumously. During the Byeongjahoran[1] he had argued for rejection of peace negotiations, but when the decision to proceed with the negotiations was made, he resigned from civil service and retired at Deokyu Mountain, where he lived until his death.

In 1820 (King Sunjo's 20th year of reign), Jeongon's descendants remodeled his birth house to the appearance still preserved to this day. The mountain range flowing from the Deokyu mountains passes the Jodu mountain and concludes at Sirubong, where the house is located, overlooking a wide plane.

The estate is partitioned into three parts, the *sarang* section with its *sarangchae* (men's quarters) and *jungmun* (middle gate); the second section that includes the *anchae* (women's quarters) and additional buildings, and the third section comprising the *sadang* (ancestors' shrine), which is separated by walls. This building concept is a regular building design of the Gyeongsangnam-do region. At the front side of the estate are the *soseuldaemunchae* (entrance door), the *sarangchae* and the *anchae* next to each other, creating a three-row parallel arrangement. Entrance to the estate is possible from both, southern and northern side, with the buildings arranged accordingly.

These buildings are rich with regard to their size, the building materials and quality; due to these features, the entire estate gives a feeling of strength and robustness and is regarded as magnificent. The floor plans of the *sarangchae* and *anchae* feature additional sliding door elements to build two rows of rooms, shielding them from the cold. This is an unusual feature for this region as the village of Geochang, in which the estate is situated, is located in the warmer regions in the south of Korea. The house, however, features a building style of the north, where the winter cold is more severe. The construction work shows modern techniques with regard to the use of building timber and the interior design. Especially the underside of the roof, the so-called *nunsseob-jibung* of the *sarangchae* are a rare sight; it is assumed that the house has been restored significantly during the Japanese occupation.

1. 1636-1637 saw 2 invasions by the Manchu. When leader Abahai rose to the Quing Dynasty, he invaded the territory of the Joseon Dynasty. After its capitulation in 1637 Joseon had to accept the Quing Dynasty's supremacy.

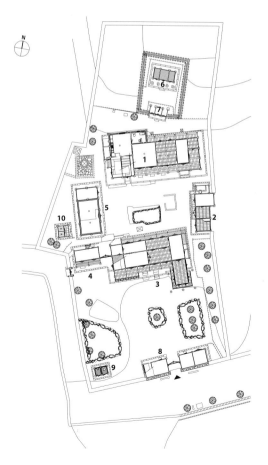

1. anchae
2. jageun-sarangchae
3. jungmun
4. keun-sarangchae
5. daemungan
6. hyeopmun
7. hwajangsil
8. heotganchae

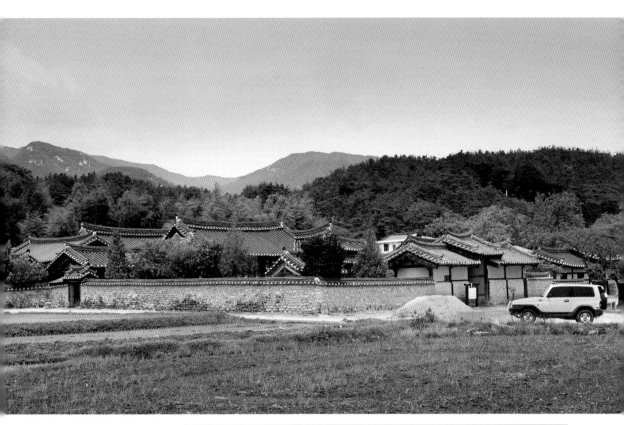

View over the
estate from afar. (top)
View of the *sarangchae* from the
front door. (bottom)

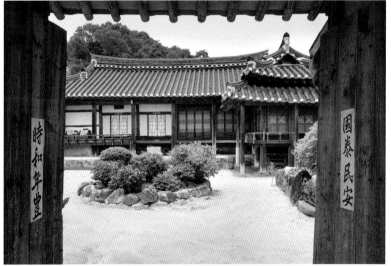

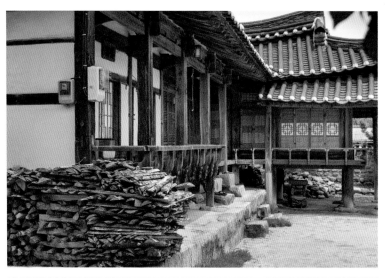

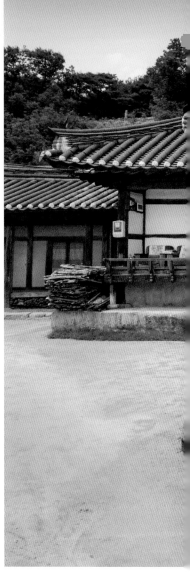

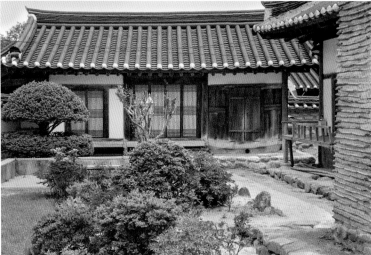

Side view of the *sarangchae*. (top) View of the *tteul-araechae*. (bottom)

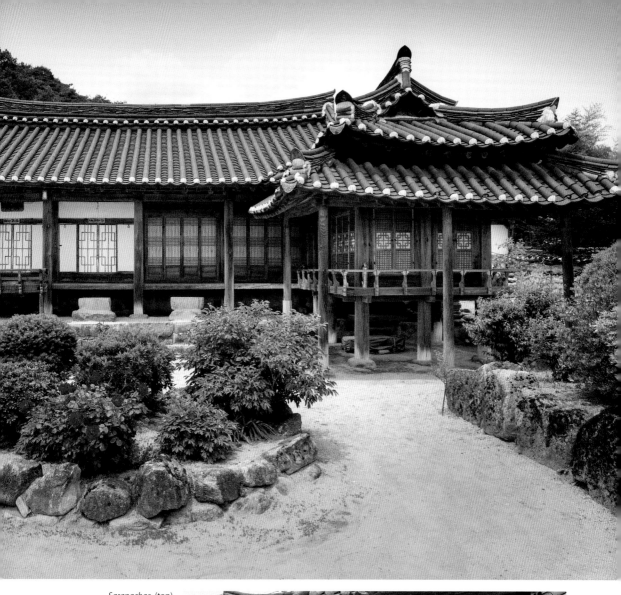

Sarangchae. (top)
Entry door of the
daemunganchae. (bottom)

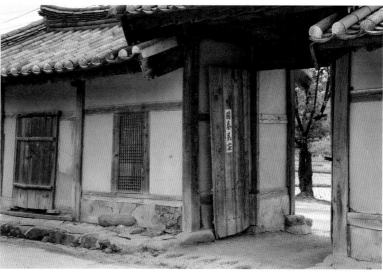

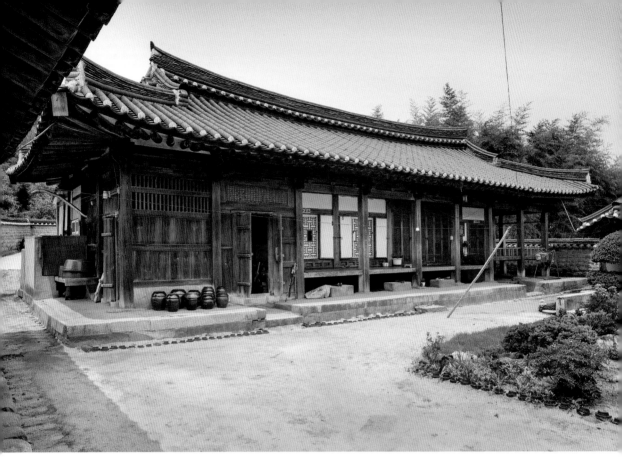

View of the *anchae*. (top)
Daemun. (bottom, left) Detailed image of the *sarangchae*. (bottom, right)

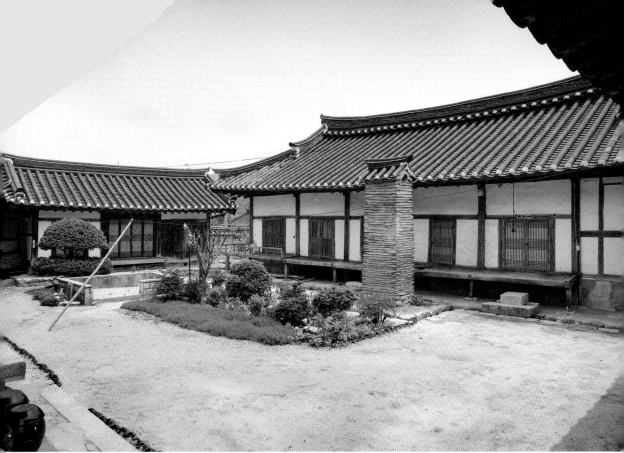

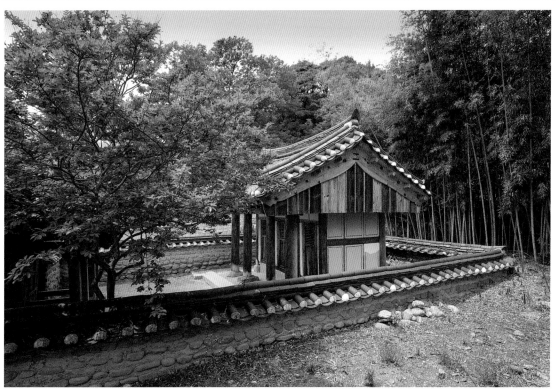

Anmadang and *tteul-araechae*, side view between *anchae* and *gotgangchae*. (top)
View of the *sadang* over the wall. (bottom)

Residence of Ildu in Hamyang

Built in 1690
50-13 Gaepyeong-gil, Jigok-myeon, Hamyang-gun, Gyeongsangnam-do

Located at the centre of the village, this private home belonged to the famous scholar Ildu Jeong Yeo-chang who lived during the early Joseon Dynasty. The remaining residential houses were gradually built by his descendants at the site of Jeong Yeo-chang's birth; the first building was the *anchae* (women's quarters) in 1690 (King Sukjong's 16th year of reign), and then in 1843 (King Heonjong's 9th year of reign) the *sarangchae* (men's quarters). During the time of construction of these buildings, his descendants simultaneously expanded their land piece by piece and established today's property. Multiple additional houses were built around the *anchae* at the centre.

The estate is reached through an alleyway; to reach it, one steps through the *soseuldaemun*, the entrance door, which faces south-east. Mounted onto the *soseuldaemun* are the five Jeongryeopae plates of *chungsin* (loyalty to the King) and *hyoja* (meaning 'filial love towards the parents'). This is an absolute testimony to the state doctrine of the time, the social codex of the Joseon Dynasty. The remaining residential buildings were in most cases restored during the late Joseon time. The estate consists of *haengnangchae* (house for service staff), *sarangchae*, *ansarangchae* (additional men's building), *jungmunganchae*, *anchae*, *araechae* (outer-wing house), *gwangchae* (storage house) and *sadang*, a total of 12 buildings and four side gates, the *hyeopmun*, and an earth-coated wall. All entities are placed according to their individual function on the estate.

Upon entering the living quarters through the *soseuldaemun*, the visitor's gaze is immediately drawn to the Seokgasan, a symbolic depiction of the Buddha mountain in front of the *sarang-madang*. Traditionally a garden is designed at the back of the house in aristocratic estates; in this case, however, the Seokgasan is located in the *sarang-madang*, which offers a striking architectural solution.

The women's and men's quarters and the side house are distinctly separate from each other, and the different architectural styles of multiple eras are important testimonials for architectural research today.

1. anchae
2. araechae
3. angotganchae
4. jungmunchae
5. gotganchae
6. ilgakmun
7. daemunchae
8. sarangchae
9. Seokgasan
10. ansarangchae
11. gwangchae
12. sadang
13. hwajangsil
14. hwajangsil

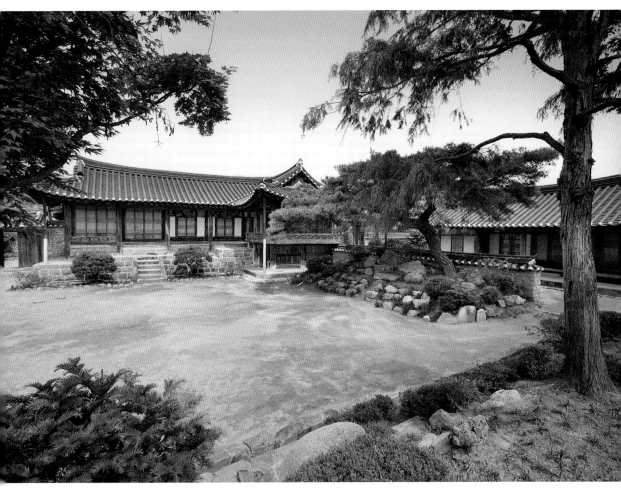

View of *sarang-madang*, *sarangchae*,
and Seokgasan at the wall. (top)
Daemun, entry gate. (bottom)

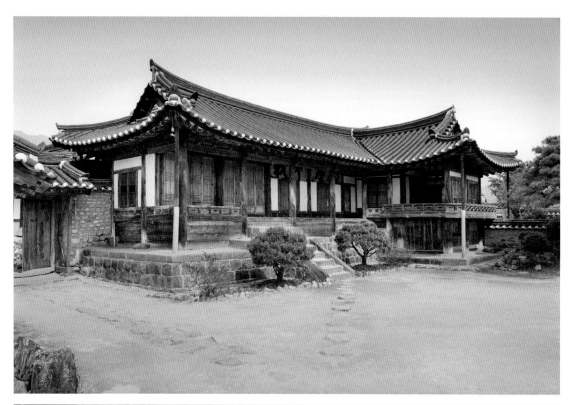

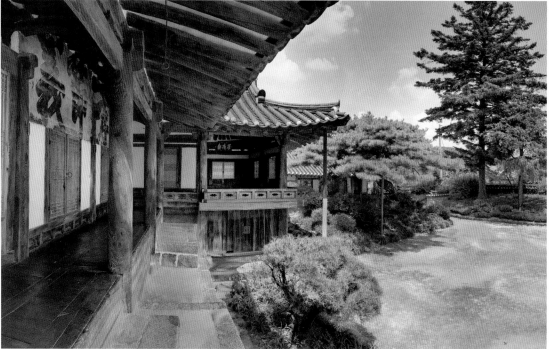

Sarangchae. (top) Lateral view of front *toenmaru* and the interior. (bottom)

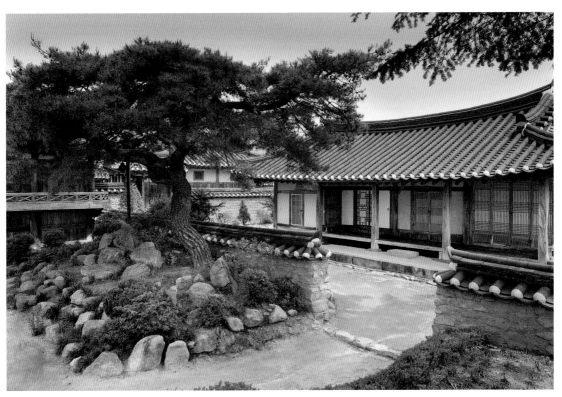

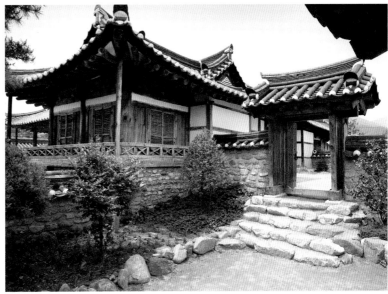

Seokgasan garden and *ansarangchae*. (top)
Lateral view of *sarangchae*, as seen from *ansarangchae*. (bottom)

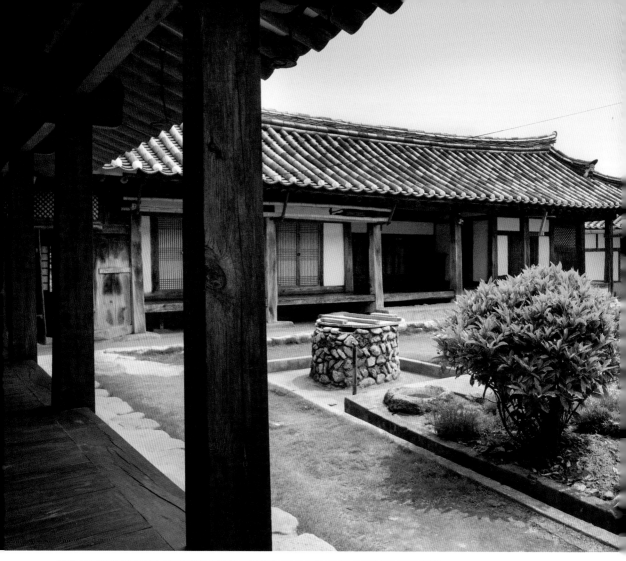

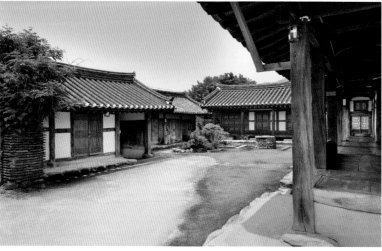

View of *anchae*, as seen from *araechae* and *angotgangchae*. (top)
View of *anmadang* and *junmunganchae*, as seen from the *anchae*. (bottom)

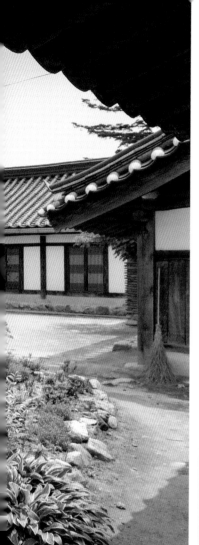

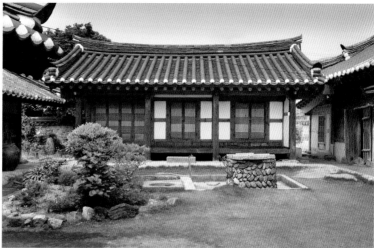

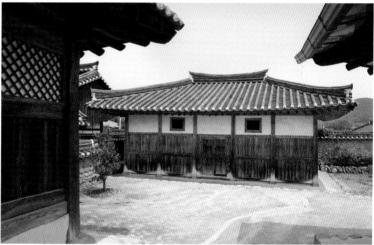

Araechae. (top) *Gwangchae,* storage house. (bottom)

Yeondang in Mugi, Haman

Built in 1728
33 Mugi1-gil, Chilwon-myeon, Haman-gun, Gyeongsangnam-do

Yeondang literally means 'garden with pond'. The featured Yeondang was created in 1728 (King Yeongjo's 4th year of reign) by soldiers of commander Ju Jae-seong, who had mustered and lead patriots from the Haman region against the insurgence of Yi In-jwa. His merits were held in high esteem and a garden with pond was thus created – around the Yeondang are the Hahwanjeong and *nugak* Pungyokru pavilions – to pay tribute to him; not far from this site was the birth house of commander Ju Jae-seong.

According to the building chronicles of Hahwanjeong and other documents, a pond must have been located at this site before; after the Yi In-jwa insurgence, his soldiers expanded this original pond. Several buildings were constructed around this pond and the area was expanded: In 1860 (King Cheoljong's 11th year of reign), the Pungyokru was built to the right of the Hahwanjeong.

In 1972, the Chunghyosa (ancestor shrine) and Yeongjeonggak (memorial house) were built to the south of the pond, as can be seen in the estate's features today.

The rotund pond's size measures 20 metres in length and 12,5 metres in width, a scale that is rarely seen in private gardens. The pond is surrounded by two steps as protective barrier. In its centre features a round shaped Seokgasan, built from rare-shaped stones. This mountain shape's symbolic image Bongnaesan reflects the Taoist ideal, in which birds of paradise play with humankind.

The Yeondang is relatively well preserved, so that we can consider ourselves fortunate to have such a fine example of a late Joseon time *yangban* family's garden pond at hand and available as a research object to help us understand the form and special structures of traditional gardens.

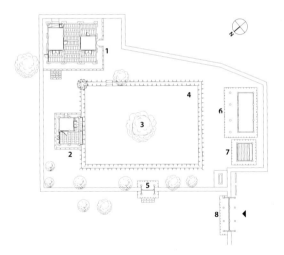

1. Pungyokru
2. Hahwanjeong
3. Yangsimdae
4. yeondang
5. Hanseomun
6. Chunghyosa
7. Yeongjeonggak
8. daemunchae

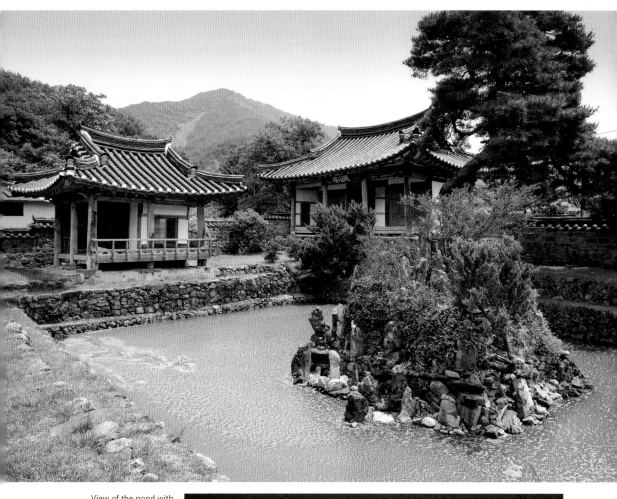

View of the pond with
Hahwanjeong and Pungyokru.
(top)
View of the pond from the
interior of the Hahwanjeong.
(bottom)

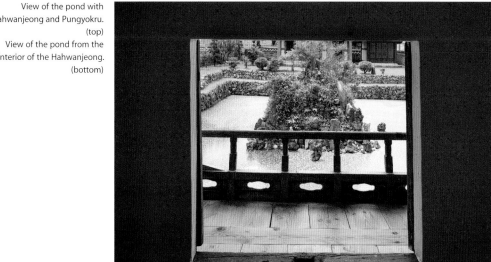

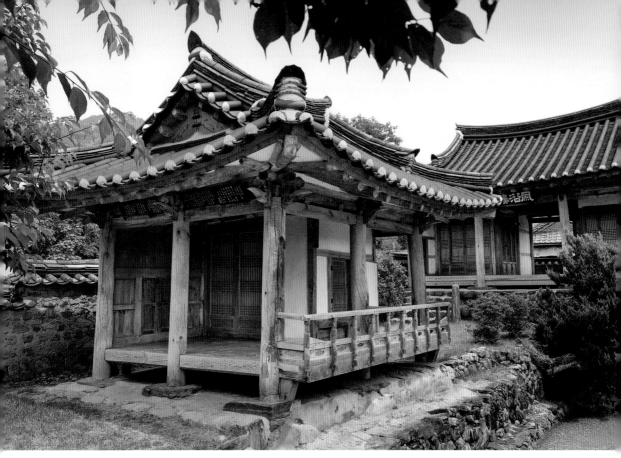

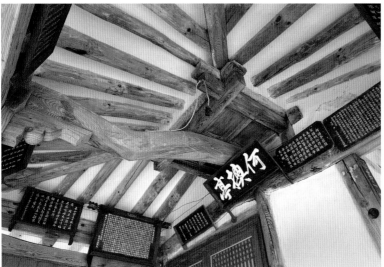

Hahwanjeong pavilion. (top)
Interior with view of ceiling construction. (bottom)

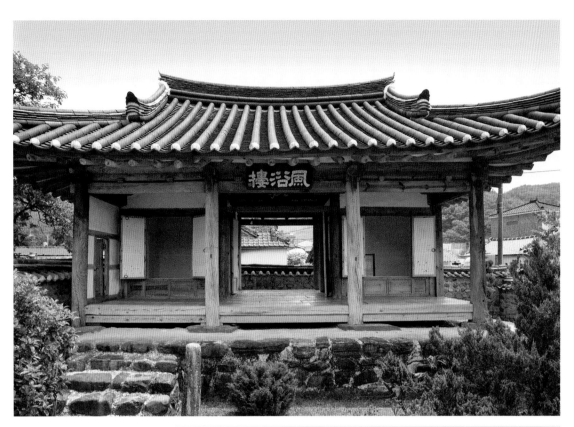

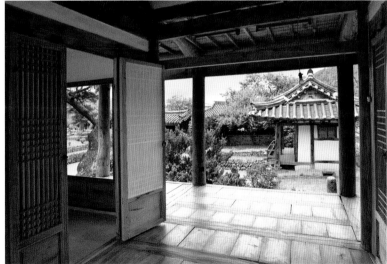

View of the Pungyokru. (top)
View from the Pungyokru. (bottom)

Honam, Jeju Areas

Residence of Kim Dong-su in Jeongeup

Built around 1784
72-10 Gongdong-gil, Sanoe-myeon, Jeongeup-si, Jeollabuk-do

Jinesan, the mountain of the millipedes, acts like a folding screen to protect the rear of the village. With the clear waters of the Dongjin River flowing in front, the village's location accords with the geomantic ideal of 'protection by a mountain in the back and a river in the front'. Similarly, the pond at the front of the estate protects the buildings from the 'fiery nature', or the firepower, of the hill Okgyebong and the Hwagyeon Mountain that lie on the far side of the adjacent fields.

After a visit in 1770, Kim Myeong-gwan, the sixth-generation ancestor of Kim Dong-su, relocated to the area; the house was completed in 1784 (King Jeongjo's 8th year of reign) after more than 10 years of construction. The pond was established during this original building period and the willows, surrounding the pond in a crescent-shape, were planted during the same time. The property received its name from the current owner Kim Dong-su, a sixth-generation ancestor of the original owner Kim Myeong-gwan.

Upon entering the private residence, the visitor first sees the cowshed and the walled-in front courtyard. The courtyard enables the harmonic arrangement of wall and buildings and the greenery, which emphasises the vintage feel of the house. Passing through the side gate, *hyeopmun*, which is located on the right side of the courtyard, we can view the *sarangchae* and its courtyard, which also includes the *haengnangchae* (house for service staff). To the right is the walled-in *sarang-madang* (courtyard) and located to the left is the *hyeopmun* (side gate). Observed in its totality, this arrangement gives an impression of comfort and cosiness.

From the *anhaengnangchae*, the view opens to the ⊏-shaped *anchae* (women's quarters) and its courtyard, *anmadang*. Located to the left of the *anchae* we find the *ansarangchae* (additional men's building). The property's well, *umul*, as well as the herbal pots and the vegetable patch lie at the back of the *anchae*. Situated at the rear and to the right of the *anchae* is the ancestral shrine *sadang* behind which we can find the *hoji-jip*, the janitor's home.

Kim Dong-su's private residence is constructed in the style of an upper class estate and its design uses the wall and buildings to give the impression of a well-shielded property. Even the frontyard was designed to shield off the private home from views from the entrance area. This is a rare, highly refined and well planned house, a clear indicator that the estate had been built for an upper class family.

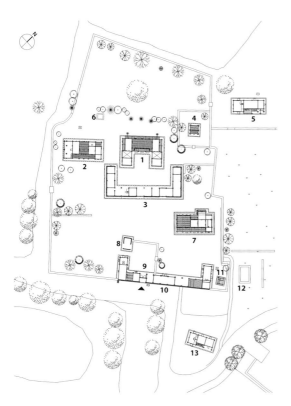

1. anchae
2. ansarangchae
3. anhaengnangchae
4. sadang
5. hoji-jip
6. umul
7. sarangchae
8. oeyanggan
9. daemun
10. bakkat-haengnangchae
11. cheukgan
12. hwajangsil
13. hoji-jip

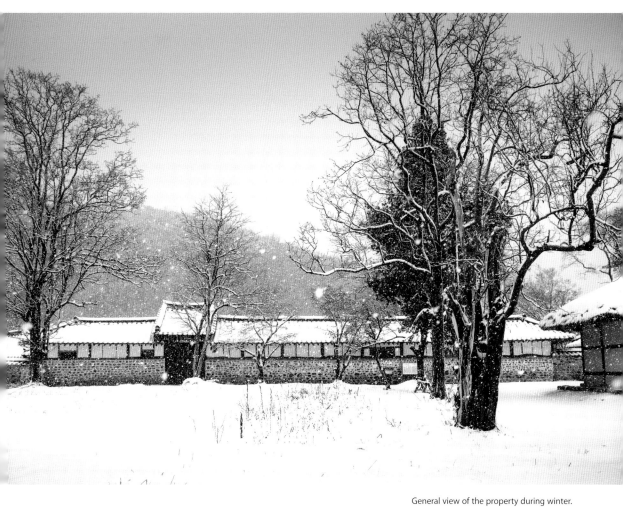

General view of the property during winter.

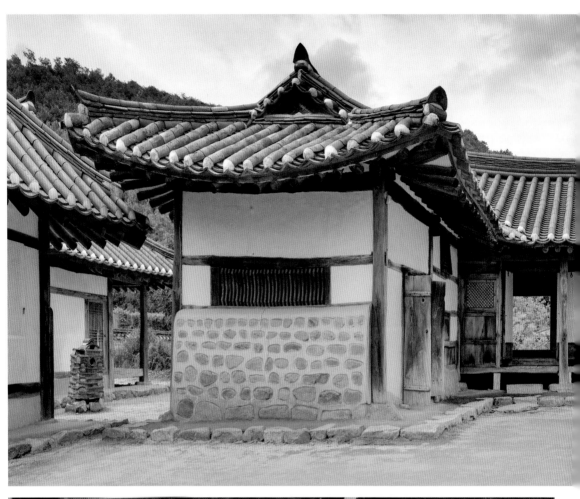

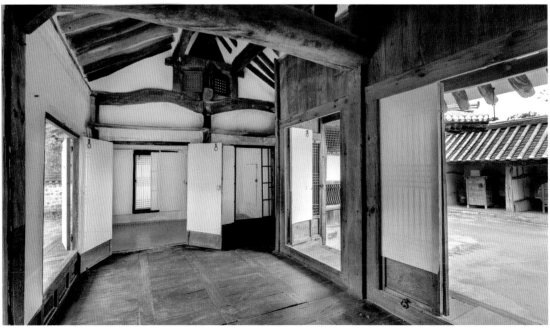

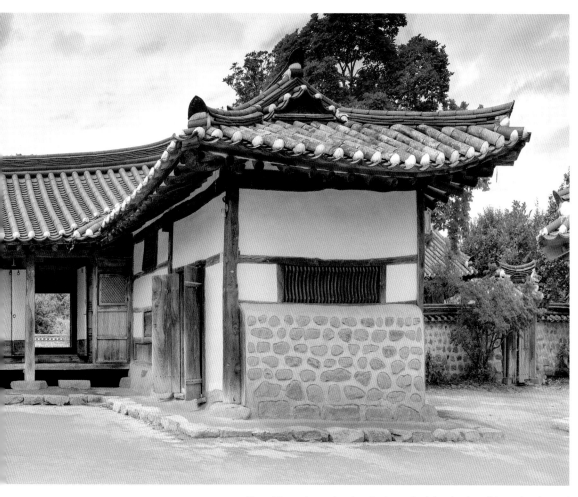

View of the *anchae* and *anchae-daecheong*. (top) Interior view of the *anchae*. (bottom)

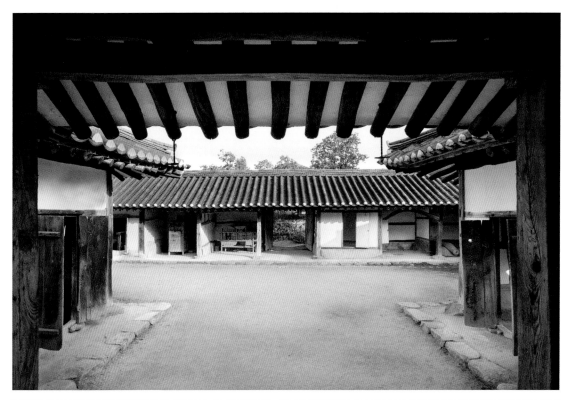

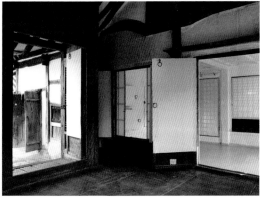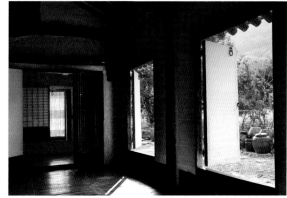

Anhaengnangchae, viewed from the *anchae*. (top)
Interior views of the *anchae-daecheong*. (bottom left, right)

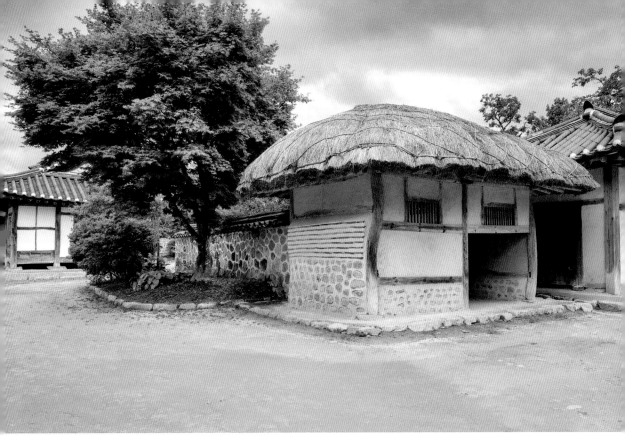

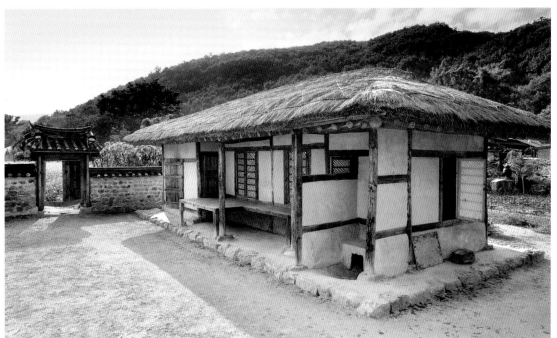

Oeyanggan. (top) *Hoji-jip.* (bottom)

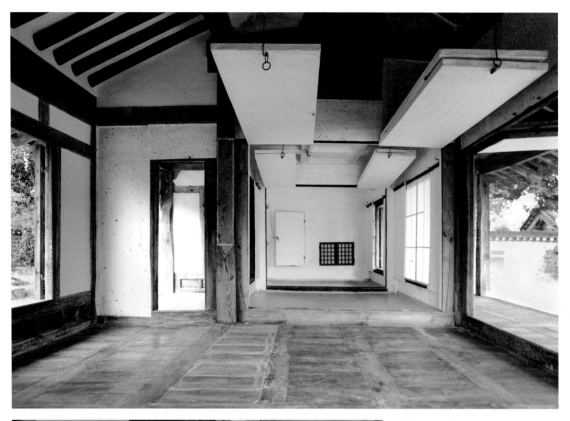

Interior view of
the *sarangchae*. (top)
Views to the house opposite the
sarangchae. (center, bottom)

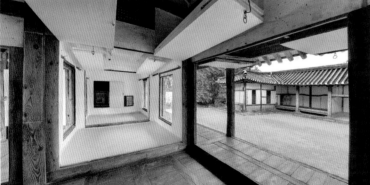

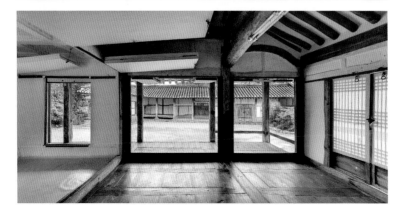

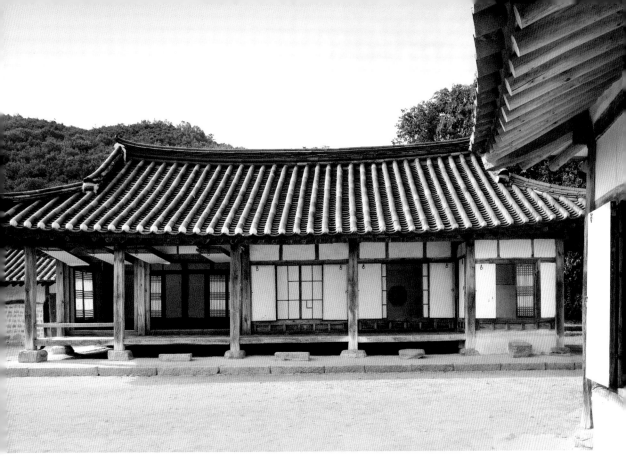

Sarangchae. (top)
Sarangmaru. (bottom)

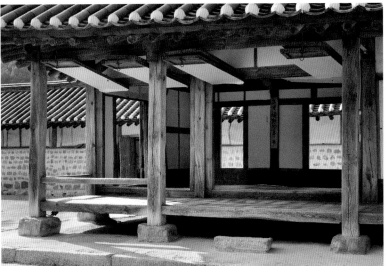

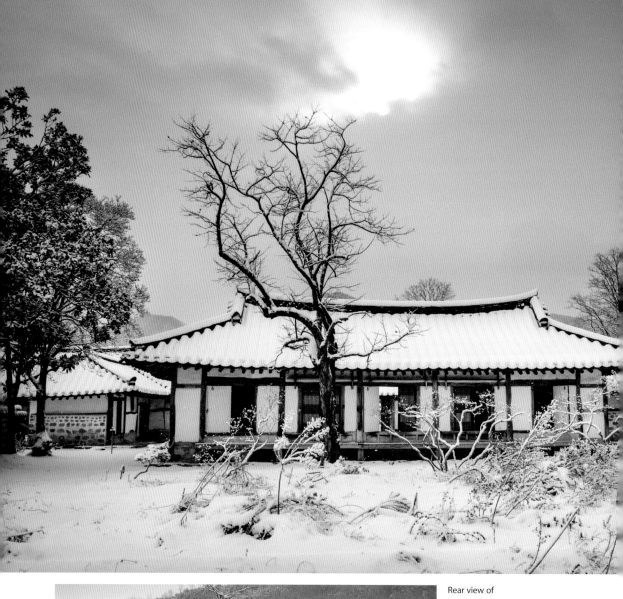

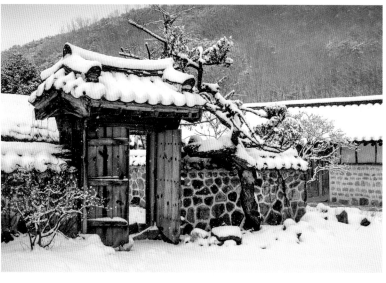

Rear view of
the *anchae*. (top)
View of the *jungmun*.
(bottom)

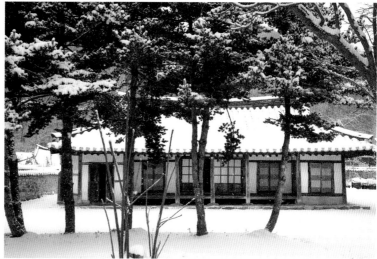

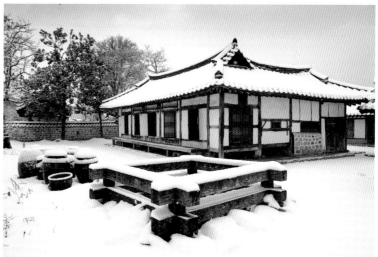

Rear view of the *ansarangchae*. (top) Well and *jangdokdae*. (bottom)

Residence of Kim Sang-man in Buan

Built in 1895
8 Gyoha-gil, Julpo-myeon, Buan-gun, Jeollabuk-do

Originally, the residence of Kim Sang-man belonged to Inchon Kim Seong-su (1891-1955) a scientist and the former vice president of the Republic of Korea from 1950-1951. Prior to setting up residence there, the family lived in Inchon-maeul, Bongam-ri, Buan-myeon. They had moved due to the danger of bands of lawless brigands who had often attacked the village. Gulpori had been the best choice for the resettlement and Kim Seong-su re-built the residential complex there in 1895 (King Gojong's 32nd year of reign). The *anchae* (women's quarters), the *sarangchae* (men's quarters), and the *munganchae* were erected in 1895 and the *ansarangchae* (additional men's building) and the *gotganchae* (storage house) were later built in 1903.

Behind the entrance gate to the *munganchae*, the *gotganchae*, there is a beautifully arranged garden. It separates the building complex where the *bakkat-sarangchae* (additional men's quarters in the outer living areas) and the *jungmunchae* (middle house with entrance gate in the inner living area) have been arranged side by side, facing in a south-westerly direction. Behind these buildings are the *ansarangchae* and the *anchae* facing north-westward. Arranged in a well-considered way, the *munganchae*, the *bakkat-sarangchae* and the *jungmunchae* together create a courtyard. The *gotganchae* and *anchae* form an inner courtyard; situated before the *anchae* is the slightly smaller *sarang-madang*.

A particularly attractive feature of this private home is that each building and wall creates a unique courtyard. Further distinguishing this complex from other private residences is the use of rice straw for its roofs even though the estate belonged to an upper class family. It is believed that originally, all roofs had been covered with reed since this type of roof material was both more durable and easier to obtain in the region.

During the restoration process in 1982, the roof of the *munganchae* was changed into a reed cover. It was reconstructed in 1984 and in 1998 the roof cover was changed back into rice straw.

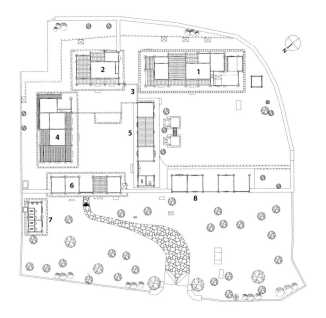

1. anchae
2. ansarangchae
3. hyeopmun
4. bakkat-sarangchae
5. jungmunchae
6. munganchae
7. hwajangsil
8. gotganchae

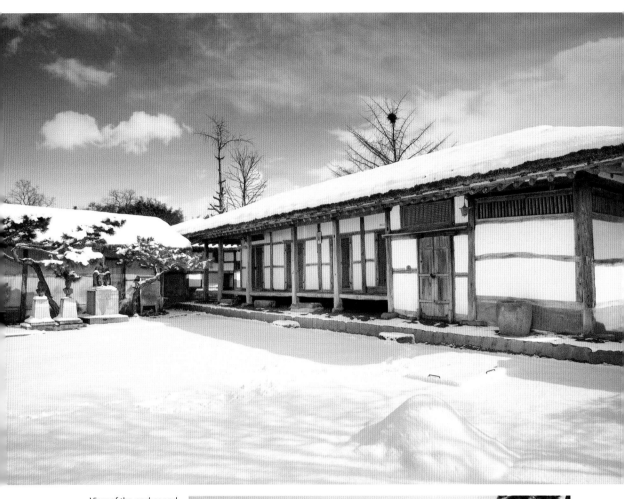

View of the *anchae* and
jungmunchae
with courtyard. (top)
View of the *daemun* and
munganchae. (bottom)

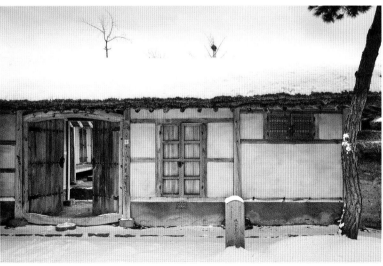

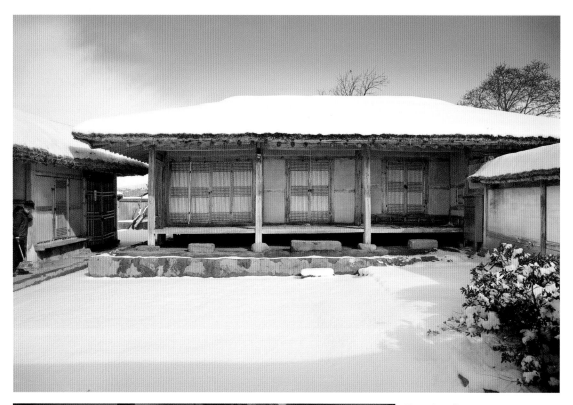

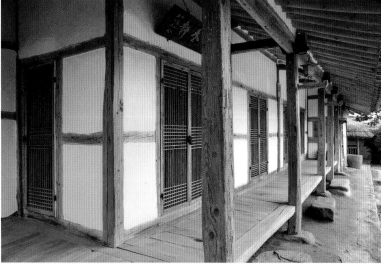

Front view of
bakkat-sarangchae. (top)
Lateral view of
bakkat-sarangchae. (bottom)

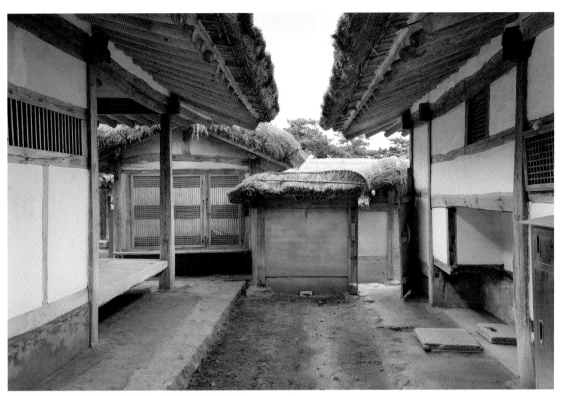

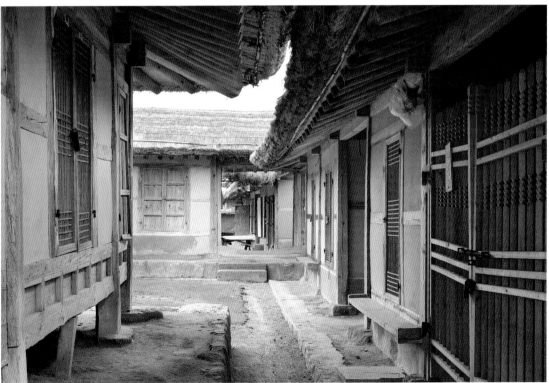

View of the space between *anchae* and *ansarangchae*, with *hyeopmun*. (top)
Lateral view of the *jungmun*, located between *bakkat-sarangchae* and *munganchae*. (bottom)

Unjoru in Gurye

Built in 1766
59 Unjoru-gil, Toji-myeon, Gurye-gun, Jeollanam-do

The property Unjoru[1] measures 99 *kan* and according to the engravings in the cross beam of the *sarangchae* (men's quarters), it had been erected in in 1776, during the 52nd year in power of King Yeongjo.

The original owner of the residence Yu I-ju had been a highly decorated civil servant, working as an administrator in the position of Samsu-Busa. Among the works left behind are the *Jeollaguryeomidonggado* and a number of diaries in which he had documented the architectural plans and the building history of the estate. These historical documents offer an invaluable insight into the living and housing arrangements during the Joseon period. The diary entries reveal for example how a building owner from an upper-middle class background acquired building material and construction workers and what type of residence he planned and desired.

Looking at the remaining buildings of Ujoru, the *anmadang* (courtyard) is encircled by the ⊏-shaped *anchae* (women's quarters), which is covered to the front by a —-shaped *anhaenangchae* (additional house for service staff) and *sarangchae*. The *haengnangchae* (house for service staff), including the entrance gate *daemungan* and a *sadang* (ancestral shrine) at the rear are positioned separately; with its size of 19 *kan*, this *haengnangchae* was larger than those of the most influential aristocratic homes.

It is not only the age of the residence that inspires the academic community; moreover, it is the estate's geomantic location and its �□-design – rare in this area – that make this private home a precious example of *hanok* architecture.

1. Literally means a pavilion of the birds in the sky.

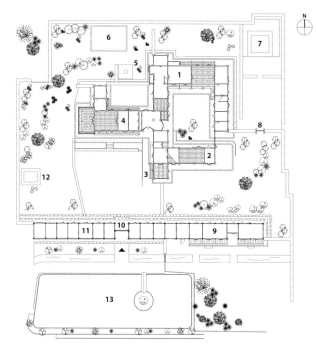

1. anchae
2. anhaengnangchae
3. arae-sarangchae
4. sarangchae
5. umul
6. namucheong
7. sadang
8. hyeopmun
9. dong-haengnangchae
10. daemun
11. seo-haengnangchae
12. cheukgan
13. yeonji

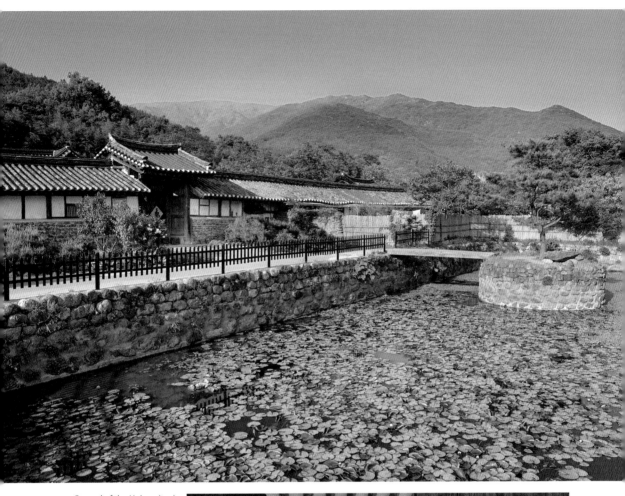

General of the Unjoru. (top)
Entrance gate, *daemun.*
(bottom)

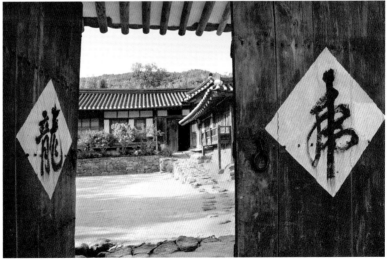

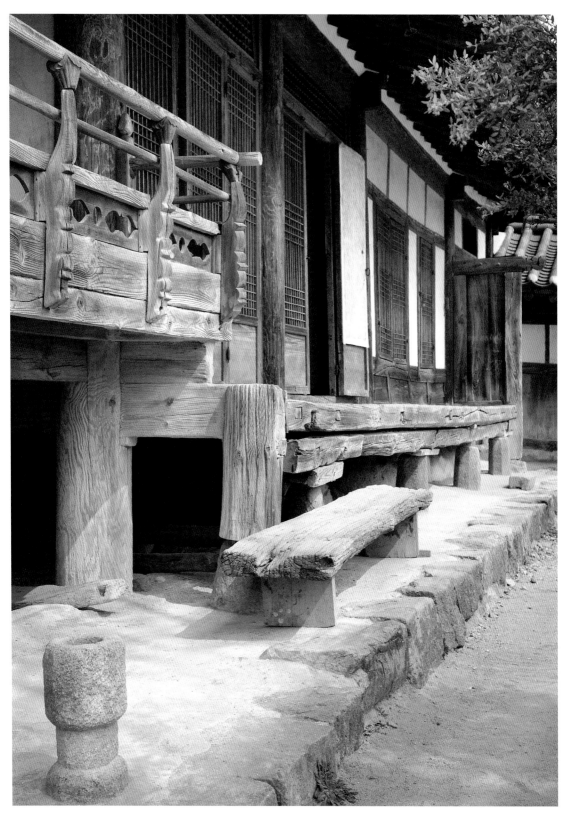

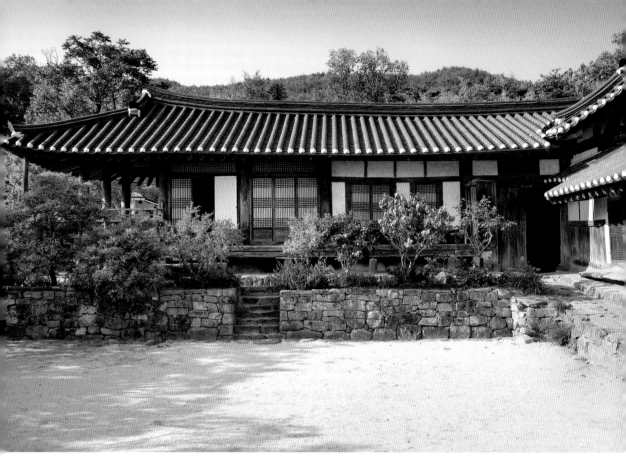

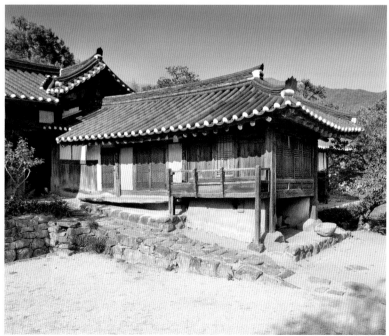

Lateral view of the *sarangchae*. (p.204)
Sarangchae, viewed from the front. (top) *Arae-sarangchae*. (bottom)

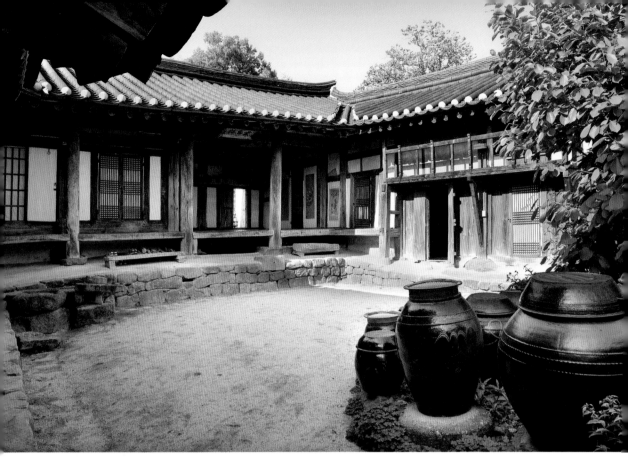

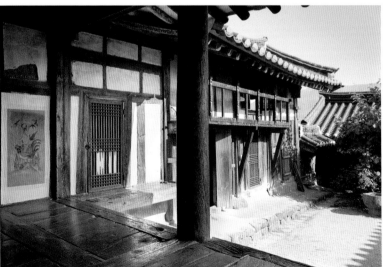

Anmadang and *anchae*, viewed from *arae-sarangchae*. (top)
Eastern side of the *anchae*, viewed from *anchae-daecheong*. (bottom)
View of the courtyard of the *anmadang*. (p.207 top) Interior view of the kitchen. (p.207 bottom)

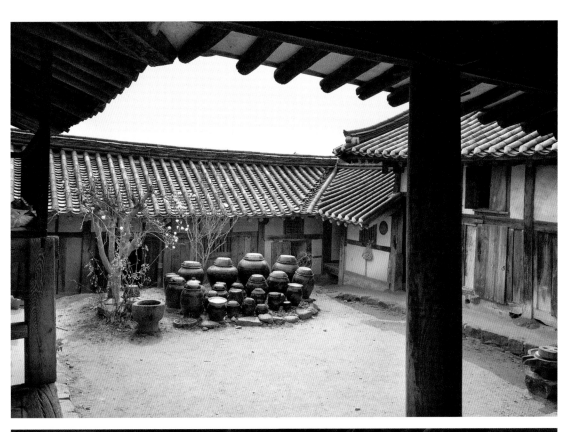

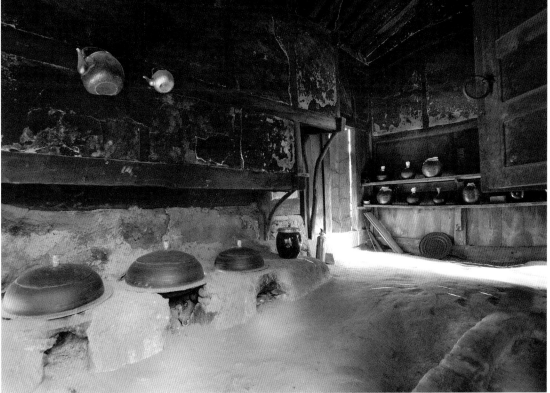

Residence of Kim Dae-ja in Naganseong

Built at the beginning of the 19th century
90 Chungmin-gil, Nagan-myeon, Suncheon-si

Facing in a southerly direction, the residences of Naganseong are located at the northern side of the main street, which runs from the eastern to the western gate. In the past various administrative agencies as well as a house for official guests and some private homes had been built. The private homes were built on the left and right side of the area populated by administrative buildings. A high wall protects the residential complex from the street.

At the back of the *anmadang* (courtyard) is a south-facing *anchae* (women's quarters); a *hoetgangchae* (storage house with rooms for servants) is located at the end of the *madang* (courtyard). The construction of the *anchae* dates back to the beginning of the 19th century. The *daechaeong* (main hall) was designed in the middle as a *jeontoe-jip* ──-shaped and with a size of 4 *kan*. The eaves of the porch do not have a *toebo* (a short joist used to connect the wall of the house to the purlin under the eaves) but are supported only by the purlin of its supporting pillars.

A special feature of this residence is the separate kitchen, which is housed in an annex built under the front eaves of the *jageunbang* (small room) enclosed by a mud brick wall. This type of construction is particular to central Korea.

Although the outside space of the complex has no special features, the following objects offer insight into the daily lives of our ancestors at the end of the 19th century and are therefore of importance: the storage platform, *jangdokdae*, with its ornately carved stone steps and stylobate as well as paraphernalia used for religious ceremonies.

While the residence is not overly large, the building materials and finely arranged straw and reed roof transmit a well-considered attitude and love for detail. The combined the character of a mud brick house with a timber house is of high value. Recently however the house has been used for business purposes in the form of a *hanok* Experience Center and some additional facilities, lacking the traditional design, have been added.

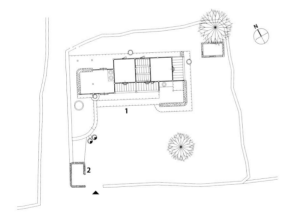

1. anchae
2. heotganchae

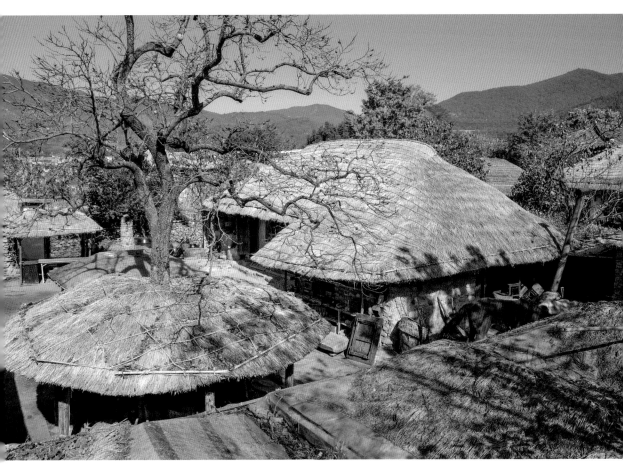

Front view of
the residence. (top)
The entrance gate. (bottom)

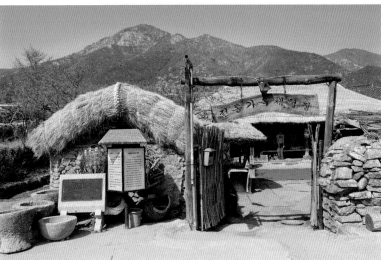

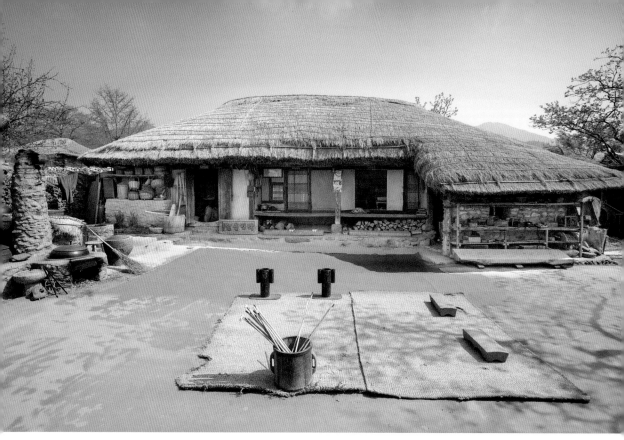

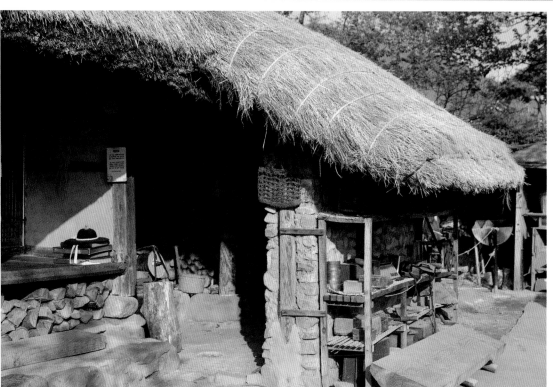

Anchae and *anmadang,* courtyard. (top) Kitchen opposite the *geonneonbang.* (bottom)

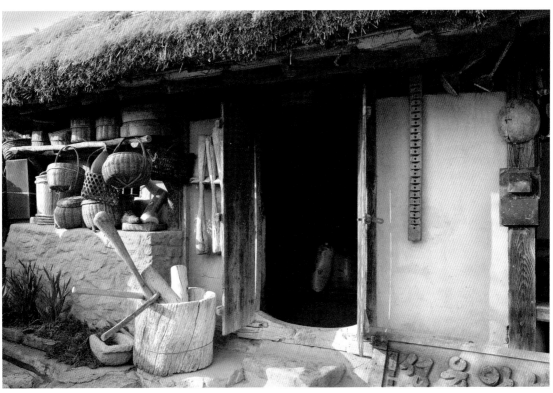

Outside view of
the kitchen. (top)
Interior view of the kitchen.
(bottom)

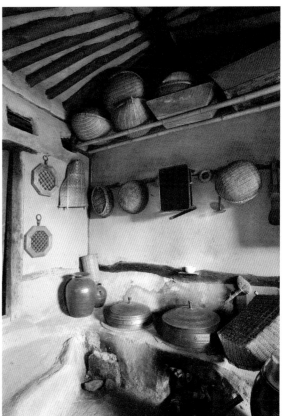

Residence of Nampa in Naju

Built before 1880's
12 Geumseon-gil, Naju-si, Jeollanam-do

The private home Nampa lies on the south-eastern foothills of the mountain range Geumseong Mountain, northwest from Naju-si. To the west of the home flows the Naju River.

The son of the clan elder Park Sim-mun came to this area during the time of the Geyujeongnan rebellion and the usurpation of power by the uncle of King Danjong in 1453. Park Sim-mun assisted the usurper and was later awarded for his services. Generations of the clan had been living in this house since the original construction and the current owner is also a descendent of the Park clan. The ancient estate houses around 4,000 old books and documents as well as information about the village Naju and its economic, agricultural and financial development over the centuries. The records also include monthly publications from previous decades, works of art made from local bamboo as well as numerous photographs from the area. These objects reveal not only much about the history and about culture of the Naju region but also about the lifestyle and housing arrangements of local estate owners and contribute to our understanding of this area over the centuries.

The residential complex faces south and is comprised of *daemunchae* (gate house), *munganchae, bakkat-sarangchae* (additional men's building), *gotganchae* (storage house), *anchae* (women's quarters), *araechae* (outer-wing house), *heotganchae* (storage house), *chodangchae* (straw thatched house outside of the living area) and *bakkatchae*. All of these buildings have been almost perfectly preserved. Unfortunately, the buildings on the east side outside the walled complex, such as the *an-jip, jageun-jip, saetgosal-jip, ab-jip* and *hoji-jip* have been demolished in the period between 1960 and 1970.

Nevertheless, the estate is considered a significant example of an upper-middle class private home from the southern region of Korea. It was furthermore common to include certain rural elements and these have also been incorporated into the building design. The home's building history as well as the historically important materials kept inside, make this residence a particularly important study subject.

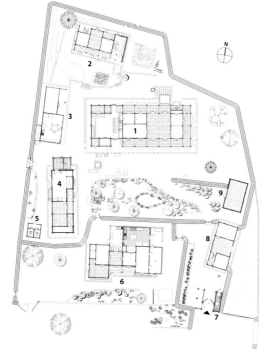

1. anchae
2. chodangchae
3. heotganchae
4. araechae
5. andwitgan
6. bakkat-sarangchae
7. daemunchae
8. munganchae
9. gotganchae

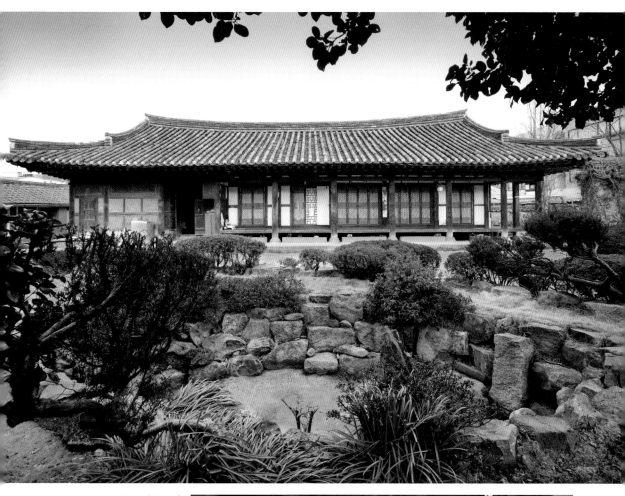

General view of
the *anchae*. (top)
Daemun. (bottom)

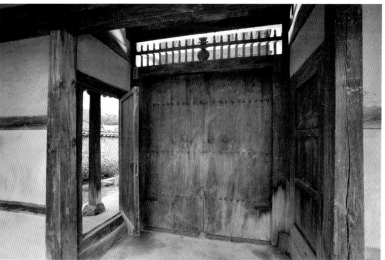

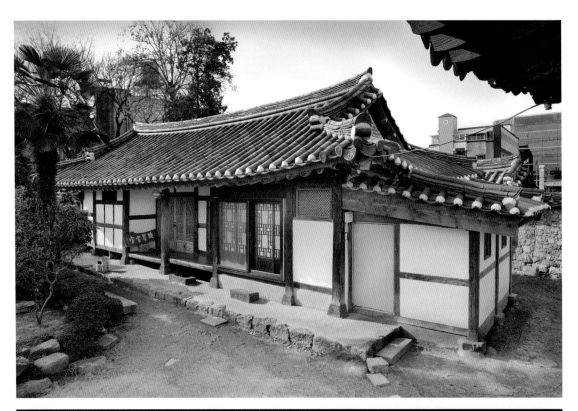

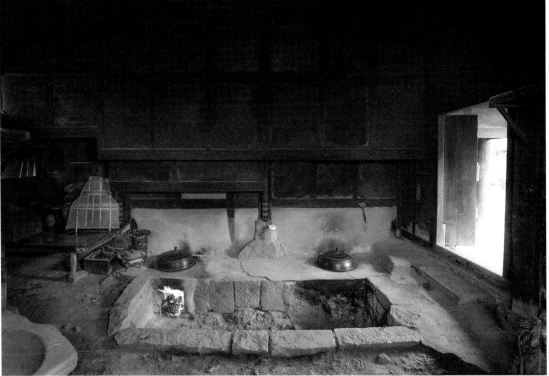

Araechae. (top) Kitchen. (bottom)

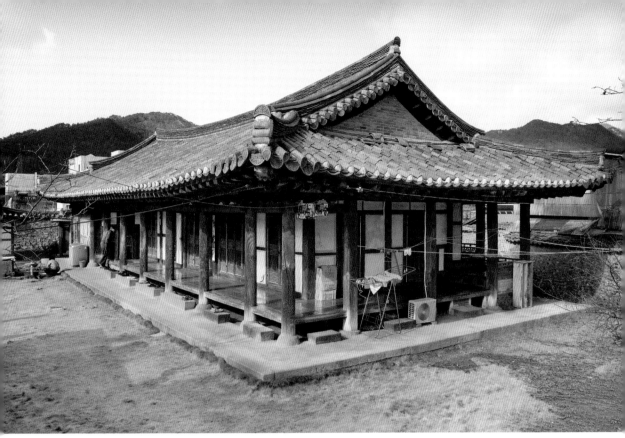

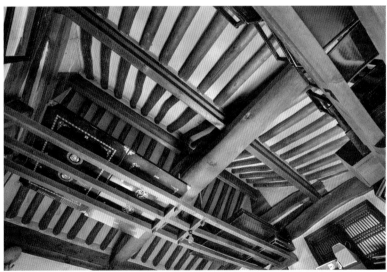

Lateral view of the *anchae*. (top) Interior roof construction of the *anchae*. (bottom)

Residence of Yi Yong-uk in Boseong

Built in 1835
36-6 Ganggol-gil, Deukryang-myeon, Boseong-gun, Jeollanam-do

The densely forested Dongsan Mountain is situated behind the house, and the Obong Mountain in front of it, together they form the landscape of the village of Ganggol. The residence itself lies in the midst of this landscape and faces southward. According to geomancy, this location of the property is considered an excellent choice for a private home.

The village of Ganggol consists mainly of members of the Gwangju Yi clan as well as the private home of Yi Sik-nae and of Yi Geum-nae, apart from this house, all three are positioned next to each other. The collection of houses is now considered an important national heritage.

The residence of Yi Yong-uk is the only home complete with a *soseuldaemun* (representative entrance gate), the sign of an aristocratic owner. With this significant characteristic, Yi Yong-uk's home has become the parent home of the clan. Especially the wide pond in front of the house and the bulky *soseuuldaemun* clearly show his social rank.

While the private home had been built during the first year in power of King Hyeonjong in 1835, the *soseuldaemun* was added only in 1940. The *anchae*

(women's quarters) and the *sarangchae* (men's quarters) were remodelled during the same time. This made it possible to discern the dates of the buildings.

The general living area consists of the *munganchae* with its accompanying *soseuldaemun,* the spacious *sarang-madang* (courtyard), as well as the *sarangchae, anchae, gotganchae* (storage house), *jungmunganchae* (middle gate house) and *byeoldang* (separate house). After entering the home through the *soseuldaemun,* the visitor then approaches the *sarang-madang* with the *sarangchae* on the opposite side. To the left of the *sarangchae* and parallel to it, is the *jungmunganchae,* whose entrance in turn allows access to the *anchae.* The house shows good cohesiveness by its excellent use of space.

The layout of the individual buildings and their arrangement to each other is particularly well achieved in this well-preserved upper class residence. Moreover, the interior decorations of both inner and outer areas offer important insights into the lifestyle and the mode of living of bygone eras.

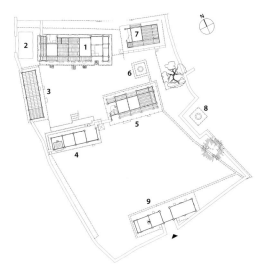

1. anchae
2. jangdokdae
3. gotganchae
4. jungmunganchae
5. sarangchae
6. umul
7. byeoldangchae
8. umul
9. munganchae

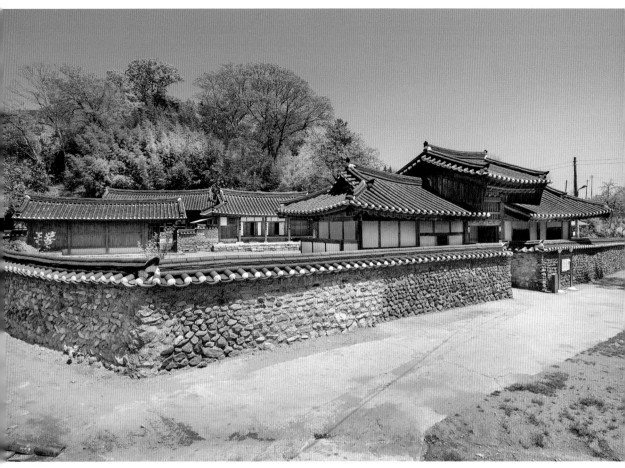

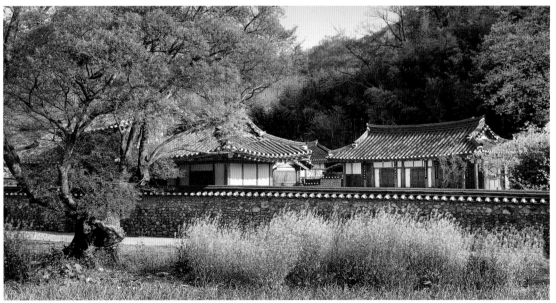

General view of the building complex, as seen from nearby. (top)
General view of the building complex, as seen from afar. (bottom)

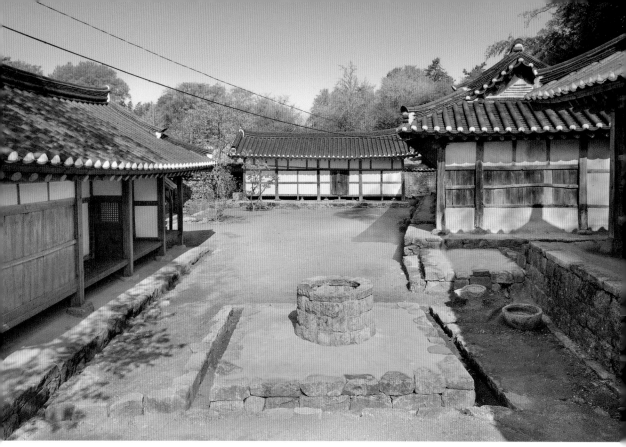

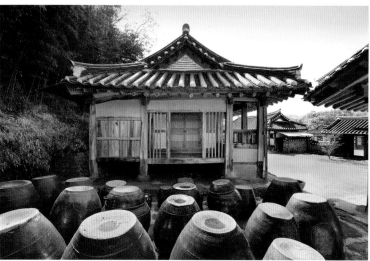

View of the *anchae-madang*. (top)
Jangdokdae and lateral view of the *anchae*. (bottom, left) Kitchen door. (bottom, right)

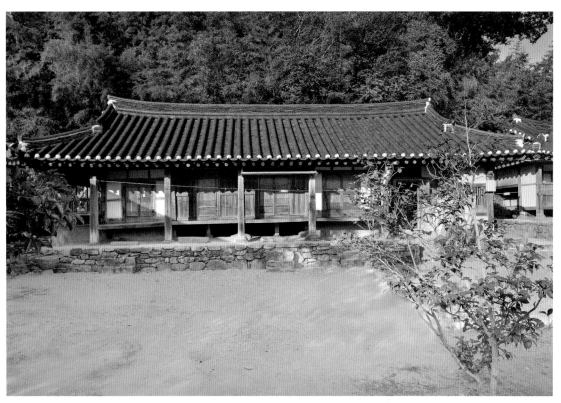

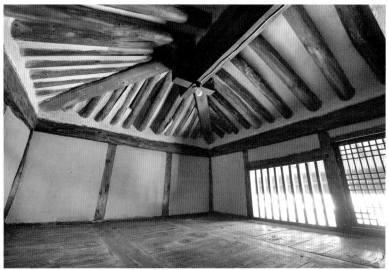

Front view of the *anchae*. (top) Interior view of the storeroom, *gongnu-darak*. (bottom)

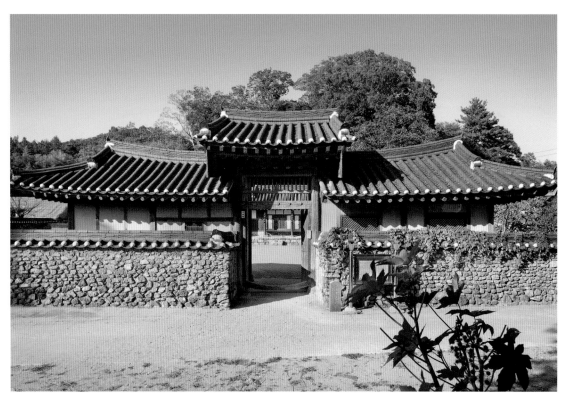

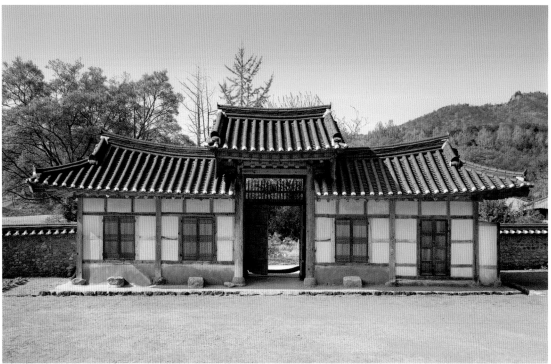

External view of the *soseuldaemun* with *munganchae*. (top) Interior view of the *soseuldaemun* and *munganchae*. (bottom)

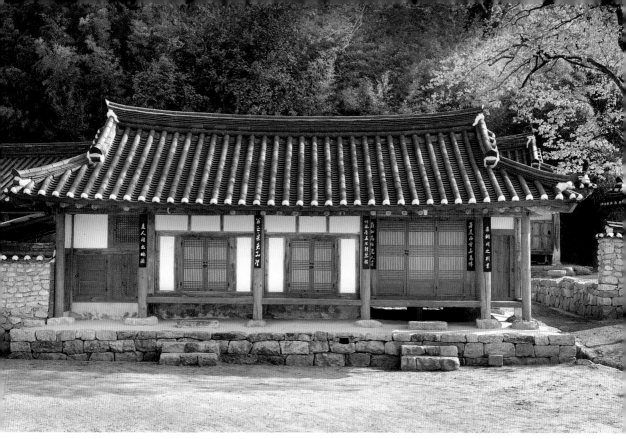

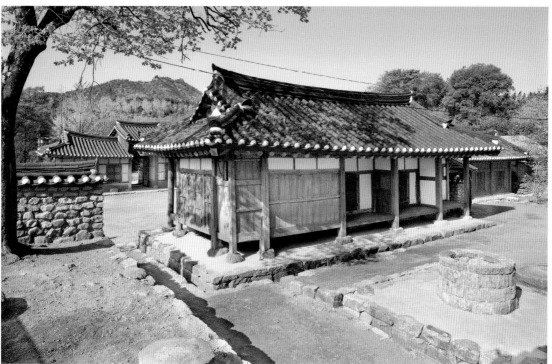

Front view of the *sarangchae*. (top) Rear view of the *sarangchae*. (bottom)

Residence of Yun Du-seo in Haenam

Built in 1730
122 Baekpo-gil, Hyeonsan-myeon, Haenam-gun, Jeollanam-do

Gongjae Yun Du-seo, a famous painter and scholar in Joseon Dynasty is the great-grandson of Gosan Yun Seon-do (1587-1671). According to inscriptions found on a ceiling beam in the *anchae* (women's quarters) and those engraved into the final brick, *maksae*, of the roof ridge, the building date was ascertained to 1730, the sixth year in power of King Yeongjo. Judging from the year the house was built, it was not Yun Du-seo who commissioned the building, but he was the first one of his generation who had settled in the village. His generation and his descendants continued their lives in this village and formed a clan community, which also gave the present residence its name 'Yun Du-seo *gotaek*'.

The private home is located on the coast of Baekpo-ri and around 20 kilometers from Haenam-eup. The village comprises approximately ten of the old homes from the Haenam Yun clan, which gives it the character of a traditional *hanok* village. This stretch of coast has also seen extended land reclamation as well as the construction of wave breakers that protect the village from the sea. Before this stretch of coast had been reclaimed, it had been under agricultural use by the Yun family.

The residence consists of the ⊏-shaped *anchae* (women's quarters), the *araechae* (outer-wing house), *gotganchae* (storage house), *sadang* (ancestral shrine) and remnants of the earlier wall. The *sarangchae* (men's quarters), *daemungan* and the *haengnangchae* (house for service staff) probably covered a living area of around 49 *kan*. Houses with ⊏-shaped *anchae* are seldom in this area and the interior design and arrangement of this private home is similar to the Nogudang of the Yeongdong in Haenam. It is in fact believed that the Nogudang served as the basic model for the homes of the Yun clan.

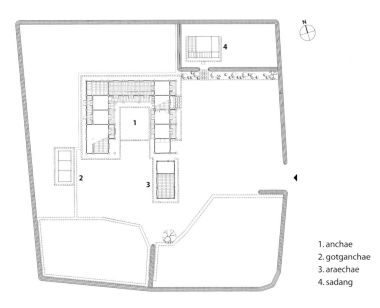

1. anchae
2. gotganchae
3. araechae
4. sadang

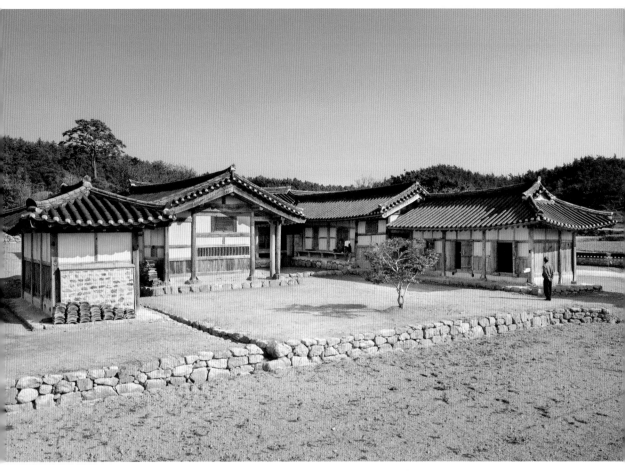

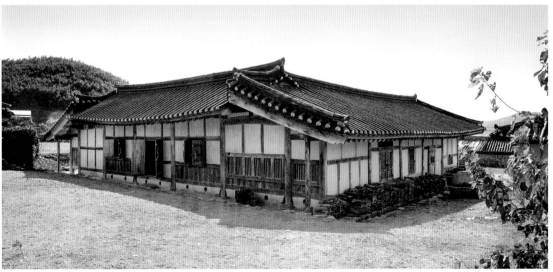

View of the *anchae*. (top) Rear view. (bottom)

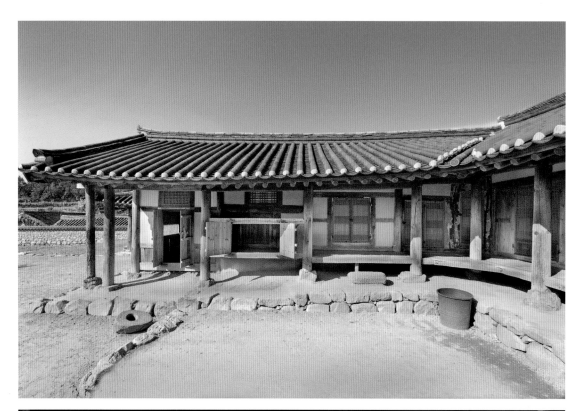

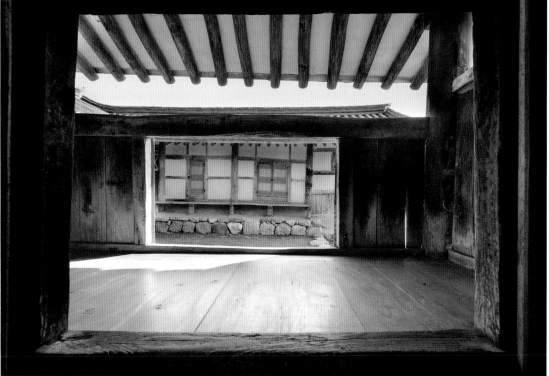

Western view of the *anchae* with kitchen. (top) Western lateral view from the kitchen. (bottom)

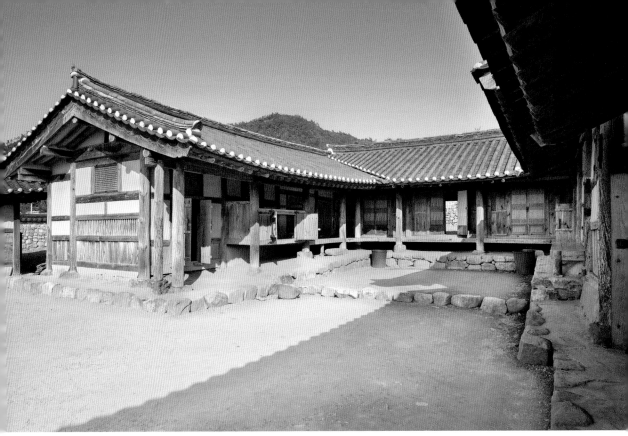

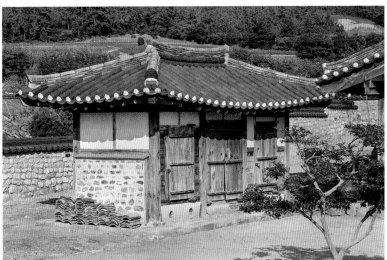

Anchae viewed from the *araechae*. (top) View of the *gotganchae*. (bottom)

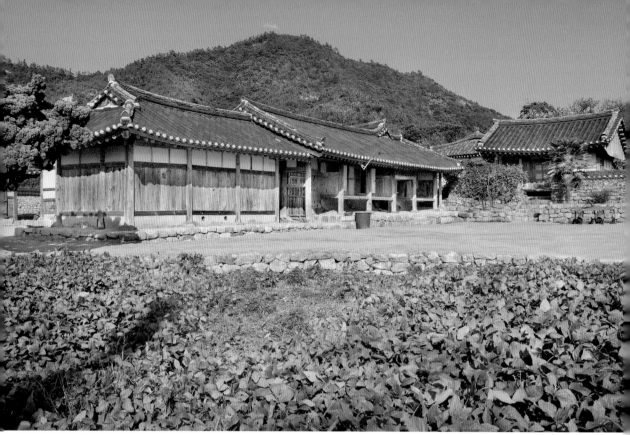

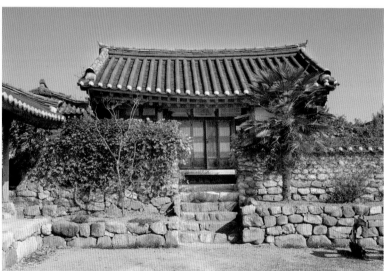

Rear view of the *araechae* and lateral view of the *anchae*. (bottom) View of the *sadang*. (bottom)

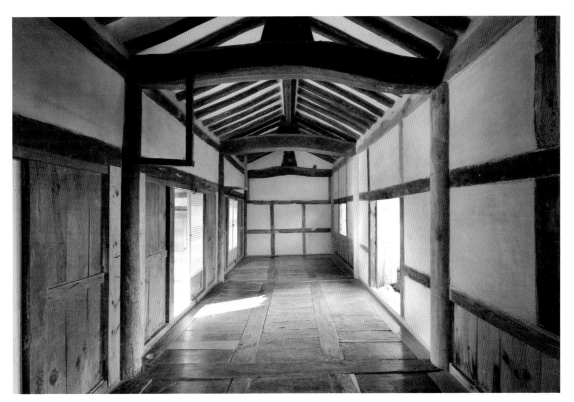

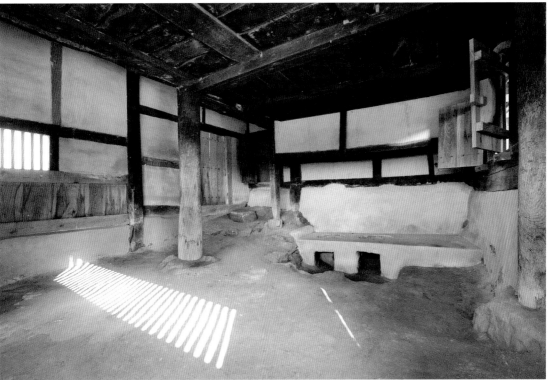

Anchae-daecheong. (top) Interior view of the kitchen. (bottom)

Original Family House of the Yeonan Kim Clan in Yeonggwang

Built in 1868

77-6 Donggangil2-gil, Gunnam-myeon, Yeonggwang-gun, Jeollanam-do

The family house of Kim Yeong from the Yeonan Kim clan was supposedly built after he followed his uncle, who was appointed to the position of Yeonggwang-gunsu, and decided to settle in this area. As a home built in the traditional design of a wealthy estate owner, it offers important insights for historical research into traditional Korean houses of the area.

The construction design has very clearly followed the principles of Confucian philosophy, which can be seen from the merit plaques that are still visibly attached at the entrance gate, Hyojamun. These merit plaques were customarily awarded for acts of 'pious service' to the king. The ancestral shrine *sadang* had been erected for the entire ancestry of the clan. Family relations as well as gendered relations and those between aristocracy and their servants are all reflected in the spatial partitioning of the residential buildings.

The living quarters consisted of *daemunganchae* with a Samhyomun signpost, *sarangchae* (men's quarters), the Confucian private school *seodang*, *yeonji* (pond), *gotganchae (anhanengnangchae)*, *maguganchae (bakkat-haengnangchae*, additional service house in the outer living area), *jungmunganchae* (middle house with

entrance gate), *anchae* (women's quarters), *sadang* and *busokchae (heotganchae,* storage house with rooms for staff). All of these buildings had been arranged according to its function within the realm of the estate. As was customary for large landowning estates, the property also has several storehouses as well as a number of servant quarters. Located outside the housing complex is a *hoji-jip* which sheltered servants who were not permanently housed on the estate.

A particular feature of this home is the additional dormer, *pot-jip*, located on the rooftop above the main entrance. This dormer represented both loyalty to the king as well as the position of power of the owner of this house from the Yeonan Kim family. Furthermore, it also signified the social status of this aristocratic family to the wider public.

Located on a hillside, the residence centres around the *anchae* and the *sarangchae*, the *daemunganchae* and *haengnangchae*, the *sadang* and the *seodang*. All of these buildings face southward and are sometimes built in close proximity, sometimes with larger gaps between each other, showing thus the intricate living arrangements of the past.

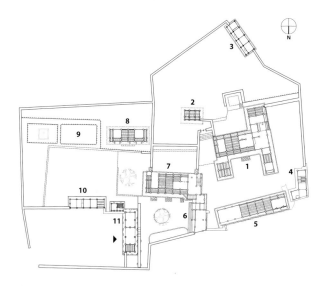

1. anchae
2. sadang
3. hoji-jip
4. busokchae (heotganchae)
5. gotganchae (anhaengnangchae)
6. jungmunganchae
7. sarangchae
8. seodang
9. yeonji
10. maguganchae (bakkat-haengnangchae)
11. daemunganchae

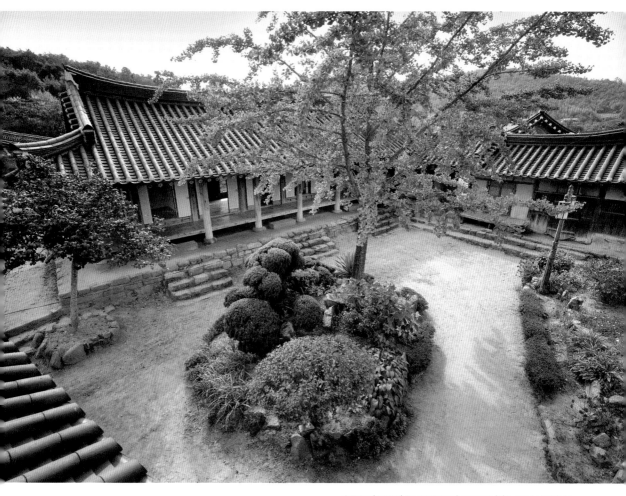

Sarangchae and *jungmunganchae* around the *sarang-madang*.

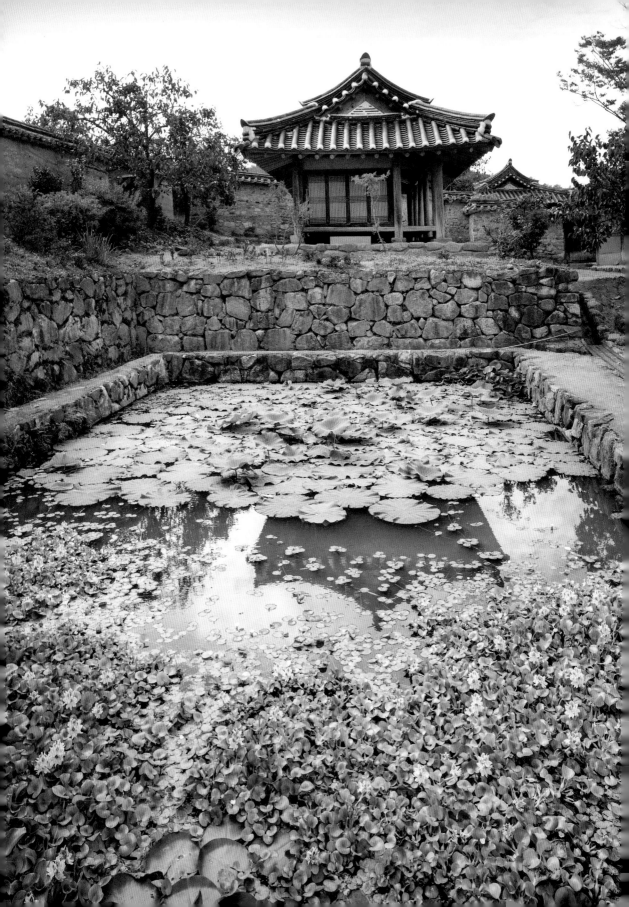

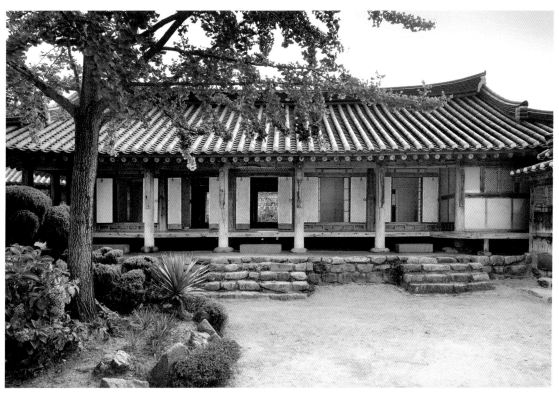

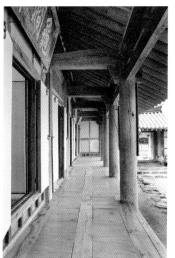

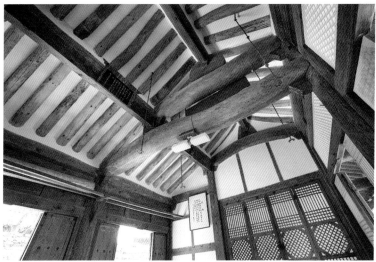

Yeonji and *seodang*. (p.230)
Front view of the *anchae*. (top)
Lateral view of the *toenmaru* of the *sarangchae*. (bottom, left)
Ceiling fittings of the *sarangchae*. (bottom, right)

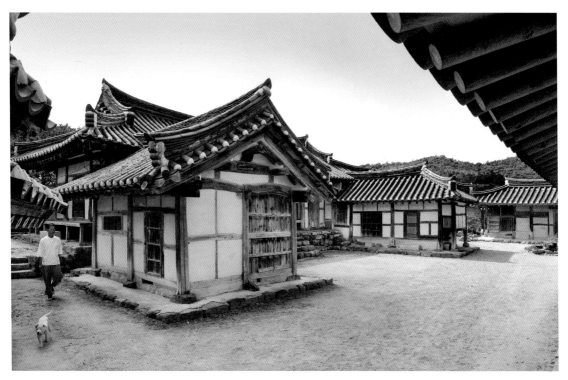

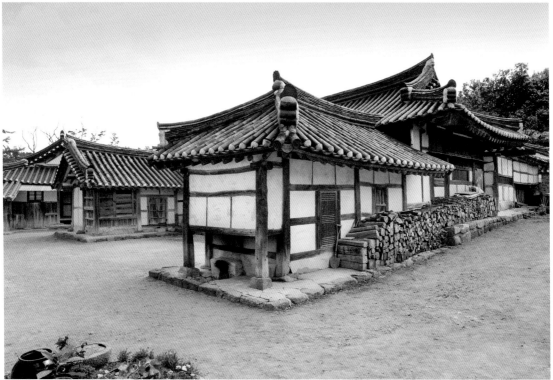

West side of the *anchae.* (top) East side of the *anchae.* (bottom)

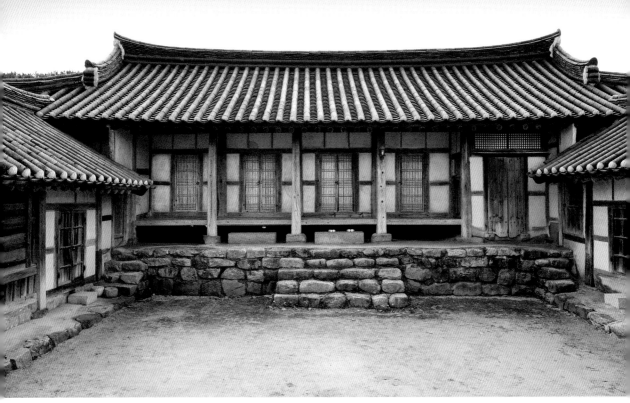

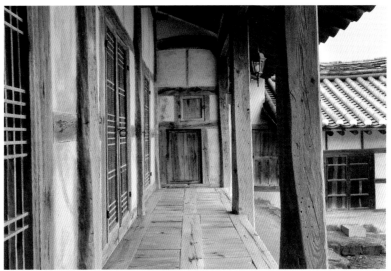

Front view of the *anchae*. (top) Lateral view of the *toenmaru*. (bottom)

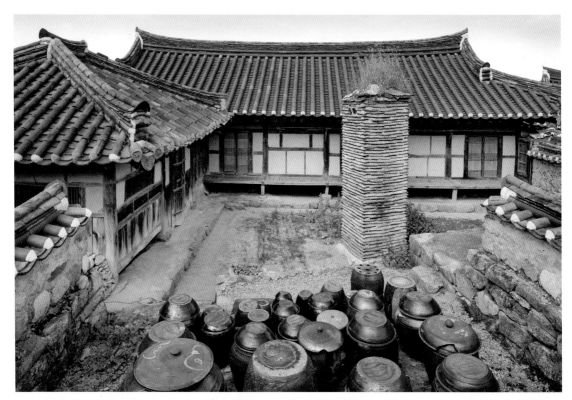

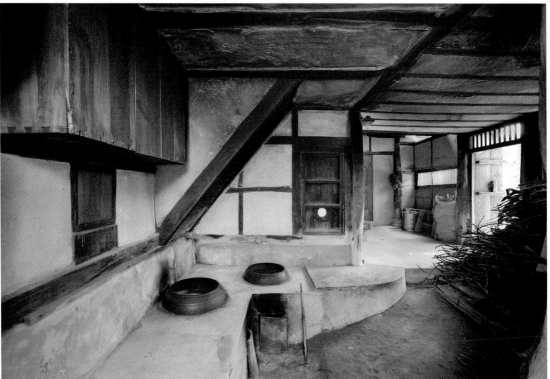

Jangdokdae, located at the rear of the *anchae.* (top) Interior view of the kitchen. (bottom)

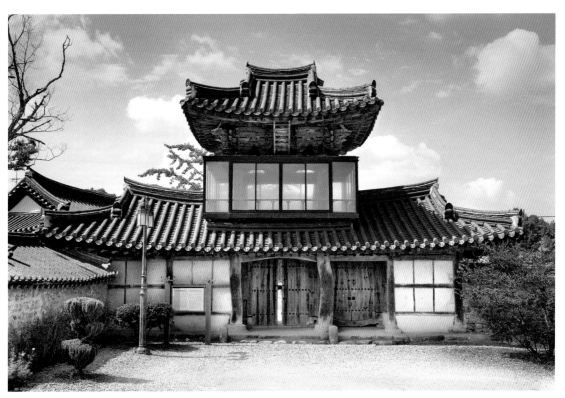

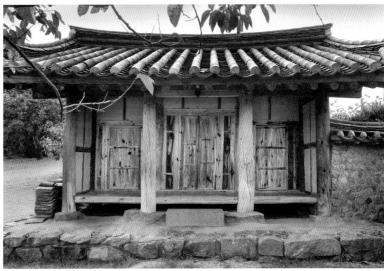

Daemunchae. (top) *Sadang.* (bottom)

Birth House of Yeong-rang in Gangjin

Built at the end of the Joseon Dynasty
15 Yeongrangsaengga-gil, Gangjin-eup, Gangjin-gun, Jeollanam-do

Nestled against a hillside, this south-facing residence lies in Gangjin-eup and is the birth home of Kim Yeong-rang, one of Korea's most revered and loved contemporary poets. Today, this house has become a very popular destination for visitors, not only due to the residence's building design, but also because of the poet's fame.

Kim Yeong-rang moved to Seoul in 1948 and since then, the home has changed owners a few times. When the Saemaeul Movement took hold in Korea in the 1970's with the aim to improve the living standard in rural areas, the Yeong-rang residence suffered a make-over: the original straw roof was substituted with concrete tiling. This was however reversed when the local council purchased the private home in 1985. According to information by family members, the house was restored to its original condition in 1992.

The estate is comprised of a —-shaped *anchae* (women's quarters) and the *sarangchae* (men's quarters). According to its individual elevation, each building faced in a different direction and was built in adequate distance from the others. Taking into consideration the particular building area and soil, the design deviated nevertheless from the traditional construction of this southern region. The usual practice on flat soil was simply to space the buildings parallel to each other in a long line.

A special feature of this *mobang* style residence is the construction of an additional room, *mobang*, in front of the kitchen. The —-shaped *anchae* comprises a *geonneonbang* (parallel room) with a *hamsil-agungi* (furnace hole with a covering stand) to the front and *toenmaru* (porch) to its side, a *daecheong* (main wooden-floored hall for reception of visitors), *anbang* (inner room), *bueok* (kitchen) and *mobang* all built in one row.

A house with a *mobang* is a design that can only be found along the south-westerly coastal regions of Jeollanam-do provice and has a very strong regional character; the advantage of this room is that the warmest floor spaces are arranged around the central *ondol* fire place.

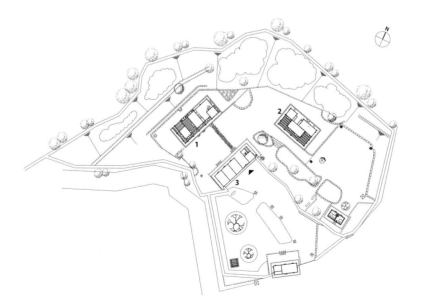

1. anchae
2. sarangchae
3. munganchae

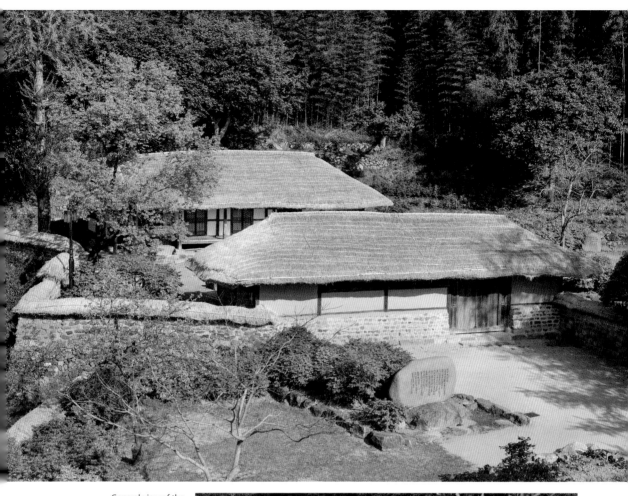

General view of the
residence. (top)
Lateral view of
the residence. (bottom)

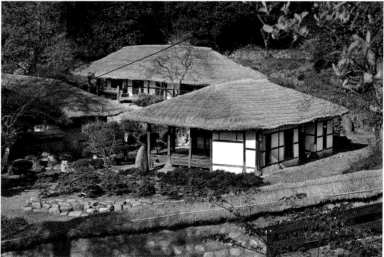

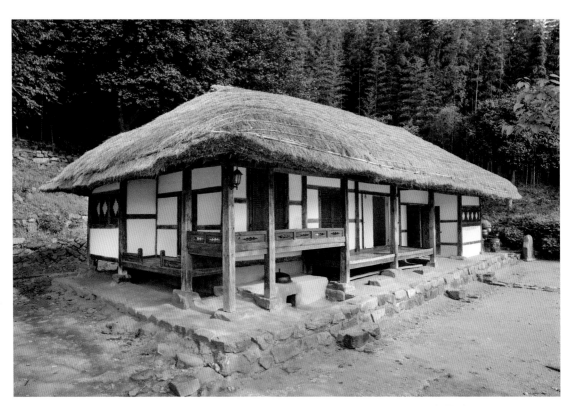

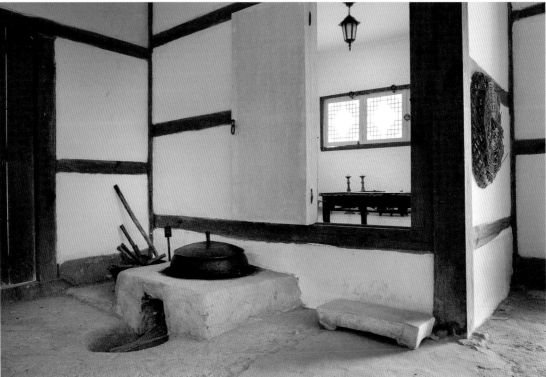

View of the *anchae*. (top)　The kitchen of the *anchae* with view of the *mobang*. (bottom)

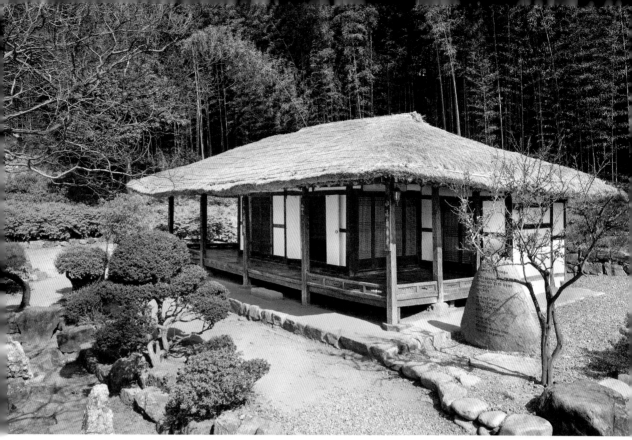

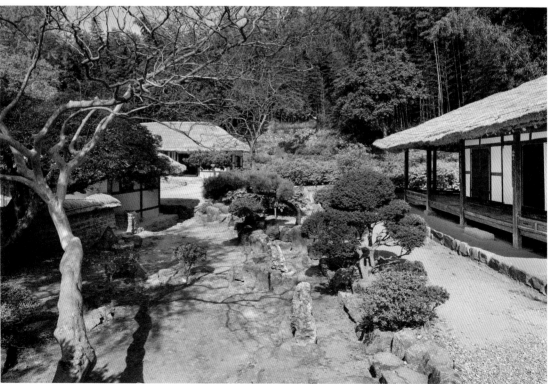

Sarangchae. (top) *Madang,* viewed from the *sarangchae* und from the garden. (bottom)

Residence of Go Pyeong-o in Seongeup

Built in approximately 1829, or at the end of the 19th century
5-3 Seongeupjeonguihyeon-ro 34beon-gil, Pyoseon-myeon, Seoguipo-si, Jeju-do

Located in the former region of Jeonuihyeonseong, today's Seongeup, the residence is now part of an outdoor museum and lies at the beginning of the Nammun Street, which runs north from the northern gate of the historic village. Entering from Nammun Street, the visitors walk on a 1,6 m long path, the *ollae*, to reach the entrance gate of the residence, the *mungan*. To the side of the gate and built parallel to it stands the *sarangchae* (dialect: *bakkeori*, men's quarters). Past this area and after passing along the additional building (dialect: *mokeori*) and taking a right turn, there are the *madang* (courtyard) and the *anchae* (dialect: *angeori*, women's quarters). The pathway has been designed in a slightly winded fashion in order to protect this inner domain from strangers. On the island Jeju, this type of design is prevalent among the wealthier homeowners.

Some historical sources date the construction of this estate to 1829 (King Sunjo's 29th year of reign) and list the great-grandfather of the initial owner as the building commissioner. However, both the floor plan

and the level of wear suggest a much later construction date – probably around the end of the 19th century. The *sarangchae* is believed to have been used as guesthouse for civil servants; this is supported by the existence of a type of water jug, reserved only for use by a district governor. There is also a *yeonjamaegan* (dialect: *malbangegan*), a millstone worked by horse or ox, in the corner.

The residence centers around the courtyard, the *madang*; in the north of the *madang* stands the *anchae*, to the south is the *sarangchae* and located to the east is the *mokeori*. Together, these three buildings form a ⊏-shape. The estate has been renovated a number of times since 1979, which may have somewhat altered the original condition of the buildings. In terms of size and function this house is different from other private houses. The structural design of both, the interior and exterior space is a good example of traditional Jeju island architecture.

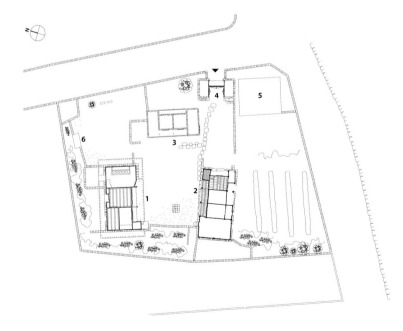

1. angeori
2. bakkeori
3. mokeori
4. mungan-geori
5. malbangegan
6. hwajangsil

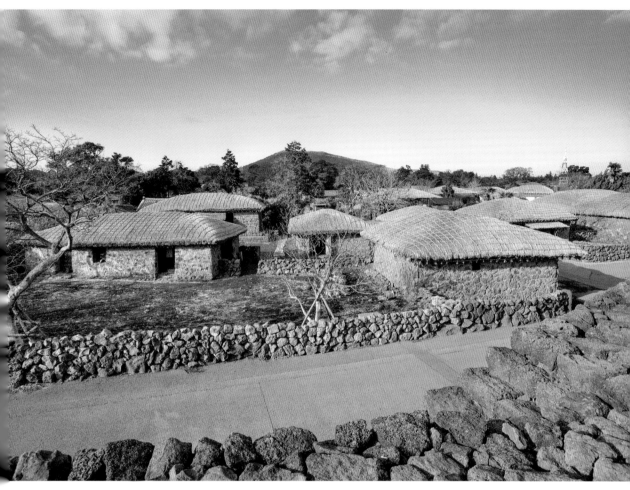

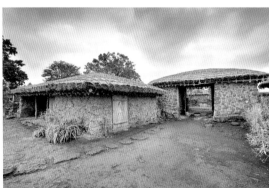

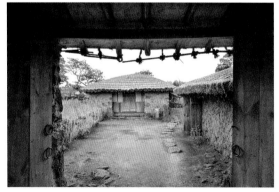

View from the pavilion of the southern gate. (top)
Mokeori and *mungan-geori*. (bottom, left) Residence, viewed from the *mungan-geori*. (bottom, right)

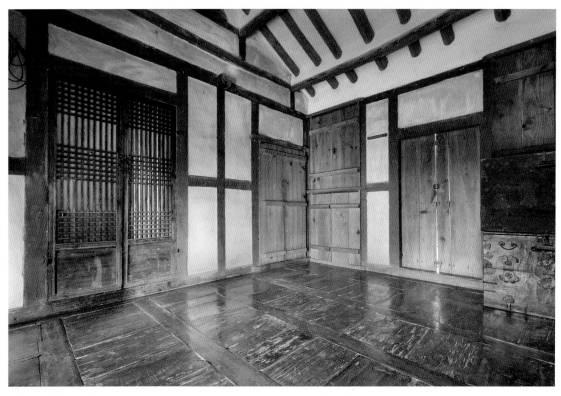

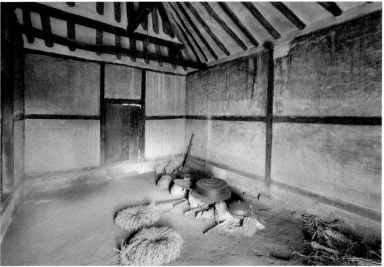

Room on the top floor of the *anchae*. (top) Interior view of the *jeongi,* kitchen. (bottom)

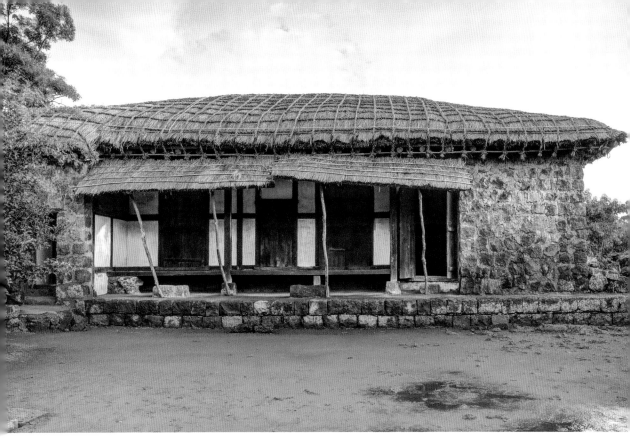

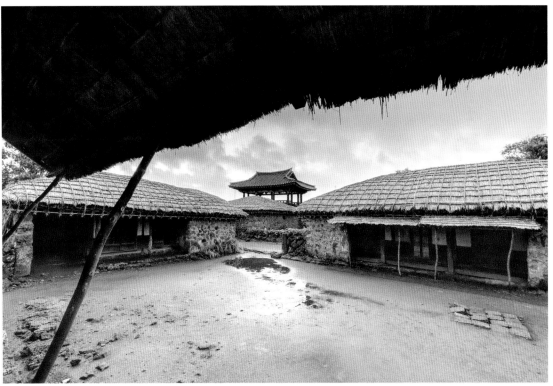

Front view of the *anchae*. (top) View of the *anchae*'s courtyard and *mokeori*. (bottom)

243

A Genuine Way to Record Cultural Heritage

Childhood as the youngest son of the Seo family in Bangjukgol

Anbang, witbang, geonneonbang, munganbang, anmadang, bakkat-madang – all these were the playgrounds of my childhood. The warmest space in the *anbang*, the women's room, was reserved for me. I slept on my mother's lap on the *maru*, when the sun shone so gloriously in spring. I was mercilessly reprimanded by my mother when, despite her stern warnings, I played on the *jangdokdae* and broke the storage pots. In autumn, when the famers used machines to peel the rice, I delighted in spreading out on the rice straw, watching them. In winter, these straw heaps provided me with hideouts to play hide and seek with friends. I remember so well riding a cart, drawn by a young cow, through those rice paddocks with my father, who said: "Those trees over there. I will fell them and build a house out of them for my youngest son, when he gets married."

Once I went to school, I had to move to the upper rooms, and later I had to leave for the city to attend secondary school. In the end, I even permanently moved to Seoul, first to attend university and now I permanently live here. When I returned to my home village of Bangjukol from time to time, the dog was the first to hear the sounds of my footsteps and the first to run up towards me, welcoming me back. My home village is shaped in a triangular form and between the entrance and the centre of the village, three great trees stand next to a pond. A little stream runs at the front of the village, behind it, the Wolbong Mountain rises in the distance. Because of its different characteristics, the village had different names over time and was called Andongne, Jeongjanamu-dongne, Bangjukgol or Yongam-maeul. The village housed about 50 families – a typical small village of Chungcheong province. Today, it no longer exists. When the express train was built, my home village disappeared with the modernisation of our cities and was integrated into Cheonam city – it had disappeared as if it had fallen off the edge of the world. In this turbulent time, my father passed away unexpectedly and his promise to fell those trees for my wedding has not been fulfilled to this day. My home village and my father only exist in the depth of my heart today and whenever I think of my youth, I can't help but wipe away some tears.

My life as photographer

"Hello, Heun-gang, come to Gwanghwamun tomorrow, we'll have lunch together,"
I heard Kang Woon-gu's voice on the phone. This was not only an invitation by a
friend, but also to be understood as a work assignment. I was to portray the *hanok*,
the traditional Korean houses designated cultural heritage. I had started taking
photos of them more than a decade ago out of private interest and now, I was to
document them throughout the country. Although I said "yes", I could not ignore the
feeling that I might have undertaken something larger than I alone could undertake
and so I asked my colleague Joo Byoung-soo to help me. We developed a strategy
to divide the country into an eastern and a western section and I took off to the
west, while Joo Byoung-soo documented the east. Two other helpers were assigned
Hanoks in other areas. We then planned to exchange sections to ensure we took
pictures from a range of different angles.

Our plan was to shoot the historic houses from a visitor's point of view. And of
course, the location of the objects and the regional characteristics were to be taken
into consideration. The view of the estate when stepping through the entrance gate,
the ground plan of the estate, the building constructions, the objects at the back of
houses, left and right sides, views of buildings from the hills behind the estate, and
views from the front – these were the most important views we wanted to capture.
We also did not forget to take pictures from the inhabitants' point of view: from
their rooms to the representative rooms used for the reception of guests, from this
room to the courtyard of the women's quarters, from the women's quarters to the
daemun, the entrance gate. Such typical angles, but also any deviation from typical
forms, were things we could not miss and had to document.

We wanted to use natural light for as many of the shots as possible, but from time
to time we also used artificial lighting, e.g. when taking pictures inside the house, as
we wanted to capture the atmosphere of a warm room. For professional images of
some of the houses portrayed here, we even needed specialist equipment. In other
words, we made full use of state-of-the-art technology to produce professional work.
For this, we not only documented the views of our objects, but also meticulously
planned the order of those images.

When people ask me what the most difficult object is and whether it may be
the surface of a porcelain vase, I reply: "No, objects of cultural heritage are the
most difficult to capture." Artefacts made from porcelain or metal are themselves
beautiful enough but with many objects of cultural heritage the colours are often
grey or dark, which is disadvantageous for photography. One has to overcome
these disadvantages with state-of-the-art technology, only then will they show their
beauty. Especially the traditional *hanok* buildings recognised as cultural heritage
no longer have inhabitants, but are in the hands of museum curators, which makes
it almost impossible to capture some of their original atmosphere on camera.

However, it was still our desire to resurrect some of their life from the past through our photographs.

"You are crazy!"

Our first destination was Yangdong village, which has now been acknowledged by the UNESCO's as a world heritage site. It was not my first visit there and so I had thought of this as an easy task. After all, we had our clear work procedures and methods, and it was only following these we wanted to interact with the objects. We were soon to discover, however, that our planning had been somewhat naïve. Unexpected issued arose, e.g. when a house was built on the elevation of a hill, or when the different types of doors, while standing for themselves, needed to be shown as connected to each other. This was also true when the houses had a specific character or type of living arrangement. It was the inner, true value and the situation the people once lived in, that we wanted to capture in the end, not only their outer appearance. After this, we let our work rest for a little while, as we had to gather information on the history, life and reality of life in the past and expand our knowledge of these before we could proceed. The objects had to be captured not only with our eyes but also with the knowledge of the past and the historical life of older building styles that was to be represented in our images. In other words, we had to find a dual method that captured both, a visitor's point of view, but also that of their owners and their lives. We tried to capture and preserve the memories of these old traditional houses as well as the lives of their inhabitants.

I visited the Segyeop Kkachi-gumeong-jip in Seolmaeri, Bonghwa together with a curator of the National Folk Museum. The building must have seen restoration works just before our arrival, and piles of construction waste were still everywhere on the premises. I immediately began clearing the rubbish and cleaning everything and the curator joined me in this effort. By the end of it, both of us were soaked in sweat, as it was a very hot day. Once the house was somewhat clean, I started taking pictures, which prompted the curator to shout at me in anger: "Are you crazy? It isn't necessary to take pictures in such detail! Is this gratifying for you? I am amazed by your enthusiasm, you really must love your work." I felt pity with him at that moment, but reconciled with him over a glass of beer over dinner.

A lot has changed over time. Especially the Republic of Korea has changed at an unimaginable pace in the second half of the 20th century. Most Koreans, myself included live in apartments and are accustomed to this lifestyle. If something is uncomfortable, nothing is done to improve things but quickly, an alternative, more comfortable way is sought. Everything increasingly gravitates towards consumerism. While everyone is quick to emphasise how important tradition is, if the road to preservation is too tedious, it is easier to close one's eyes and not go down this road at all. Through my career as a photographer, spanning over 20 years, I see, feel and

notice how our modern life has changed in so many ways. I visited other continents like Asia, America and Europe, and learnt about their ways of life and culture with a certain amount of envy. What would these strangers think about Korean culture? I constantly reflect on how to capture the 5000-year old history and culture of Korea in images and share it with the world in an approachable, lively way. To this day, I have not found an answer to this question.

Over the course of two years, while I captured *hanok*s across the country, I saw and learnt a lot. I think, I have found a part to the answer – one needs to work on such a task with intensity, dedication and strength. I have not found my lost home, but Kang Woon-gu intended to lead me down this road and support my search for this lost past. I also thank Joo Byoung-soo for his support.

May 2015
Seo Heun-kang

Glossary

anbang inner room, women's room

anchae literally 'inner court', meaning the women's living quarters

andaecheong representative room for reception of guests in the women's quarters, mainly used in summer

anhaengnangchae additional *haengnangchae* in the inner living area

anmadang courtyard of the *anchae*

ansarangchae additional *sarangchae* in the inner living area

araechae literally 'lower house', meaning the outer-wing house

bakkat-sarangchae additional *sarangchae* in the outer living area

bangmun room door

bongdang soil floor. The unfloored area between two rooms

bueok kitchen, also called *jeongji*

bunhap-mun *bunhap* literally means 'to fit together'. These doors consist of four parts and can be folded up in summer, generally fitted between a room and *daecheong*

busokchae attached house

byeolchae/byeoldang separate house (*dong-byeoldang* is the eastern separate house and *seo-byeoldang* is the western separate house)

byeonso toilet house, also called, *cheukgan, dwitgan, hwajangsil*

changmun window

cheok Korean measurement, approx. 30,3cm

cheukgan toilet house, also called *dwitgan, byeonso, hwajangsil*

chi Korean measurement, approx. 3,03cm

chimbang bedroom of the patriarch

chodangchae straw thatched house outside of the living area

choga-jip straw thatched roof

choseok foundation stone

chunyeomaru overhang on a hipped roof

daecheong the main wooden-floored hall, representative room for reception of guests, mainly used in summer

daecheong-maru main wooden-floored room or hall

daemun main entrance door to the house

daemyo honorary temple for the ancestors of the family, and where honorary ceremonies for the ancestors are held at special times

dang house, less representative than *jeon*

ttijangneol-mun door made of thin and small horizontally connected pieces

deul-mun door that can be folded up, mainly used in summer

dongjae/seojae eastern/western house

dwitgan toilet house, also called, *cheukgan*, *byeonso*, *hwajangsil*

gamsil chest for ancestral worship

gaok house (Chinese word)

geonneonbang literally 'room on the opposite side', situated parallel to the men's or the women's room, the *daecheong* for reception of guests is located in between

giwa-jip house with tiled roof

gobangchae storage house

gongnu-darak storage room

gotaek old residential house (historic)

gotganchae storage house for goods, also called *gotgan* or *gwang*

gudeul floor heating system, also called *ondol*

gudeulbang room with floor heating system, also called *ondolbang*

gulpi-jip house with *gulpi*, oak bark

gwallisa administration house, or security and janitor's office, also called *sujiksa*

gwang storage space, also called *gwangchae*, *toetgan*

gwiteul-jip square wooden framework house, the gaps filled with clay

haengnang-madang courtyard in front of the *haengnangchae*

haengnangchae house for service staff and storage facilities

heon representative pavilion, administrative building

heotganchae storage house with rooms for service staff

hoji-jip house for guest workers not part of the permanent staff. Also a house for a janitor or administrator

hyanggyo Confucian academy or village school

hyeonpmun side gate leading to another house, most often to the *sarangchae*

iksa wing house

ilgakmun simple entrance door with one column

imsacheong room for preparation of ancestor rituals

ja Korean measurement, approx. 30,3cm

jaesa memorial house for ancestors

jageun-sarangchae young men's quarters (son's residence)

jangdokdae pedestal or free storage space outside for storage of spice stock kept in clay pots

jecheong room for the ancestor ritual

jeon representative palace or temple building

jeong pavilion

jeongja pavilion

jeongji kitchen, also called *bueok*

jeonsacheong room for preparation of ancestor rituals

jeontoe-jip house with surrounding *maru* and the outer walls constructed with

wood and clay, and with *ondol* heating

jip house (Korean word)

jongdori ridge purlin, also called *jungdori*

jongtaek original family house

junggansolju supporting thin wooden pole in the middle of a room door

jungmun middle gate, middle entrance to the living quarters

jungmunchae middle house with entrance gate in the inner living area

jusa kitchen for food preparation used in ancestor ceremonies

kan distance between columns, depending on building type between 1,8m and 2,4m; also used as special measure, 2,4x2,4m = 5,76m²

keun-sarangchae great manor house/ men's quarters (residence of the patriarch or father)

kkachi-gumeong-jip so-called 'magpie house'. The fireplace/kitchen and the cow stables are housed in the same building. A vent for smoke produced by cooking also allowed for birds to occasionally enter the house, giving the house the name magpie house

madang courtyard, courtyard garden

maguganchae stable for domestic animals

maksae end tile, a roof tile placed at the end of the roof to finish and decorate the edge

maru wooden-floor / wooden-floored room

marubang wooden-floored room

marudaegong support post, or supporting element resting on the middle beam and carrying a ridge purlin

meoritbang literally 'upper room', located next to the *anbang*, if the house has an *anbang*. Also called *witbang*.

mobang room located in immediate proximity to the fireplace, where the warmest floor areas were, next to the central *ondol*-fireplace

momchae main building, like *anchae* and *sarangchae*

munganchae gate house

munganbang room in the entrance gatehouse

naerimmaru ridge on a hipped roof, on palace or temple roofs, which features various animal figures to deter negative spirits

naewon flower garden in the inner living quarters

neol-mun door with thin diagonal wooden boards

neowa-jip house thatched with *neowa*, shingles made of red pine tree. Only a small number of such houses can be found today

nu/ru open pavilion at a pond

numaru open, roofed two-storey structure with a raised wooden floor built beside the *sarangchae,* used mostly in summer for reception of guests

nunsseop-jibung literally 'eyelash roof'. Roof of an annex building at the *hanok*, attached to the main roof's overhang. The name comes from the optical effect of the secondary roof, similar to eyelashes above the eyes.

oeyanggan stables, cow stables

ondol floor heating system, also called *gudeul*

ondolbang room with floor heating system, also called *gudeulbang*

palgak-jibung octagonal roof

paljak-jibung gable-and-hipped roof, also called *matbaejibung*

pyeong space measure still in use today in Korea, approx. 3,30m²

sadang shrine, memorial building for the ancestor

salimchae residential house for the family, general living quarters

sarang-madang courtyard of the *sarangchae*

sarangbang men's room

sarangchae men's quarters

sarangmun gate leading to the *sarangchae*

seokkarae timber rafter

seowon Confucian academy or school

sinmun gate for the spirits (entrance to the ancestors' areas)

sireong pole attached to the wall for hanging clothes

soseuldaemun entrance gate, entrance gate to a aristocratic house rising over other parts of buildings

soseuldaemunchae representative entrance gate or entrance gatehouse

sujiksa administration house, or security and janitor's office, also called *gwallisa*

toenmaru narrow wooden floor (outside of a room)

tumak-jip wooden blockhouse built with reed and clay. The outside supporting structure consists of wooden logs

ujingak-jibung hipped roof

yeongssangchang door with thin wooden pole

yeonmot pond, also called *yeonji, yeondang*

yongmaru ridge

Yi Ki-ung was born in Seongyojang, Gangneung, Korea. He began his career as a publisher in 1960. Ever since he founded Youlhwadang Publishers in 1971, Yi has actively developed art publishing in Korea. In 1988, he initiated the Paju Bookcity and became president of the Bookcity Cultural Foundation. An accomplished author himself, he has been invited to participate in the Korea Pavilion of the Leipzig Book Fair. He also serves as the president of the International Culture Cities Exchange Association and organised the traveling exhibition Scripts of the World in 2014.

Seo Heun-gang was born in Choen-an, Chungcheongbuk-do, Korea and studied photography at Chung-Ang University. As a photographic journalist, he has contributed to several professional journals. Today, he works as a freelance photographer and has held several photographic exhibitions (1986, 1989, 1994, 2003, 2011).

Joo Byung-soo was born in Seoul, Korea and studied photography at Chung-Ang University. He works as a freelance photographer and has contributed to several encyclopedias.

Isabella Ofner was born in Germany and studied at Tübingen and Regensburg Universities. After living in Korea, she now works in the Faculty of Graduate Research portfolio at Monash University, Australia.

Tina Stubenrauch was born in Germany and studied at Regensburg and Korea Universities and the University of Melbourne. After living in Korea and the United States, she now works as International Engagement Manager for the Faculty of Arts at Macquarie University in Sydney, Australia.

Hanok, the Traditional Korean House © 2015 by Yi Ki-ung
Photographs © 2015 by Seo Heun-kang and Joo Byoung-soo
English Translation © 2016 by Isabella Ofner and Tina Stubenrauch
English Edition © 2016 by Architectural Publisher **B** and Youlhwadang Publishers
Original Korean Edition © 2015 by Youlhwadang Publishers

First Published in 2016, and reprinted in 2021.

Co-published by Architectural Publisher **B** and Youlhwadang Publishers

Architectural Publisher B
William Wains gade 9
1432 Copenhagen K. Denmark
www.b-arki.dk gilberthansen@b-arki.dk

Youlhwadang Publishers
Gwanginsa-gil 25, Paju-si, Gyeonggi-do, Korea
Tel +82-31-955-7000 Fax +82-31-955-7010
www.youlhwadang.co.kr yhdp@youlhwadang.co.kr

ISBN (Architectural Publisher **B**) 978-87-92700-11-7
ISBN (Youlhwadang) 978-89-301-0516-3

This book is published with the support of the
Literature Translation Institute of Korea (LTI Korea).